Andreas Feininger

NATURE CLOSE UP
A Fantastic Journey into Reality

Dover Publications, Inc., New York

To Wysse, with love . . .

The photographs on the following pages were produced on
assignment for LIFE Magazine, are copyrighted by Time, Inc.,
and are here used with the permission of LIFE Magazine: 90,
91, ©1949, Time, Inc.; 82, 83, ©1952, Time, Inc.; 74, 75, 76,
85, 86–87, 88–89, ©1953, Time, Inc.

Grateful acknowledgment is made to the Collector's Cabinet,
153 East 57th Street, New York, N.Y., for making specimens of
dendrite, breccia, and agate available for photography.

This Dover edition, first published in 1981, is an unabridged, slightly altered
republication of the work originally published by the Viking Press, New York,
in 1977 under the title *Mountains of the Mind: A Fantastic Journey into Reality*.

International Standard Book Number: 0-486-24102-5
Library of Congress Catalog Card Number: 80-69745

Manufactured in the United States of America
Dover Publications, Inc.
180 Varick Street
New York, N.Y. 10014

Centre For Business, Arts and Technology
Learning Centre
444 Camden Road, London N7 0SP
T: 020 7700 8642
E: batlib@candi.ac.uk
W:www.candi.ac.uk/cbat

CITY AND ISLINGTON
COLLEGE

This item is due for return on or before the date last stamped below.
You may renew by telephone, email or online. Please quote your
student ID if renewing by phone.

Fine: 5p per day

I WEEK LOAN

2 1 JAN 2009

0 5 JUN 2017

0 6 MAY 2009

1 9 APR 2010

1 9 APR 2010

CPD6017

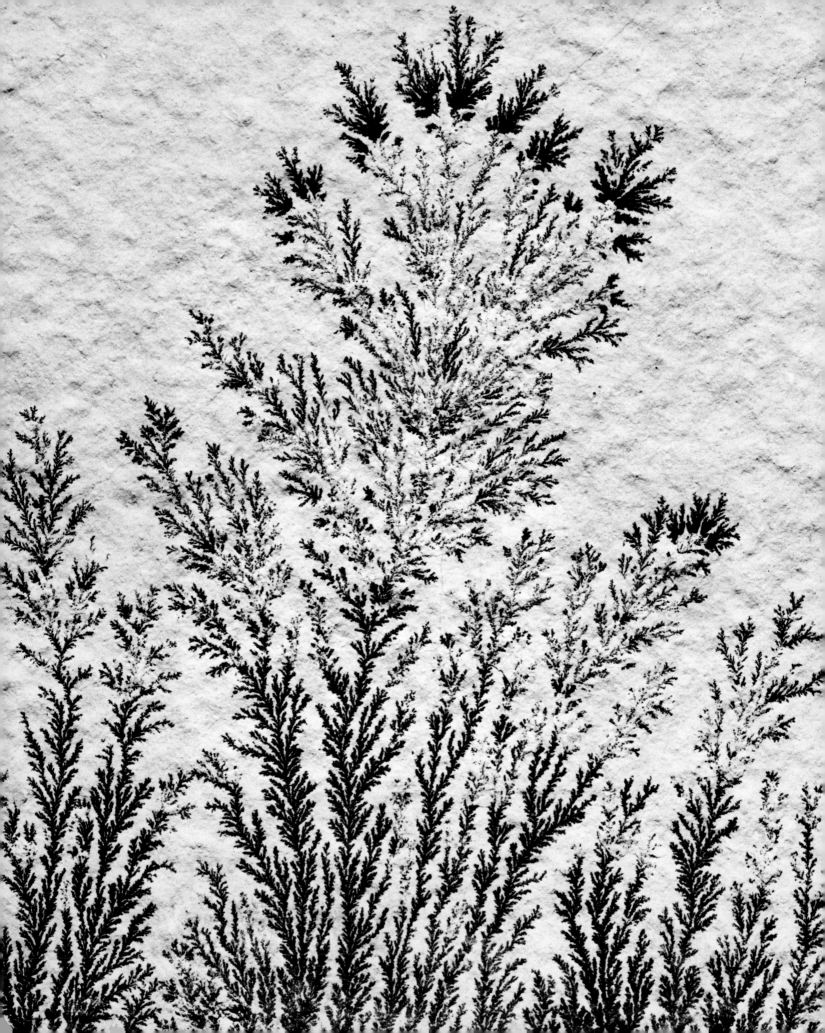

Contents

Foreword

The mind can be said to operate on many levels. In their thoughts some people never rise above the drudgeries of daily life—their jobs, the rent, the price of meat. Others are able to leave the plains and valleys of their existence and ascend to the heights—to the hills and the mountains.

If this sounds cryptic, let me give an example: some people see in a tree nothing but a source of wood and, accordingly, measure its value in dollars. Others esteem it as a giver of shade on sultry summer days and have an eye for its beauty. And then there are those who are aware of all these aspects but, in addition, experience a tree as one of the marvels of creation: a living, growing organism endowed with a special set of senses responsive to light, gravity, moisture, temperature, pressure, and time; a chemical factory of incredible complexity and sophistication surpassing anything created by human hands, seething with inner activity, providing, in the process of converting solar energy into food, the oxygen indispensable to all the creatures on earth, including man. People who can see the wonder in a tree, who can extrapolate from a tree to a forest, who can look at a single tree and realize the cosmic implications of all plants—such people have scaled one of the mountains of the mind.

The key to reaching such heights is imagination. Imagination is the power to form mental images of something not actually experienced, of reaching out into the unknown and coming back with visions, of drawing conclusions, combining different and sometimes seemingly unrelated observations and coming up with concepts that are greater than the sum of their parts.

Imagination is like a ladder in the realm of thought. Step by step, it can take the mind higher and higher, from one image or concept to another, set in motion at the bottom rung by a casual observation and rewarding us at the summit with an insight that encompasses vast realms, like the view from a mountain.

Such an experience happened to me not very long ago: I was mowing the narrow trails which I keep open on my land since otherwise the brush would

overrun it totally. Now, in the course of this work, it was inevitable that I also cut off hundreds of cinquefoils, beautiful little yellow flowers that here seem to grow nowhere except along the edges of my paths. Seeing their lovely little heads fall under the whirling mower blade was almost more than I could bear, but the alternative—to relinquish mowing—would mean their end since the dense brush would soon crowd out these sun-loving plants. Besides, within a few days new flowers would spring up—a temporary setback being the price of life.

This thought led to another one, based on the observation that slowly but surely I am losing my battle with the brush. My house stands high on a hill with a commanding view over a valley and a river. But unless I succeed in keeping the slope in front of my windows reasonably free of trees, my view will disappear behind a wall of green. Originally this land was covered by forest; my modest clearing is still surrounded by miles of wood. Now the encroaching trees are making a concerted effort at reclaiming their domain. All over the meadow thousands of saplings raise their little crowns—hop hornbeam and sweet birch, red cedar and black oak, hemlock, dogwood, and tulip tree, all standing from a few inches to several feet in height. A few years ago I brought in a sickle bar and cut down the whole lot. Alas, to no avail, because, the following spring, two, three, and more new shoots grew out of every little stump—the mass of vegetable matter quadrupled almost overnight. And not only the trees, but most of the other plants, especially the brambles, barberry, wild raspberry, and poison ivy—a thoroughly obnoxious lot.

This is one of the consequences of man's interference with nature. This steeply sloping rocky land is best suited to supporting a mixed hemlock-hardwood forest, and unless I wage a constant and expensive war, the trees will return. What I witness right now is the transition from meadow to forest—the ruthless struggle for life where one plant tries to overshadow and crowd out the next, where thousands of little saplings shoot up like mush-rooms after the rain and where, perhaps, one in ten thousand will succeed, mature, and grow into a tall and stately tree. But I also know that once the balance is restored, the jungle will disappear and order reign again. The trees of the climax forest will stand well-spaced on relatively unobstructed ground, each plant receiving its rightful share of light and air.

This realization gave birth to further thought: the fact that thousands of little trees must be born and die young so that a few may live, reach maturity, and

My house stands on a hill . . . but I am in danger of losing my battle with the brush. . . .

propagate their kind. For if each tree were to produce only a measly few seeds, the odds are overwhelming that none of them would survive the insects, the field mice, the squirrels, the birds, unfavorable growth locations, or disease. Conversely, if every seed were permitted to develop into a full-grown tree, the world would soon be choked with trees. Space and nutrients would give out, and global disaster would become inevitable.

This realization in turn set me to thinking about our present most pressing problem: overpopulation and uncontrolled economic growth. I remembered that almost two hundred years ago, Thomas Robert Malthus (1766-1834), a British clergyman and political economist, had already predicted that eventually space and food would run out for mankind. At that time, according to the best available estimates, the number of people in the entire world was only between 500 and 550 million. But already by 1900 this figure had risen to 1600 million, and by 1960

it stood at 3000 million. Today—1975—the number of people was around 4 billion and increasing at the fantastic rate of 200,000 more births than deaths *each day*.

The story that these frightening figures (which are irrefutable) can tell us is this: while man's ascent was slow in the beginning, the rate of population growth accelerated steadily. It took hundreds of thousands of years before man's numbers reached a certain level—an estimated 275 million by A.D. 1000, some 500 million during Malthus's time. However, within the next two hundred and fifty years *the number of people tripled*. Soon afterward acceleration turned into explosion: according to figures provided by United Nations demographers, within only seventy years (between 1900 and 1970), the world's population *more than doubled*, rising from 1.6 billion to 3.6 billion. Ten years ago the British physicist John H. Fremlin* had calculated that, at the then prevailing rate, *the world's population would double every thirty-seven years*. Simple arithmetic tells us that, on this basis, it will take only three hundred and seventy years until the number of people has *increased a thousandfold*. In other words, within only three hundred and seventy years there will be *more than three thousand billion people!* What this means can be visualized by imagining that for every man, woman, and child alive today a *thousand* men, women and children will clog the cities and jam the highways in A.D. 2345.

Fremlin then went on to say that, by artificially melting the polar icecaps with nuclear energy (which, incidentally, would raise the ocean levels almost forty feet, inundating most of the world's largest cities) and intensely farming reclaimed land, the world's population could be quintupled again and brought up to fifteen thousand billion people (yet even this most unlikely and perhaps technically impossible measure would give humanity a reprieve of less than a hundred years). If all the world's animals were destroyed and eliminated as competitors for food, and if food were synthesized out of solar energy, mineral matter, and recycled human waste products, including homogenized cadavers, the earth, according to Fremlin, could sustain one million billion people, raising the population density to two people to every ten square feet of ground.

Time, November 13, 1964. Portions of the following text have been adapted from the author's book *Forms of Nature and Life*, The Viking Press, 1966.

The end, again according to Fremlin, would come in less than a thousand years from today. By that time, he visualizes some sixty million billion people who live, twelve on every square foot of ground, in gigantic air-conditioned structures two thousand stories high. But the stupendous amount of heat generated by this astronomical number of people and their machinery would heat the ground to an incandescent red. . . .

This is not a nightmare out of science fiction but a pragmatic scientist's sober projection of current figures into the future. To my mind, it is a prospect more terrifying than the specter of thermonuclear war. Yet it will happen as surely as the sun will rise tomorrow unless concerted efforts to prevent it are made on an international scale immediately.

In the face of these figures, it is hard to understand how any thinking person can be opposed to the principles of zero population growth, family planning, and birth control. Yet such objections are voiced daily, usually on religious grounds, sometimes on the grounds of national defense. Man, flattering himself to have been created in the image of God, imagines himself endowed with godlike powers, gifted with godlike wisdom, the chosen master of everything that is or lives—his to use, his to exploit, and his, if he wishes, to misuse and destroy. And so he goes on raping the land, killing its animals for "sport" and profit, cutting down its trees, dumping his waste into the rivers and seas, polluting the soil, poisoning the water and air until he destroys his life-giving environment and in his abysmal vanity, ignorance, and greed endangers his very existence.

This is the gist of the train of thought that crossed my mind while I was mowing my trails. Like any aware person, for years I had, of course, heard and read about "the population explosion," so much, in fact, that I had become pretty much inured to its ramifications. Now suddenly the whole nightmare situation became real. Watching a similar struggle for food and *Lebensraum* among the shrubs and trees take place in front of my eyes brought home the fact of its reality with terrifying force. Suddenly I knew the difference between reading about a disaster and actually experiencing it. It was like a flash of insight, as if I had personally discovered the consequences of unrestricted population growth. All of a sudden I was involved in it; it was *my* problem, *my* fight for survival in a desperate race against time. And with the clarity of a

vision I saw that the earth is finite in regard to resources and space, while the breeding potential of man is infinite. While I had known this all my life intellectually, I now felt and accepted it emotionally. It implanted itself in my mind like an article of faith: the earth is limited, man's growing capacity as a species is not. These are facts. They speak for themselves. They cannot be wished away by juggling figures or by faith and prayers or by invoking Almighty God.

Therefore, since we can increase neither the size nor the ultimate carrying capacity of the earth, the only alternative to extinction is voluntary adjustment of our members to an order of magnitude which is consistent with existing means of subsistence. No longer can we play the comfortable role of children who trust that a Heavenly Father will take care of them and see to all their needs. The moment has finally arrived when man must act like a man, for he alone can shape the course of mankind.

Perspective and a point of view

Everything is relative—another fact which, although as obvious as the finitude of the earth, is seldom given the attention it deserves. This was brought home to me unexpectedly while guiding my mower along the trail and watching the tiny flowers at my feet. All of a sudden I saw myself as a giant, immensely tall, striding over the earth which lay, gaily patterned, far down at my feet—green grass and leaves, yellow wood sorrel, white clover, magenta Deptford pinks.

A feeling of unreality took hold of me, and my mind began to wander. I saw myself "in perspective"—a giant relative to tiny flowers, a dwarf in comparison to towering trees. I remembered my emotions of not so long ago when I was photographing redwoods and giant sequoias for my picture book *Trees**: I then had felt like the most insignificant creature on earth, a nothing face to face with eternity. Now I realized that I am neither giant nor dwarf but a human being, halfway in size between the atom and the galaxy, a minuscule yet important part of the cosmos.

This thought struck me as significant: man, being neither so small as to be helpless nor large enough to be all-powerful, lives on the border of two worlds—a world of smaller creatures and things which he dominates and

*The Viking Press, 1968.

subjugates, often treats with contempt, uses ruthlessly, and, through ignorance and greed, gradually destroys; and a world of larger phenomena—forces of nature, earthquakes and hurricanes, supernatural powers—which he fears.

Contemplating this unlovely picture, which seemed particularly typical of modern Western man, it struck me that many of his underlying motivations—and justifications—had their basis in religious beliefs. Confident of having been given dominance over the earth and its creatures by Almighty God, admonished to multiply and populate the land, he fancies himself apart from nature and above her laws—a potentially fatal fallacy. For notwithstanding the fact that man's intellectual and spiritual powers set him apart from all other creatures, his body still is of the earth: like the lowest animal, man still requires food, shelter, living space, and a functioning environment. But these necessities of life will be given to him, at least in the long run, only if he learns once more to live in harmony with nature, a fact which he consistently disregards.

In contrast, how different from Western man's rapacious attitude toward nature is the outlook of the peoples of the East. One of the tenets of Hindu ethics, for example, is profound compassion toward life. Seeing God in everything, the Hindu feels reverence for everything—elephant or ant, giant tree or small weed. Likewise, the Five Precepts of the Buddhist—a practical code of conduct—forbid the taking of life. And one of the main principles of traditional Chinese religious thought, and an indispensable necessity for the attainment of spiritual satisfaction and peace of mind, is the achievement of harmony between man and nature. Whereas Western man sees himself as the crowning glory of creation, the devout Chinese considers himself merely another part of nature, important but not privileged. And while Western man believes himself to have the right to subjugate nature for his own materialistic ends, the traditional Chinese regards nature as an aesthetic pageant whose sublime order and beauty are to be enjoyed and treasured.

In contrast to the Eastern beliefs, the dominant Western religions—Christianity, Judaism, and Mohammedanism—seem to bring out the worst in man. The bloodiest of all the wars in history and the most ghastly atrocities have been committed in the name of God—the Thirty Years' War, which all but depopulated medieval Europe, the Crusades, the persecution and slaughter of Jews from ancient times to the present, the bloody mess in Ireland today, not

to forget the unspeakable horrors of the Inquisition, the witch trials, the burnings at the stake, the ruthless oppression of every progressive thought—all these despicable deeds have been committed in the name of God, to "save immortal souls," or for the greater glory of the Church. How can one help wondering: was the cost really worth the result?

For notwithstanding their lofty codes of ethics, Christians, Jews, and Moslems still lie and cheat and steal and murder and wage war no less than people of other faiths. And although I have heard the Pope express intense concern over the fate of unborn children, I never heard him condemn the bombers, snipers, arsonists, and perpetrators of atrocities against women and children in the present Irish Catholic-Protestant conflict. Nor can I see any great difference between the Christian Paradise and the Eastern Nirvana. But I see a world of difference between the Eastern and Western attitudes toward nature. And of the two, it is most certainly the Eastern view that offers man the greater chance for survival.

There is no doubt in my mind that man, if he expects to continue as a species, must learn to see himself again "in perspective"—related to the animals and plants, a part of his environment, subject to nature's laws. He has to change his point of view from that of an overlord to that of a partner. This thought is underlying every picture in this book: both viewpoint and perspective are those of a partner of the depicted subject—an equal—manifested in a low and level camera position which shows, for example, a shell seen from the viewpoint of another shell, an eye-level instead of the usual downward view of that overbearing tin god—self-centered Western man.

The marvel and the mystery

The enormous progress made during the last fifty years has led many people to believe that science can solve all man's problems, that nature is predictable, and that the few still unresolved questions will soon be answered. Unfortunately, this complacent attitude is also a fallacy.

All my life I have had a burning interest in the manifestations of nature. I have read the proper books, studied the great collections, and talked to many authorities. I know therefore what I am saying when I maintain that nature is *not* predictable and that man will *never* solve its mysteries.

I do not find this thought disturbing. On the contrary, I find reassurance in the fact that something bigger than I exists, something I will never be able to comprehend fully. Because, like any other human being, I have a need for something permanent. Some people find this strength in God. I found it in the mysterious aspects of nature.

I know that "mystery" is a dirty word in any scientist's vocabulary. But mysteries exist. For what is a mystery but something inexplicable, incomprehensible? Here are a few examples:

One of the burning questions of modern cosmology is whether the universe is finite or infinite. But no matter what the outcome of this discussion (provided it can ever be settled irrefutably, which I doubt), the result will always be incomprehensible. Because, if the universe is finite—that is, if there is an end to it somewhere billions of light-years away in space—the obvious question is: what lies behind it? And if the universe is infinite, it is *ipso facto* incomprehensible because the human mind is inherently incapable of conceiving infinite extension of space.

Similar considerations apply, of course, to time. We simply cannot conceive a beginning of time (because, in that case, what came before?), nor can we imagine that time will ever end (because, in that event, what would follow?). And infinite time is equally unimaginable.

Cosmologists constantly search for theories that could explain the origin of the universe. At the moment the favorite is that of the "Big Bang," the cataclysmic explosion of a "cosmic egg" that ejected particles and energy quanta at unimaginable speeds into the void where eventually condensation took place, forming the galaxies and stars. However, no matter whether true or false, to believe that such an explosion can account for the origin of the universe is fallacious. Why? Because it fails to explain the origin of the "cosmic egg." Some people, of course, believe that the "cosmic egg" was created by God—but out of what? Can matter be created out of nothing, as certain modern cosmologists seriously seem to believe? But in that event, who or what created God?

In the last analysis every living thing consists of atoms—"dead" particles of elements—which combine to form molecules, which aggregate to macromolecules, which in turn are the building blocks of cells, which combine to

form the tissues and organs of any living thing. But at what moment does the combination come to life? Where is the boundary between the animate and the inanimate? As a matter of fact, does a sharp dividing line really exist?

Crystals grow slowly through accretion but are obviously not alive. On the other hand, viruses, when desiccated, crystallize like minerals and are then indistinguishable from "dead" chemical compounds. Yet on contact with living cells, these crystalline powders reconstruct themselves to form viruses which, with the aid of the living cells of their host, reproduce their kind—an unmistakable characteristic of life. But what is life?

So far, nobody has been able to give a satisfactory definition that makes it possible to distinguish categorically between "dead" and "living" matter. Personally, I believe there is no such dividing line. If we go down the ladder, starting at the top with a living creature and examining its parts all the way down to their smallest components, we find that the human body, say, consists of a head, a trunk, and four limbs; organs such as the brain, the heart, the lungs, the stomach, liver, kidneys, and so forth; tissues which form these organs, which in turn consist of cells, the basic building blocks of life.

Down to this point there is no problem; cells are unquestionably alive. But then the picture becomes hazy because a cell is not simply a tiny bubble filled with sticky goo, but an incredibly complex structure consisting of many different parts collectively called organelles which fulfill different functions and are comparable to the organs of multicellular structures.

The organelles in turn can be broken down into smaller components—membranes, granules, tubules, and threads—which consist of polymers and macromolecules, which are aggregates of smaller molecules, which are composed of atoms. And atoms are unquestionably "dead." The whole sequence is analogous to a set of Chinese boxes—boxes within boxes within boxes—where the largest one represents the living organism in its entirety and the smallest one its smallest physicochemical component—"dead" matter. But where on the way down the ladder did we lose the thread of life? Nobody knows, and life still is, and probably always will be, a mystery.

But what about my statement that nature is not predictable?

This conviction is based upon the fact that radioactive substances decay spontaneously in a way that, as far as individual atoms are concerned, seems

totally irrational: although the average rate of decay of any radioactive element is precisely known (its measure is the half-life, the length of time it takes for the respective substance to decrease by half), there seems to be no way to predict which of its atoms will disintegrate next. While one atom may remain unchanged for another hundred, thousand, or million years, its neighbor may explode within the next second, notwithstanding the fact that both were created at the same time and are identical in every detectable respect. But if nature is unpredictable in regard to some of its most basic components, it stands to reason that this uncertainty must carry over into higher levels, a conclusion that, incidentally, has convinced many thinkers of the reality of Free Will.

I used the word "marvel" in the heading of this discussion. What I had in mind is this: whereas a true mystery is a phenomenon the understanding of which is beyond the capability of the human mind (like the concept of infinity), a marvel, in the sense I use the term here, is, so to speak, a mystery of a lower order—a phenomenon capable of explanation in rational terms which, nevertheless, is astonishing, verging on the miraculous. Here is a brief account of some of the marvels of nature that I find particularly fascinating:

Each fall the yellow garden spiders spin their orb webs. In the geometrical perfection of their design, these webs are marvels in themselves, especially if one considers their size relative to the size of the spider and the fact that they are always spun at night. How can the spider visualize the final shape at the time it plans the layout, determine the anchor points that may be several feet apart, and take into account possible obstacles in the form of leaves or branches that might interfere with the flatness of the web? Consider the size of the spider and visualize the size of its brain—an aggregate of primitive nerve cells smaller than the head of a pin. Yet this almost microscopic organ is capable of planning and directing the execution of that fantastic orb. But what strikes me as still more marvelous is the fact that no parent taught the spider how to fabricate its web—the knowledge is instinctive, inherited, encoded somewhere in the depth of its minuscule brain in a form that is, perhaps, a mystery forever beyond our knowledge.

The feat of the yellow garden spider is not unique in the animal world. Another artisan whose skill borders on the miraculous is the Baltimore oriole.

Its pouchlike nest, usually dangling from the end of a slender branch, can best be seen after the trees have shed their leaves. What makes it so fascinating is the skill with which it is woven—yes, woven!—plus the fact that, again, this skill is not taught by a parent bird but inherited. Imagine—not only physical characteristics but also specific skills can be inherited, handed down through countless generations of birds (or spiders) since time immemorial. But by what physical means is this marvel accomplished—not only the ability to build a complicated nest (or web) but also the compulsion to weave (or spin), each species of bird (or spider) following its own distinctive design? The secret must lie in the composition and arrangement of the molecules—"dead" matter!—in certain genes. But how can a sequence of molecules—a string of matter— encode and transmit anything as insubstantial as knowledge, a drive, a skill, a design, on and on, forever?

Among the most remarkable manifestations of nature are the sense organs—the information-gathering systems of animals and plants. Here the list is endless, so I can mention only a few that strike me as particularly miraculous:

"Color" is a concept that, strictly speaking, is a human "invention." A physicist might define color as a psychophysical phenomenon induced by light. And light, as any high school student knows, is a specific form of electro-magnetic radiation—that is, energy. And energy is colorless. However, in the form of the human eye, nature has created an instrument not only capable of receiving light signals, focusing them into precise images, and passing them on to the brain for processing and evaluation, but also capable of distinguishing between light impulses of different wave lengths which it translates into colors of corresponding hues. This in itself is a rather miraculous achievement, but the precision with which the incoming waves are measured, sorted, and trans-formed into the appropriate colors is almost unbelievable, accuracy being of the order of close to one-millionth of an inch. As a result of this incredible sensi-tivity, we can distinguish between about a hundred and fifty different hues, many of which may appear in more than a hundred different stages of satura-tion, each stage in turn manifesting itself in more than a hundred shades from light to dark, with the result that the number of different colors, tones, and shades that the human eye can distinguish exceeds one million.

Speaking of sensitivity: the French entomologist Jean Henri Fabre has

shown that the male of certain night-flying moths can locate the female at distances of more than a mile by picking up her scent with his antennae and following this aerial trail—an absolutely fantastic achievement which pre-supposes a degree of sensitivity that must involve the ability to react to, and distinguish between, single molecules.

While what we crudely may call "the mechanics" of seeing and smelling are at least partly understood (although how the incoming signals are processed by the brain, evaluated, and transformed into responses is still largely unknown), other senses exist which are completely mysterious. How, for example, do the green turtles find their way to their breeding ground? These marine animals were known to live on seaweed off the coast of South America but, unlike other sea turtles, did not lay their eggs on the nearest shore. Since it was also known that green turtles breed on Ascension Island, which is a mere speck of rock lost in the vastness of the South Atlantic Ocean, marine biologists tagged a number of turtles in an effort to learn something about possible connections between the island turtles and those of the mainland. To their surprise, they discovered that both belong to the same population, that these animals are born on Ascension Island, that they migrate to the coast of Brazil, where they live for a few years, and that they subsequently return to their native island, where they mate and lay their eggs. This is now established as a fact. But how these turtles manage to find their way unerringly across a thousand miles of trackless ocean to make landfall at a pile of rocks lost in the immensity of the sea—by what sense and in what way they navigate—is still a mystery.

And the same can be said of the king salmon which, in search of food, ranges as far west as the central Aleutian Islands, only to return, when their time has come, across some twenty-five hundred miles of ocean to their native spawning grounds in the tributaries of the Columbia and Snake rivers, the places where they were born. How do they know? How do they find their way?

Similarly, the European and North American freshwater eels migrate from their native rivers to the Sargasso Sea in the South Atlantic Ocean, there to spawn and die. But their larvae—the elvers or leptocephali—make the same journey in reverse, a voyage of several thousand miles that may take up to two years to complete, following the ocean currents until they arrive at their ancestral rivers in Europe or North America. There they mature and live until

they too perceive the call and a nameless instinct drives them to abandon the comfort of their feeding grounds, head out to sea, and depart on that last voyage from which there is no return. What is it that unerringly guides these fishes to their destiny?

Well-publicized and spectacular are the migratory feats of birds. An arctic tern, ringed as a nestling on the coast of Labrador, was retaken ninety days later and nine thousand miles away in Africa. Another tern, banded in arctic Russia, was picked up off the Australian coast after having flown more than fourteen thousand miles. Sandpipers migrate from Canada to the southern part of South America and often don't stop until they reach the southernmost tip of Tierra del Fuego. The European stork and European and North American swallows regularly make migratory journeys twice a year that involve distances from seven thousand to nine thousand miles.

But astonishing as the distances birds can travel may be, still more spectacular are their navigational feats. Golden plovers taking off from Alaska find their winter homes in the Hawaiian Islands across two thousand miles of water. The bristle-thighed curlew, a shore bird summering in Alaska, spends the winter in Tahiti and nearby Pacific islands after having crossed six thousand miles of open sea. A Manx shearwater, taken from its home on Skokholm Island, off the coast of Wales, to Boston and released there, was back at its nest twelve days later after a flight of three thousand miles. What is that unknown force that tells these travelers—these tiny packages of energy driven by an indomitable spirit through storm and night toward their goal—when to leave, where to go, and how to find the way? We do not know. Scientists have several theories, few facts, many conjectures, and no convincing explanation at all.

A swallowtail dips and glides across my path, starting another train of thought: symmetry in nature. With few exceptions, animals are either bilaterally symmetrical—the mammals, birds, reptiles, fishes, insects, and so forth—or radially symmetrical—the sea urchins, sea anemones, and starfish. And flowers can have from one to several axes of symmetry. Leaves and crystals are also often symmetrical. And this symmetry is usually not confined to the main features of the animal or plant structure, but extends to details and even ornamental design, such as the pattern of butterfly wings. I see in this another marvel of nature: during the process of growth, one side of the body (or flower or leaf) seems to know what the other one is doing. What is this fabulous mechanism that sees to it that, say, the curlicues and colors of one butterfly

wing are accurately mirrored in the opposite one? How is this information encoded in the genetic material of animals and plants? How is it realized in growth?

Watching the butterfly brought to my mind the fascinating story of its development. Mammals produce young which are more or less miniature replicas of their parents and which slowly grow up into the adult form. Not so butterflies, which lay eggs from which caterpillars hatch, which in turn transform themselves into a chrysalis from which the adult butterfly emerges. To me, this is another one of nature's marvels. I see with my mind's eye the caterpillar, that sluggish sausage stuffed with vegetable matter whose only purpose in life is to eat. I see it approaching the end of its larval stage, probing around restlessly, instinctively searching for the spot where the Cinderella performance will take place, that magic act that transforms the crawling slug into a lofty creature of the air. Imagine what this involves and what happens: having tied itself securely by its hindmost pair of legs with silken bonds to a twig, the caterpillar hangs straight down, motionless, awaiting the great event. Gradually, it seems to shrink, it shrivels, it splits, the skin peels off, and out of its discarded hide the shiny chrysalis emerges, a jeweled vessel within the walls of which the caterpillar dissolved. Yes, it literally dissolved, it liquefied itself, and if I were to open the chrysalis all I would find inside would be a sticky jelly. Eventually the butterfly will break its voluntary prison's walls, ascend to the end of the twig, expand its wings, and fly away into the light. How did this magic happen? How is it possible that a caterpillar liquefies itself, completely remakes its body, grows wings and scales and turns itself into a butterfly—a creature so totally unlike its former self that one who did not know the story would never believe the truth?

Thinking of the transformation of a caterpillar into a butterfly brought to mind another kind of transformation: the transubstantiation of matter. From the moment it leaves the egg, the caterpillar of the swallowtail eats nothing but the leaves of Queen Anne's lace (wild carrot). As a result, the entire caterpillar consists of nothing but wild carrot stuff, and since it doesn't take up food during the pupal stage, so does the adult butterfly. I see in this another marvel of nature: the transformation of a lovely flower into North America's most beautiful butterfly. When one looks at things in this romantic way, it seems unreasonable to make a face each time one bites into a worm when eating an

apple. After all, this worm—actually the grub of a kind of wasp—is nothing but transubstantiated apple.

As I guide my mower along the trail, the sun burns hot on my back, reminding me of the fact that the sun is a star—a star!—just like the stars that glitter in the night sky. I live on the satellite of a star—what a fantastic thought! Why do I always make a mental distinction between the sun and the stars? I know that the sun is some 93 million miles from the earth and that its mean diameter is about 865,370 miles—figures that convey nothing to me because they are too big; they are inconceivable. But then I read not long ago that the sun is "burning" into helium 564 million tons of hydrogen *every second*, liberating *each second* an amount of energy equal to that released by several million H-bombs! This process has been going on at the same stupendous rate for at least ten billion years without appreciably diminishing in intensity and is expected to continue for another 4 to 6 billion. That did it. That put things in perspective. Now I can grasp, not only intellectually but also emotionally, the awesome grandeur of a star.

Speaking of putting things in perspective. . . . A thought-provoking analogy illustrating the age of the human race takes the form of shrinking the age of the earth to one year, its moment of creation coinciding with zero hour on January 1, the time in which we live with midnight on December 31. Measured on this scale, man entered the picture at about 8:35 P.M. on December 31, Christ was born 13 seconds before midnight on the same day, and the average human life spans less than half a second.

I continue my mowing surrounded by a sea of leaves. Green leaves are everywhere—grasses and plants, shrubs and trees of every kind and description. And I ask myself: why so many different forms of leaves, why such diversity? Why not standardization on a few particularly efficient types? Why, for example, are some leaves large and others small? Specifically, why do tree saplings usually have leaves that are much larger than those of the parent tree? Is it to enable the youngster to grow more rapidly out of the danger period of childhood—of being vulnerable because small—by giving it an extra-large capacity for manufacturing food? Why are the baroque leaves of a tulip tree indented at the tip while other leaves end in a point? Why are some leaves roundish, others oval, still others long and slim? Why are some leaf margins

smooth, others serrated, toothed, wavy, or lobed? Why are some leaves single and others compound? The answer to these questions is probably adaptation. But precisely why adaptation takes these particular forms is unknown.

Well-known, however, is the fact that leaves—more precisely, green plants—are the very foundation of life. Without green plants, neither man nor animals could exist. This is so because the only everywhere-available, unlimited source of energy is the sun. But animals cannot utilize solar radiation—it is as useless to them as money to a man dying of thirst in the desert. Only green plants have discovered the secret of utilizing solar power for the production of food. The process by which they perform this marvel is photosynthesis. The energy that makes it possible is light. Under its influence six molecules of carbon dioxide combine with six of water to form one molecule of sugar and six of oxygen in a reaction which, although still not fully understood, can roughly be expressed by this equation:

$$6CO_2 \quad + \quad 6H_2O \quad + \quad 674 \text{ Kcal.} \quad = C_6H_{12}O_6 + \quad 6O_2$$

carbon dioxide water energy sugar oxygen

This is truly the formula of life, the most important equation in the world. Because this single molecule of sugar, multiplied by the astronomical number of such molecules synthesized at any given time, sustains all life.

Without the marvel of photosynthesis we would have no wheat, corn, rice, or potatoes, no trees or flowers, no leaves, no grass. As a matter of fact, there would be no plants. And without plants, there would be no plant-eating animals—no cattle, horses, sheep, or pigs, no chickens, ducks, or geese, no antelopes or elephants, no caterpillars, butterflies, or bees. And without plant-eating animals, there would be no carnivores—no dogs or cats, lions or eagles, and, of course, no man. And in the sea, without the phytoplankton—minuscule free-floating plants—there would be no shrimps, crabs, barnacles, octopuses, sea lions, whales, or fish. In short, without photosynthesis, there would be no organic compounds or products of any kind whatever; no coal, oil, or gasoline, and except for a few kinds of autotrophic bacteria, the earth would be as gray and lifeless as the surface of the moon.

In the process of manufacturing sugar, leaves release large quantities of oxygen. This liberated oxygen is just as important for the continuance of life as

the food made available by plants. For although oxygen is one of the most abundant elements on earth, most of it is chemically fixed in the form of water or as an oxide (for example, limestone). Besides, large amounts of oxygen are constantly withdrawn from the air by the respiration of living things—the burning of coal, oil, gasoline, wood, garbage, and other organic compounds, and by natural oxidation processes like the rusting of iron and the weathering of rocks. As a result, in the course of time, were it not for the activity of plants, these factors would combine to extract all the oxygen from the atmosphere. For although plants use up oxygen in respiration, the amount is smaller than that released by the dissociation of water in photosynthesis. In the end more oxygen is liberated into the atmosphere than is withdrawn from it. As a matter of fact, most scientists now believe that originally the atmosphere contained considerably less oxygen that it contains today and that its present high content of almost 21 percent by volume is largely due to the activity of plants. If this process were ever reversed—if man were foolish enough to destroy a large percentage of all plants either accidentally or deliberately—life as we know it would become extinct.

That man has been able to understand such complex interactions and ponder the consequences is one of the major marvels of nature. The basis of this achievement and its embodiment is the human brain. Unfortunately, although the focus of years of the most intensive study, little of real importance is known about the way it works. How, for example, are sense impressions received, sorted, analyzed, combined and acted upon, or stored for future use and retrieved?

I vividly remember one morning not so long ago when, as I walked along a street in New York, a smell wafting out of nowhere suddenly triggered a memory that had been dormant for more than sixty years. In an instant I saw myself again as a little boy in a specific place and situation; the vividness of it almost overwhelmed me. Another time, seeing a particular shade of a certain color brought back another childhood memory which, up to that moment, had been completely submerged. And every time I hear the scratchy song of starlings—those happy birds in which I see the harbingers of spring—I think with great fondness of the sleepy little town in southern Germany where I spent an important part of my youth.

Olfactory, visual, and audio sensations—how are they stored in the brain? How valid is the popular analogy with a computer? A computer asked to identify a specific fingerprint which, presumably, is stored among thousands of others in its memory bank, scans with lightning speed all the prints on file and, if it finds a match, stops and delivers. Are memories evoked in the same way? That is, does a sense impression that matches a previously recorded one, upon entering the brain, by coinciding with the stored one, liberate it so we "remember"? If so, it would explain one of the many principles according to which the brain functions, but gives us no clue in regard to others or details of operation. How, for example—in what chemicoelectrical form—are the thousands of different words of the languages I speak preserved in my brain, ready for instant retrieval when I talk, listen, or read? Or the millions of different "bits" that represent the experiences and memories of my long and eventful life? The faces and voices of people I have known, the impressions I gathered, feelings of love and tenderness, expectation, disillusionment, or hate . . . sadness and happiness, frustration, boredom, ecstasy and joy . . . all the emotions that can be released by visiting a certain place or looking at a certain photograph, old and faded, pulled from a bottom drawer in my files, forgotten for twenty, thirty, forty years, yet instantly revived through the power of remembrance. . . .

A long-forgotten melody linked to a treasured hour, the fragrance of a scent once loved but no longer remembered, the cry of a sea gull flapping its way along a lonely beach, evoking ghosts . . . all the books I have read, all the events I have experienced, all the feelings I had, all the people I have met . . . all the pictures I have made, the triumphs and disappointments of my career, the richness of an active life spent observing, questioning, pondering, enjoying . . . suffering, loving, and hating . . . doing things, despairing, giving up and trying again . . . waiting for a phone call, a letter, a word, a moment of truth and perfection . . . all the billions of bits of sensory impressions received by eye and ear and nose and taste and touch—yes, touch!—they all are stored in my brain. Nothing, apparently, is ever lost, for what seems to have been forgotten because it sank below the surface of awareness can still be retrieved under the influence of hypnosis or scopolamine. A marvel, if not a mystery, unfathomable as the sea or the heavens, is the human brain.

But to me, the ultimate marvel is the fact that matter can contemplate itself.

For what is the human brain except an organ consisting of nerve cells and blood vessels, which in turn consist of molecules, which are aggregates of atoms, which are the essence of matter?

Yet, in the form of the human brain, this aggregate of matter can direct the dissection and study of another human brain, write poetry, compose a symphony, or find a way to the moon. A strange, inexplicable substance, this matter, endowed with mysterious powers that enable it to experience compassion, the ecstasies of love, the violence of hate, the abysmal depths of despair . . . to create a technology that changed the course of the world and could destroy the earth . . . to enjoy the beauty of a sunset or plan the death of a man. . . . Matter, consisting of atoms, which consist of protons and neutrons and electrons, the substance that constitutes the stars. To think that we are made of star stuff . . .

The restless mind is never satisfied, and inevitably the question arises: precisely what is matter? Everyday experience tells us that matter—wood, metal, stone, and so forth—is "dead" substance characterized by volume, weight, solidity, and immobility unless set in motion by extraneous forces. Not so, says the physicist, who maintains that matter is mainly emptiness sparsely populated by atoms, which in turn consist of a complex nucleus surrounded by a cloud of electrons. The atoms are anything but motionless; they spin around their axes; they quiver with thermal motion; the electrons whirl elusively, and the whole structure has a quality of unreality because, in the last analysis, it consists of unimaginably small particles which may be packages of energy likely to vanish in a flash of radiation. No trace of solidity, because the distances between the components of an atom are relatively immense. If we imagine the nucleus of an atom enlarged to the size of a cherry, the electrons could be represented by gnats buzzing around in circles more than a mile in diameter. And the distances between neighboring atoms are so vast that the "cherries" would have to be spaced hundreds of miles apart. If it were possible to squeeze all the space out of a man, his body would be reduced to a speck the size of a period in this type. And if one of the electrons whirling, planetlike, around the sunlike nucleus of an iron atom in my typewriter were inhabited by subatomic beings, such beings, contemplating their subatomic universe, would feel, as I do, dwarfed by the immensity of their surrounding "cosmic void." And the awesome thought occurs to me that, since the atom and the universe seem to

be organized along somewhat similar lines, perhaps still larger structures exist in which the solar system is only an atom, and galaxies are molecules, in a superstructure of unimaginable dimensions.

At first such a thought may seem absurd. However, there is an analogy. Contemplating, for example, a beetle feeding on a leaf, it occurs to me that, although I can see the insect clearly, it cannot perceive me except perhaps in the haziest manner as a presence, a feeling of something strange and immense. Most certainly it cannot have the faintest idea of who or what I am. We live on levels so different that the denizens of the lower one do not even know that the higher one exists. And the disquieting thought arises that perhaps still higher levels exist and that I, too, am watched by something so immense that it is forever outside my ken.

As a matter of fact, what proof do I have that mine is the highest level? Not long ago man was convinced that the earth was the center of a universe measured in human terms. Then he found that actually it is nothing but a speck of dust in a galaxy so vast that it boggles the imagination. And today we know that even this immense galaxy is only one of billions of other galaxies that drift in a space of such titanic dimensions that astronomers had to invent the light-year to fathom it. A light-year is the distance which light, traveling at a speed of some 186,000 miles per second, traverses in one year—close to six trillion miles. And today man's horizon in space—the depth to which he has penetrated with the eyes of giant telescopes—lies more than two billion times six trillion miles away. And still there is no indication of a limit of the universe.

Another thought occurs to me: this peaceful room in which I write, deep in pastoral Connecticut, surounded by flowers and trees, is seething with a never-ending stream of energy. Cosmic rays from the depth of the galaxy, gamma and X-rays from exploding stars, gravity waves, radio waves carrying music and speech, high- and ultra-high-frequency waves encoding the images of television—they penetrate the walls of my house and the bones and tissues of my body, and yet I neither see nor hear nor feel anything. Without sophisticated instruments I would never know of the presence of these ghostly invaders. But if phenomena like these can exist, what guarantee do I have that still stranger events do not occur—events as yet unknown or unknowable because we have no suitable means of detection? Thought waves, telepathic energy, telekinesis, sensory emissions by plants, spirits and ghosts?

Anyone dreaming that modern man has fathomed the secrets of nature is in for a rude awakening. So far, what we can see is only the tip of the iceberg. The more we learn, the more we realize how little we really know. At the time of Einstein, scientists were reasonably sure that most of nature's secrets were known and that the few remaining mysteries were on the threshold of solution. Today quasars, pulsars, neutron stars, and "black holes" testify to the contrary, each new discovery raising more questions than it answers, opening vast vistas into new and unimaginable realms. By now our understanding of nature has reached a point where it is no longer possible to interpret every scientific discovery in common-sense terms. Trying to translate into mechanistic analogies related to everyday experience many of the mathematical formulas used today by physicists to describe complex phenomena is as futile as trying to see realistic objects in modern abstract art. No human brain can visualize a four-dimensional, positively (or negatively) curved, closed (or open) space-time continuum, although it can be expressed in the form of mathematical equations. The same is true of the behavior of light, which, in an incomprehensible way, combines the characteristics of a wave with those of individual particles. And the behavior of the electron can only be described by means of probability waves. As a result of these realizations, we are slowly forced to accept as fact that, just as even the most intelligent animals will never be able to understand (except, perhaps, on the most superficial level) the functioning of man's creations, so man himself, despite his marvelous brain, may be congenitally unable ever to comprehend fully the nature of the universe.

Some words about this book

Nature—the world, the universe—is a magic garden where everything is beautiful and nothing what it seems to be. Some people, of course, are more interested in profits than in magic gardens and pursue money rather than mysteries. If that were all, people with eyes to see, minds to question, and souls to enjoy could simply disregard them. Unfortunately, by their selfishness and greed, the "realists," as they like to call themselves in contrast to us "dreamers" —Loren Eiseley's "world-eaters"—damage or destroy the wonders of this world. This we cannot tolerate, especially since in destroying what we value they also endanger the future of the human race. It was in an attempt to counteract these destructive forces that I put together this book.

I may be a dreamer, but I am not so naïve as to believe that a single book could persuade inveterate materialists to change their ways. But I believe—in fact, I know—that raindrops can level mountains. In this sense, I consider this book one drop in the flood of enlightening literature which, I hope, eventually will reverse the present tide of materialism, neglect, and destruction.

I furthermore believe that everybody who can contribute to the cause of conservation—to a sane environmental policy—is duty-bound to do his share. Being both a photographer and a writer, I make my contribution in the form of photographs and words.

Finally, I believe that the future of mankind lies in the hands of the young people of the world whose minds are still curious enough to let them see for themselves, to analyze their findings, and draw their own conclusions. It is they who someday will have to make the important decisions and live with the results. My greatest wish is to reach these young people, the teen-age boys and girls whose minds are still receptive to the marvels and mysteries of nature. Because once this interest is roused, their entire future will be influenced by it. Parents who wish to insure a better world for their children might wish to put into their hands this book.

The subtitle of this volume, *A Fantastic Journey into Reality*, is, I think, self-explanatory. Nature, as I tried to show in the preceding text, is fantastic as soon as we penetrate the surface. Yet these fantastic aspects represent reality to a higher degree than our superficial and subjective sense impressions. Superficial—because only instruments like the microscope, the telescope, the spectroscope, the cyclotron, the Geiger counter, and others can show us the "real" face of nature. Subjective—because man's eye and mind are "programmed" to see and consider primarily those aspects with which he is familiar, either from everyday experience or by tradition and training. New viewpoints and perspectives are almost always looked at askance—with suspicion, fear, and disapproval—man is inherently conservative in his beliefs. It is in an attempt to break this suffocating shell of dogma, complacency, and rote that I selected the subjects and made the pictures for this book. I wanted to give the reader a new point of view—as from the summit of a higher mountain. I wanted to show him familiar subjects in new perspectives, stimulate his mind, and make him aware of things and relationships he may not have known or thought of before.

Subject selection. The subjects of all my photographs are at the same time

familiar and new. Familiar—because everybody knows what a seashell is or a bone or a rock. New—because the specific shells, bones, or rocks I chose for presentation are seldom seen by the average person. By making this selection I hoped to make the transition from the ordinary to the new experience easy and enjoyable.

Perspective. From his height of five to six feet, man looks down on everything that is smaller than he, looks up to anything larger. This, of course, is perfectly understandable but has the drawback that most people believe there is only one correct perspective, only one viewpoint, only one valid way of looking at things—man's. I don't agree with this attitude. I believe that, say, a dog's, a bird's, or a beetle's perspective is just as valid as man's. Different, to be sure, but neither inferior nor wrong. Accordingly, on the following pages, I often show my subjects in their perspective—a shell, for example, seen as another shell might see it if it had eyes (some shells, such as the scallops, actually do have eyes). I followed this approach with two objectives in mind:

 1. Seeing a familiar object in an unfamiliar perspective is bound to give the viewer a new visual experience and a new viewpoint—literally as well as figuratively speaking. As a result, he might see features he hadn't seen and learn facts he hadn't known before.

 2. He might realize that man's is not the only viewpoint by which to judge the rest of the world—a realization that implies that man's rights are neither more nor less valid than the rights of other living things and that treating animals, plants, and even inanimate objects of nature *with respect* establishes a relationship beneficial to all.

The close-up. Limitations inherent in our form of vision prevent us from seeing clearly objects at distances closer than approximately eight inches. The result is that the unaided human eye can perceive small objects and fine detail either only indistinctly or not at all. The camera, however, is not subject to these restrictions. Accordingly, I constantly made use of its ability to magnify—to enlarge small forms and fine detail to sizes that are pictorially effective and thus informative. As a matter of fact, many of my subjects are shown in from two to ten times or more their natural size.

Lack of scale. Looking at pictures of certain objects (rocks, shells, etc.) taken out of their natural surroundings, can make it impossible for the viewer to gauge their actual size. Although at times confusing, in the proper context this state of scalelessness can be extraordinarily stimulating, making the subject of the picture appear monumental and giving it an aura of unreality. In the interest of recreating the feeling of excitement and mystery I had when confronted with my subjects, I frequently made use of this photographic device.

Subject approach. Despite the often fantastic appearance of the pictures, each is a documentary photograph. I never used such tricks as perspective distortion, double exposure, multiple printing, "artistic" unsharpness or blur, solarization, posterization, zooming during exposure, or any other means designed to give a photograph a more "creative" air. The only artistic liberties I took consisted in setting up my shells or other objects in certain ways (such as standing a shell on end) normally not found in nature in order to enhance the object's inherent monumentality; and, in a few instances, I converted a positive image into a negative one to emphasize specific subject qualities. But apart from these openly used and immediately apparent devices, every photograph shown in this book is straight. In other words, things are really what they seem to be, and if he saw it in the appropriate magnification in reality, the reader would have gotten exactly the same impression of the subject as that conveyed by the photograph.

The captions are an indispensable part of the book. They identify the subject and tell the hidden story—the reasons that motivated me to make the photograph. Some people seem to believe that picture books are for looking only, and they habitually disregard the text, perhaps because of previous experiences with captions that are merely descriptive. This, I can assure the reader, will not be the case here. These captions were specifically written to supply additional information, liberate the creative faculties of the reader, stimulate his imagination, and send him off on a fantastic journey into reality.

Andreas Feininger

A walk along the beach

Bright and burning is the sun, dazzling the sand, hypnotic and soothing the surge of the surf. On my left is the sea — ancestral home and birthplace of all life — remnants of which still course through my veins; the chemical composition of the liquid basis of blood is virtually identical with that of seawater. On my right is the beach, that stretch of no-man's-land where the tides rise and fall, eternally changing the contour of the land, building up and tearing down in endless ebb and flow, depositing in winding windrows the wrack and spoils of the sea. It is here that I find treasure.

Not Spanish doubloons, not pearls, not anything of monetary value, but the speckled carapaces of crabs, sand-scrubbed driftwood, pebbles polished by the sea, fish bones, and shells. Mostly bleached and broken, rarely intact, always fascinating because they speak to me of evolution and adaptation, structure, and the interplay of function and form.

To be able to enjoy these gifts from the sea we have to change our viewpoint and our values; like Alice, we have to be transformed. Alice's perception of the world was changed when she walked through the looking glass; we can transform ours by walking through the driftwood arch shown on the facing page — ten inches high from sandy bottom to wooden top — if not literally, then in imagination. This will give us the proper perspective by shrinking us to a size that brings us eye to eye with the flotsam from the deep and the jetsam that litters the beach.

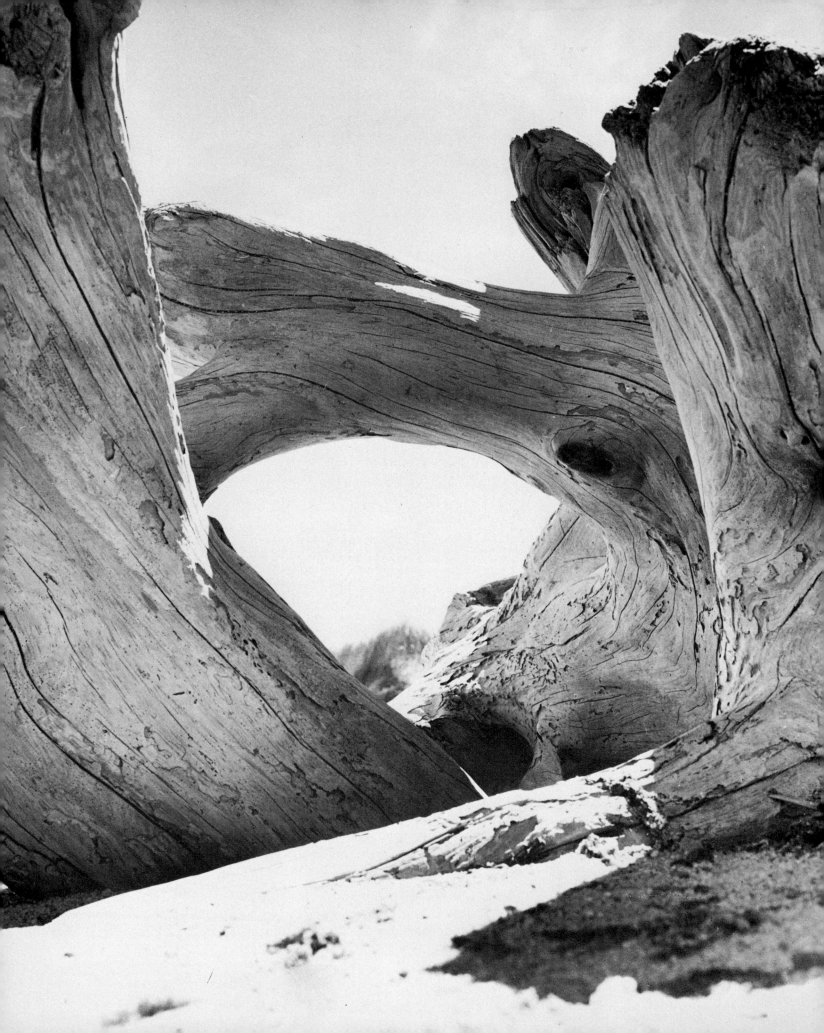

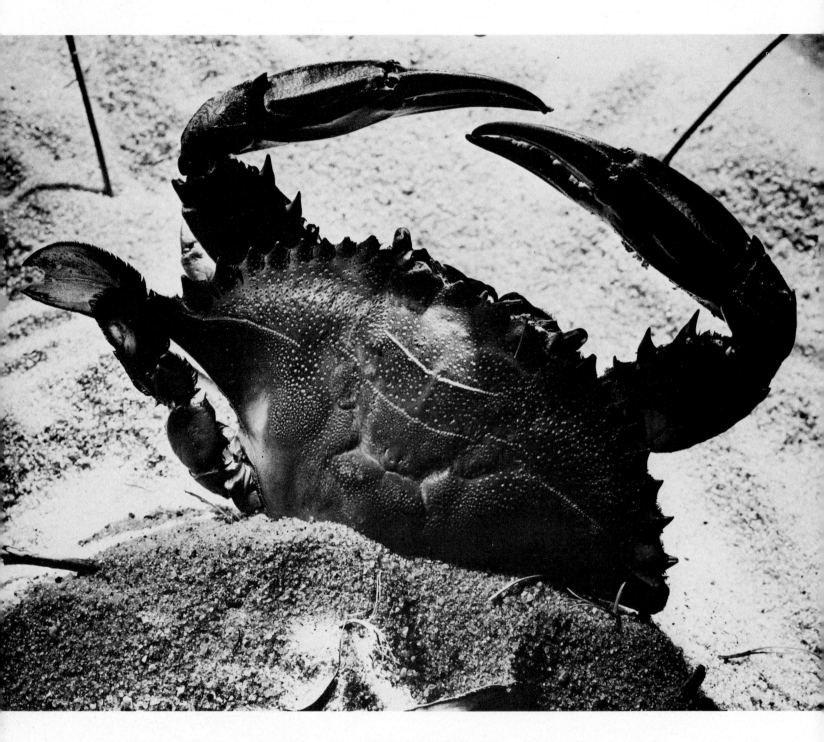

The carapace and armament of a blue-claw crab, half-buried in the sand, looms like a burned-out tank, a monument to defeat, bringing home the fact that, no matter how strong or well-armed a creature is, there is usually another one stronger or better equipped who, in the struggle for life, will defeat the first and make a meal of him — literally, if an animal; figuratively, if man. Compassion is unknown in nature, rare in the world of man, yet in it lies the salvation of mankind.

Toward evening I discovered a blowfish cemetery (*opposite*). The whitened skulls peeked from the sand like tiny, exquisitely sculptured ivory boxes.

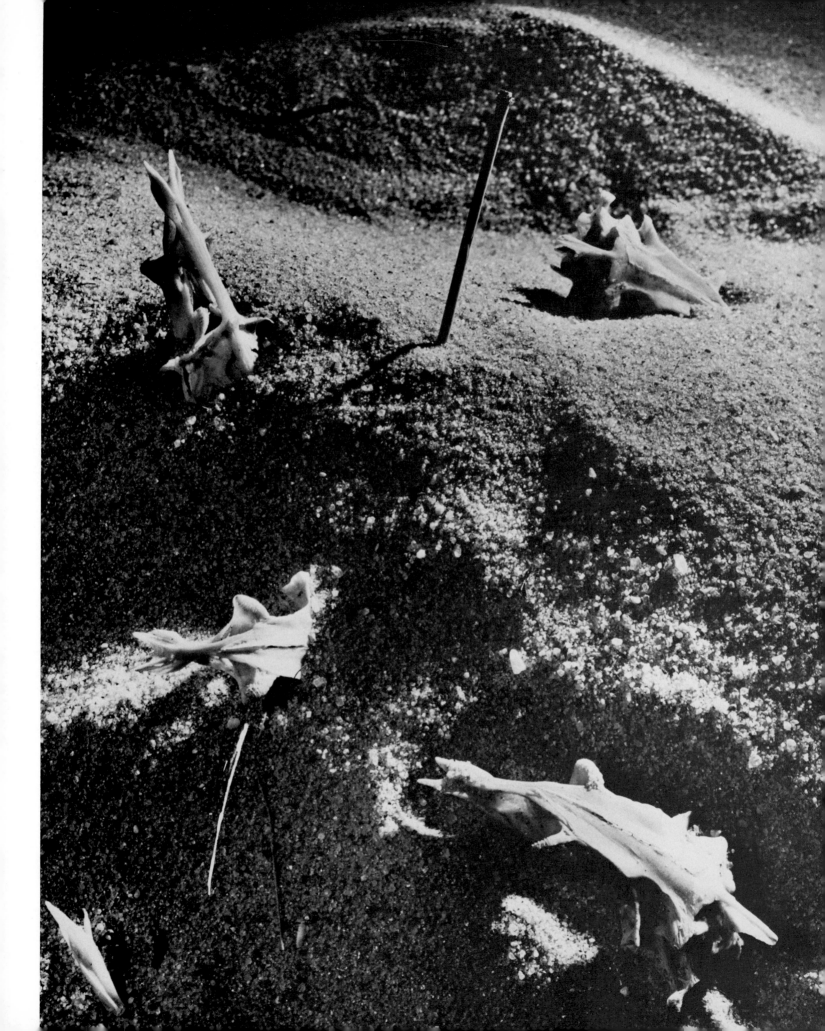

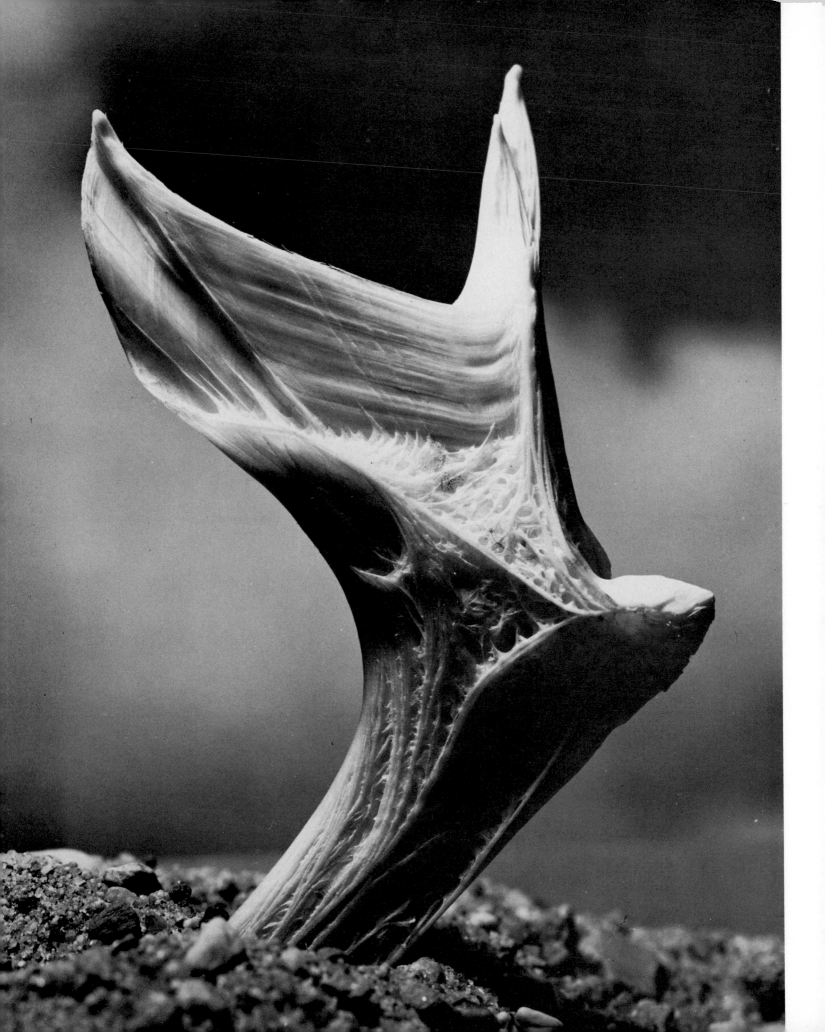

Not far from the blowfish calvary, I came upon this anglerfish bone. With the uncompromising clarity of a computer-constructed, three-dimensional model of a stress analysis, it gives reality to the concept of function shaping form. Nothing is haphazard or accidental in this structure, which is the result of millions of years of evolution. Now, honed to perfection, it stands before us like the masterpiece of an inspired sculptor, the embodiment of pure force, a joy to any mathematician, structural engineer, and anybody with a mind receptive to beauty.

To me, a former architect and structural engineer, bones have always had a special fascination because of the way they combine utility and beauty, proving in the most convincing form what industrial designers so often forget: the fact that a strictly utilitarian structure can be beautiful in itself, without additional embellishment.

Bones are functional in the strictest sense of the word, combining maximum strength with minimum weight and expenditure of material. Joined to form skeletal units, they provide rigidity combined with flexibility and delicate articulation, linked together in the form of structures that make use of the same engineering principles as roller bearings and hinges, ball-and-socket joints, cantilevered constructions, suspension bridges, arches, vaulted roofs, and pre-stressed concrete shells. Their smoothly rounded and often highly complex shapes are a delight to the eye and a pleasure to handle and touch.

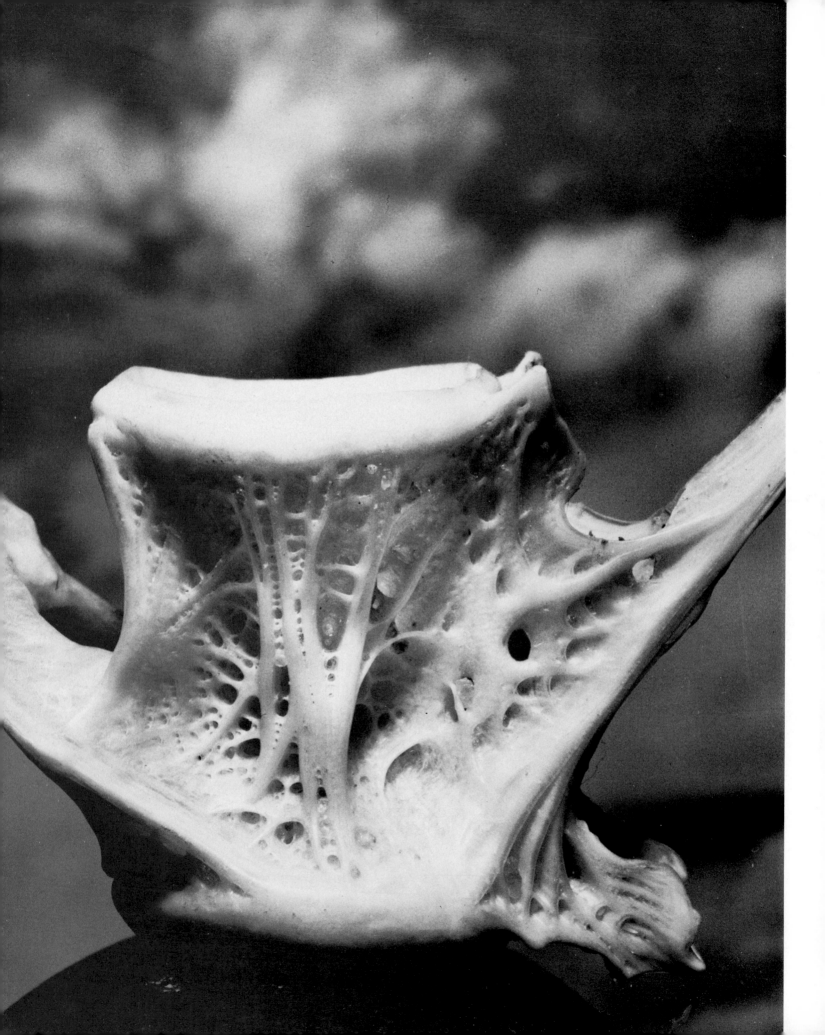

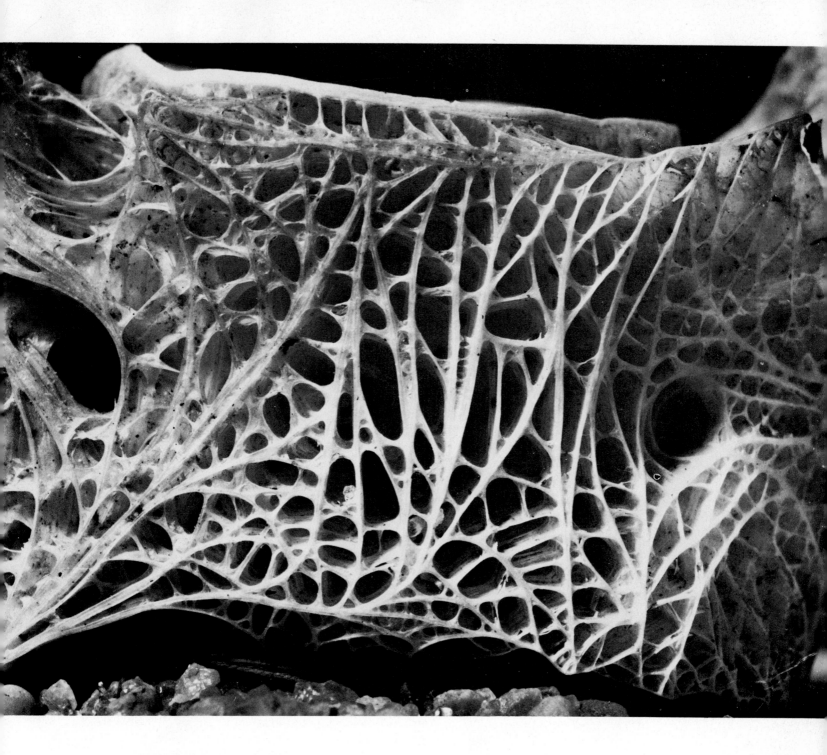

On the sands near Montauk Point, New York, fish vertebrae are among the most common objects washed up by the sea. But to the contemplative mind, they are marvels of engineering, featherlight yet incredibly strong, mirroring in the organization of their structural detail the pattern of stress and strain to which they are subjected while performing their function in the living body of a fish.

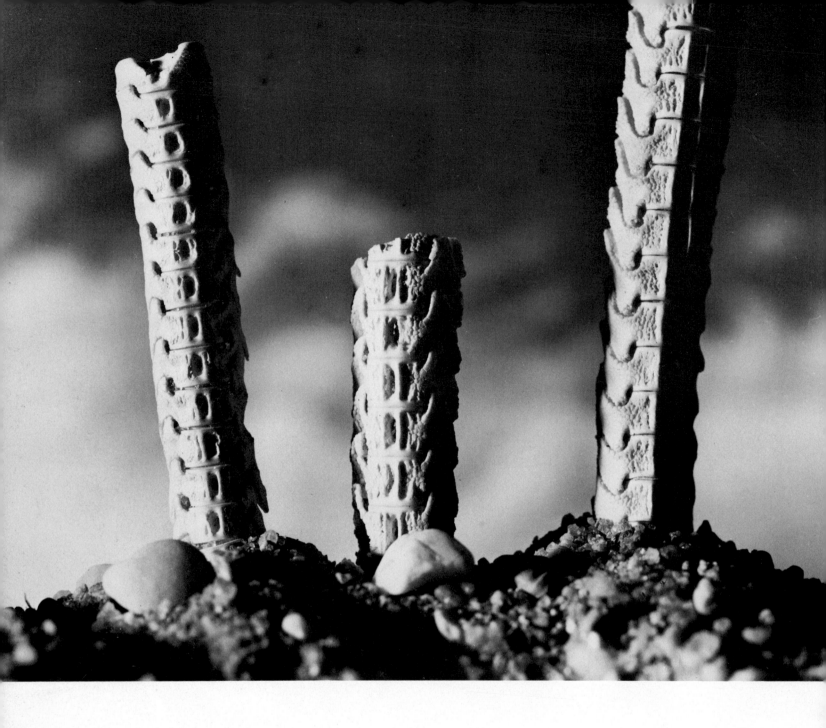

Sections of the spines of skates (fish belonging to the ray family) and jawbones from an anglerfish. Exquisitely shaped down to the last minute detail, these bones and teeth are formed to tolerances which no human engineer would dare to specify.

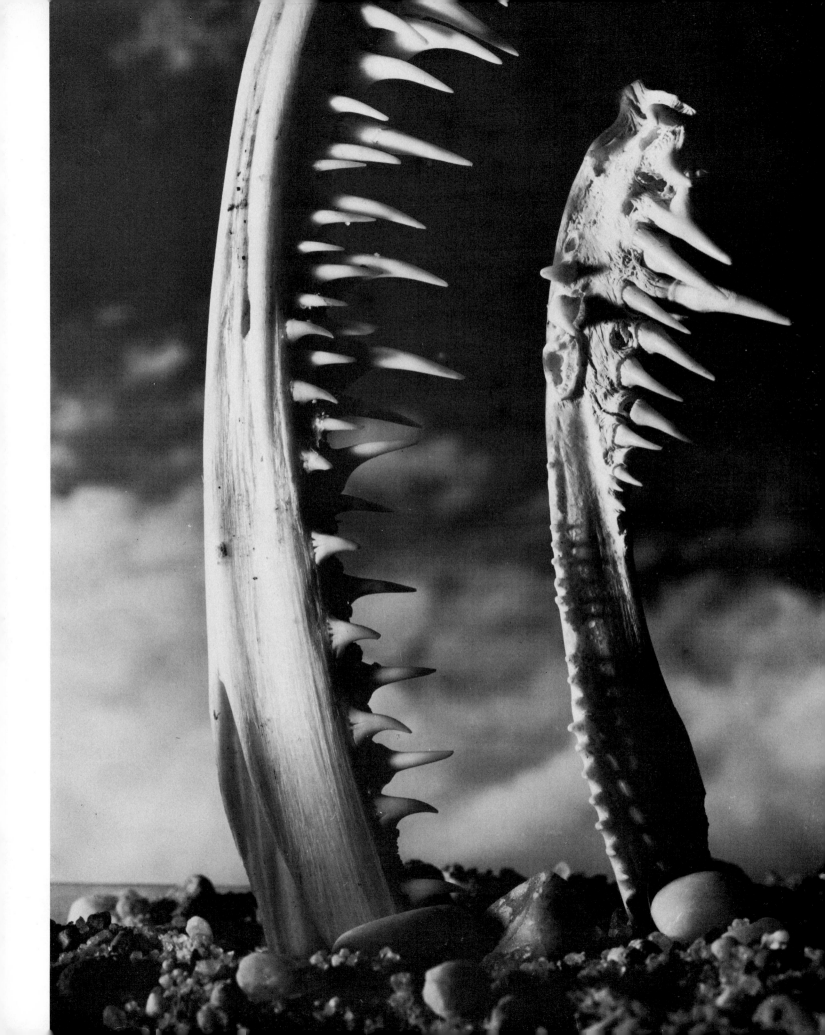

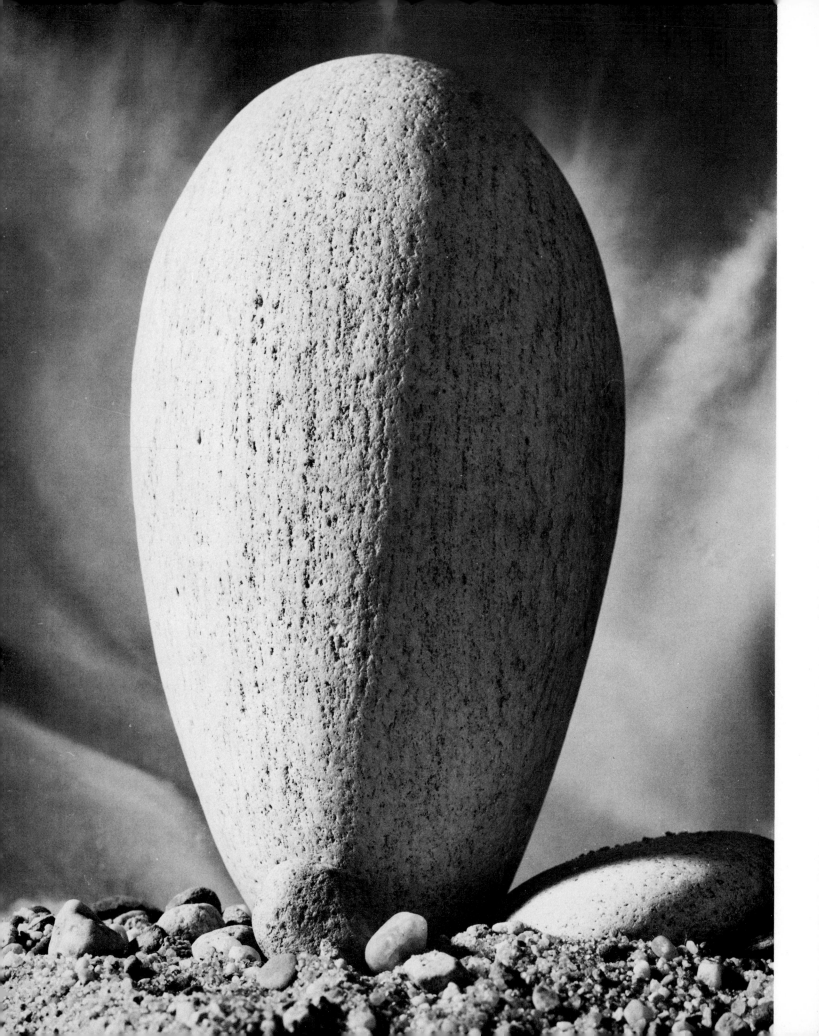

Not far from Montauk Point on the easternmost tip of Long Island, New York, lies a secret cove to which I gave the name Singing Pebble Beach. Ringing it are towering walls of clay cliffs composed of geological debris piled up by the glaciers of the last ice age some twenty thousand years ago. Now the restless sea, undercutting the cliffs, causes their gradual collapse, making them spill their load of rocks into the water, where the roiling surf grinds and polishes each stone to a geometrically perfect ovoid or ellipse.

With every wave that washes on the shore, tons of pebbles, from pea size to the size of coconuts, ride up on the beach, only to slide back again as the waters recede, producing in the process an unforgettable sound—a rolling, bumping, pounding, scratching, grinding noise, a cacophony which, despite its jarring undertones, succeeds in producing an effect that is melodious, beautiful, and wild. The ovoid stone shown on the opposite page, which brings to mind the sculpture of Brancusi or Arp, is a creation of the Singing Pebble Beach.

The owl-like stone shown on the following spread in both positive and negative versions was likewise shaped by the surf of Singing Pebble Beach—all but the "eyes," which are the work of rock-boring marine mussels. In the negative form it seems aglow, illuminated from within, a fantastic nighttime effect that gives the stone a weird life of its own.

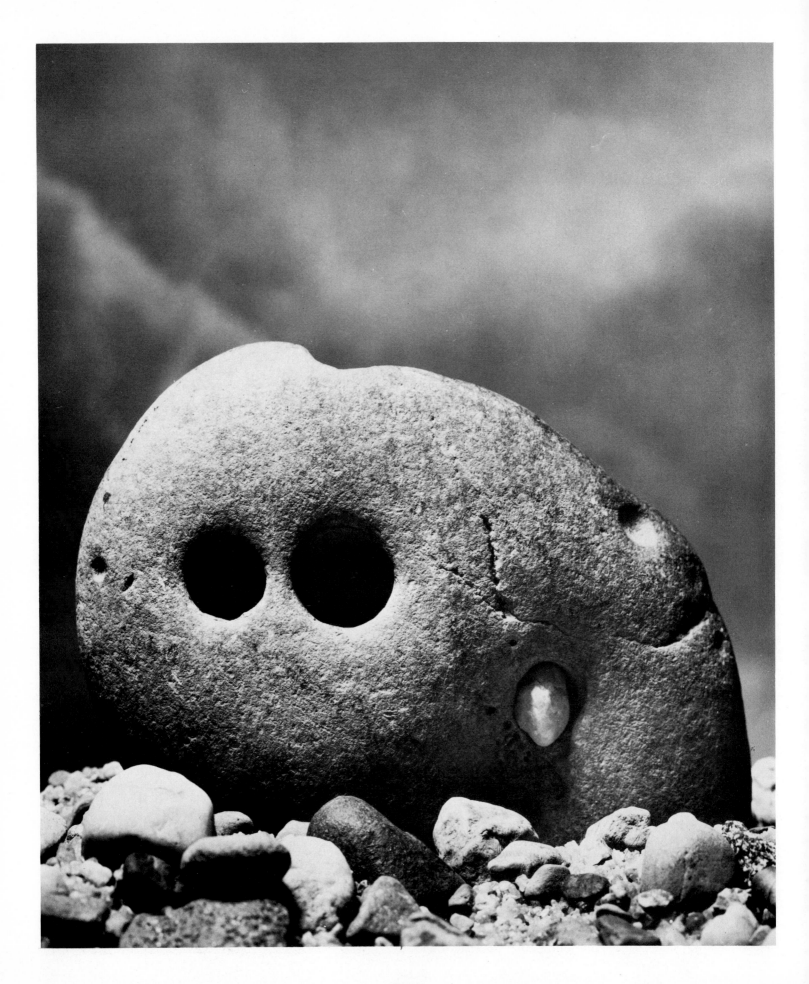

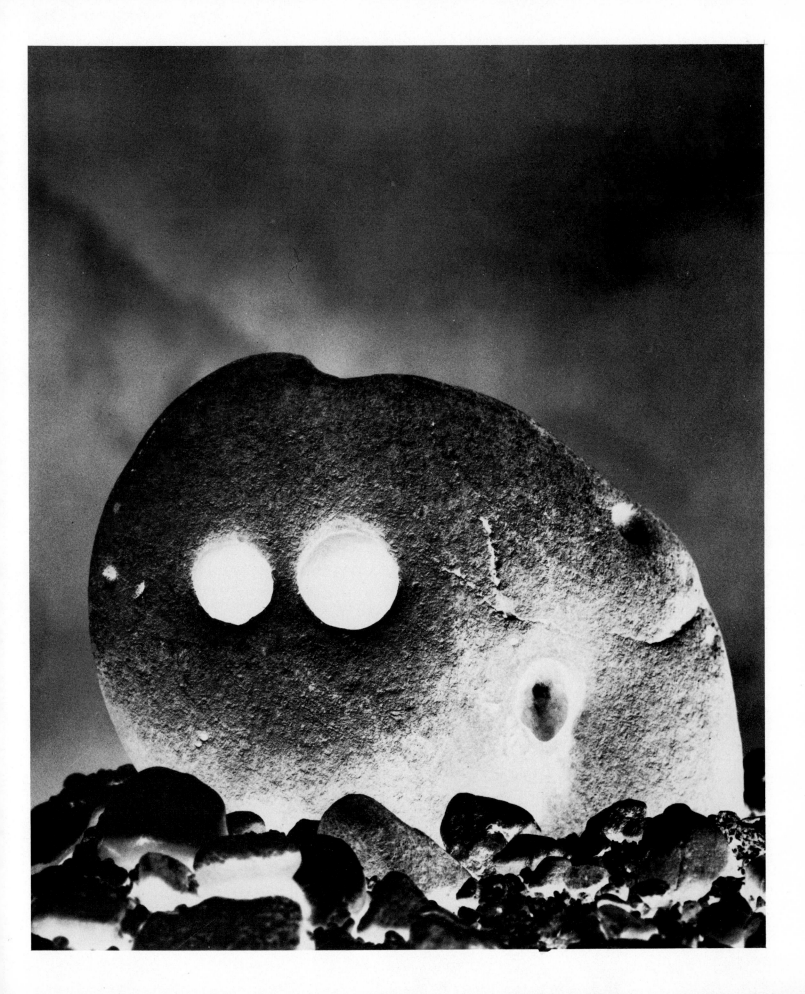

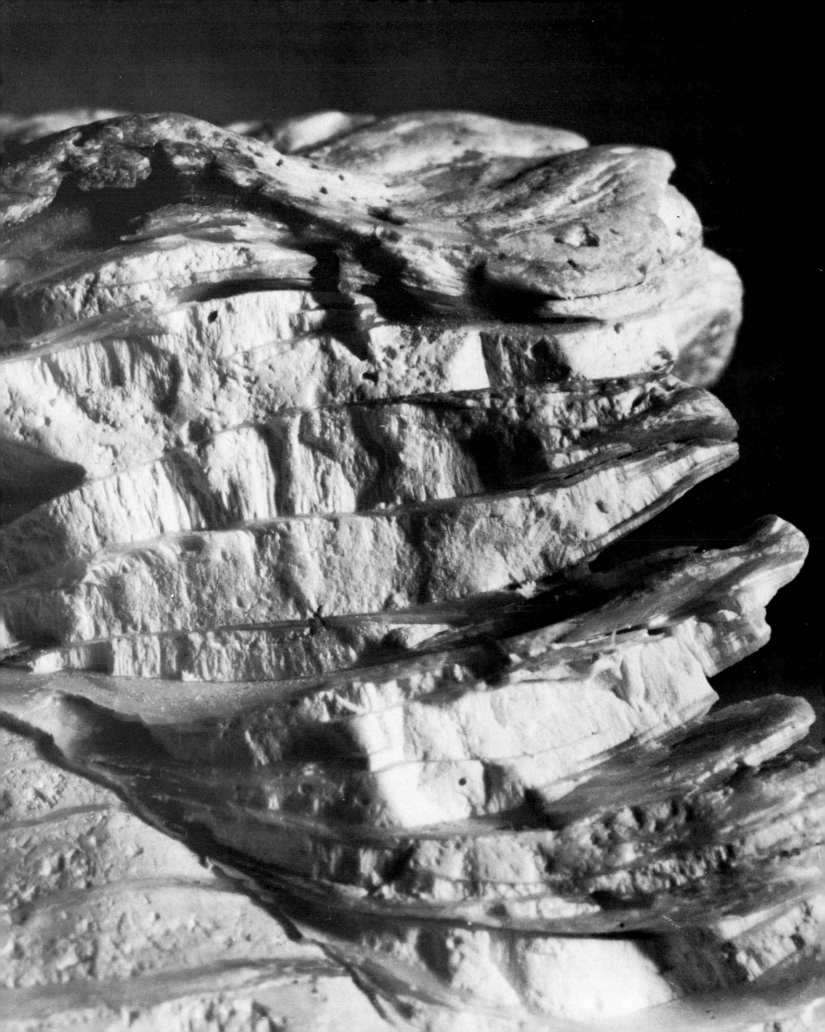

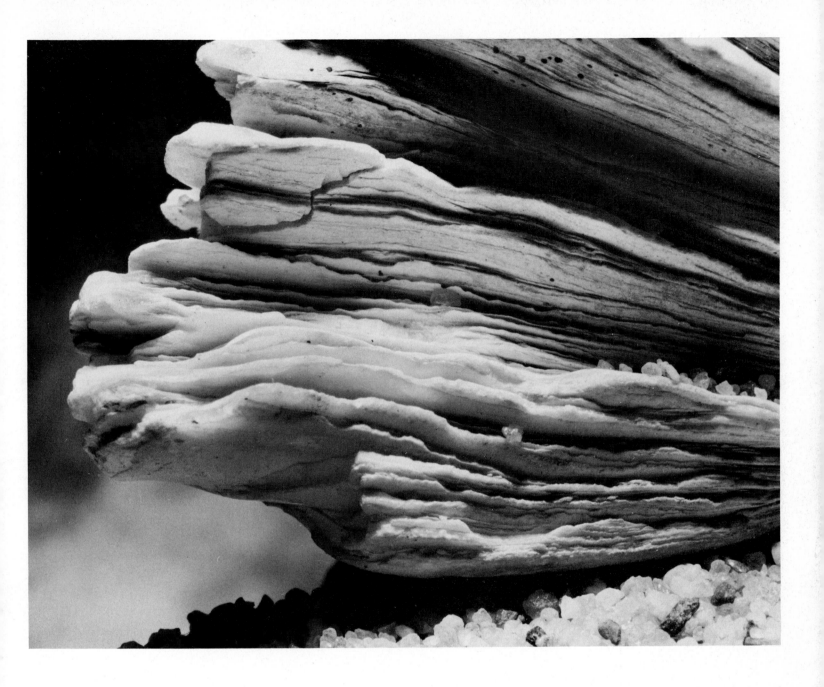

The valves of shells consist of a limy substance — calcium carbonate — the same stuff that occurs in nature as limestone, chalk, or marble. In other words, the material in shells and certain minerals is the same. So it is perhaps not surprising to find that shells are structured like certain rock formations, built up layer by layer through accretion. If sufficiently enlarged, pieces of broken shell resemble rock formations to a degree that makes the two almost indistinguishable from one another. This is evident from these two pictures showing bits of broken oyster shells in approximately 15× magnification. What fascinates me is the fact that shells, trees (in their annual rings), and parts of the crust of the earth (the sedimentary rocks) are constructed in accordance with the same principle — growth through accretion during specific time intervals — showing the existence of a universal natural law.

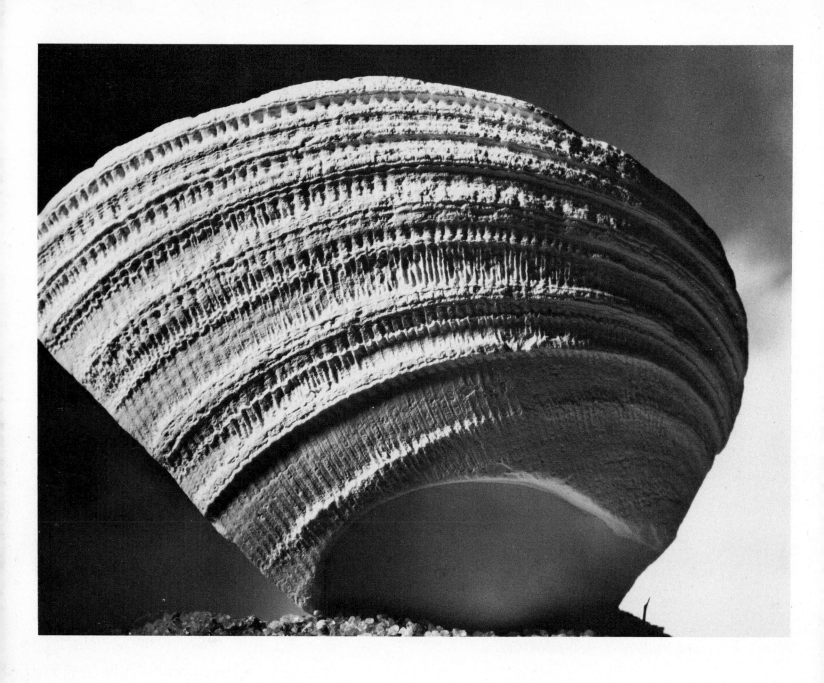

Two views of the same piece of broken quahog shell, its surface removed by erosion, reveal the internal structural arrangement which in abstract beauty rivals a classic frieze. This is but one example of what I meant when I spoke earlier of finding treasure on the beach.

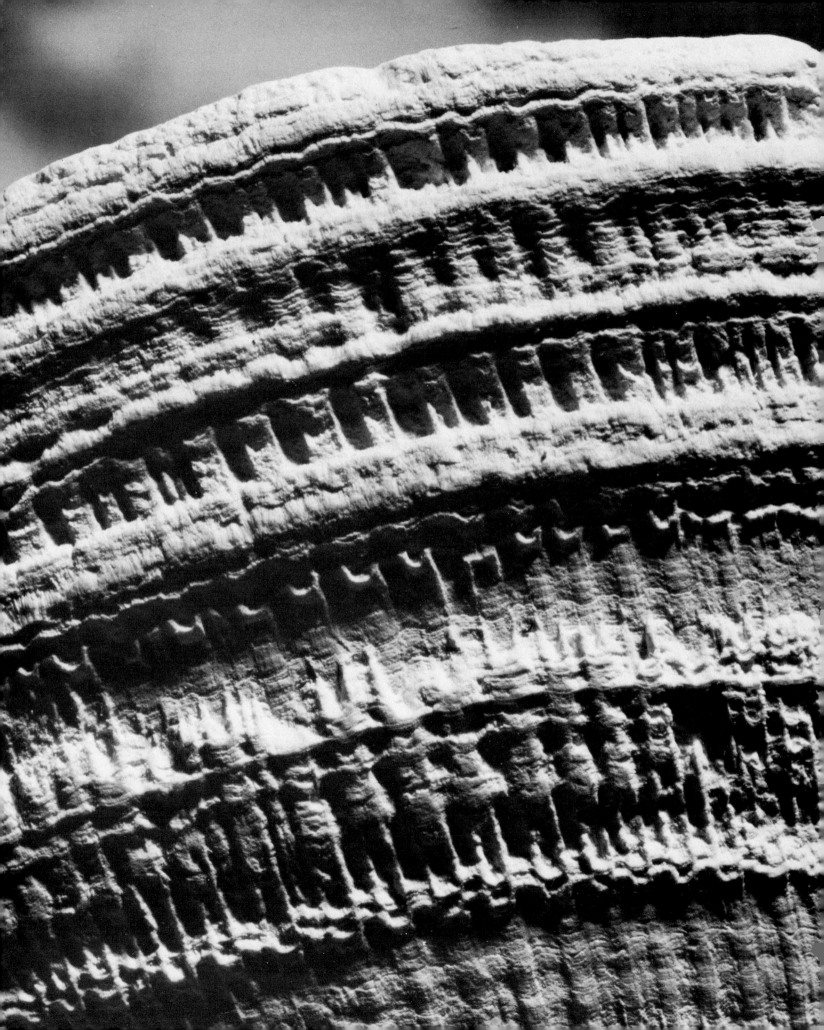

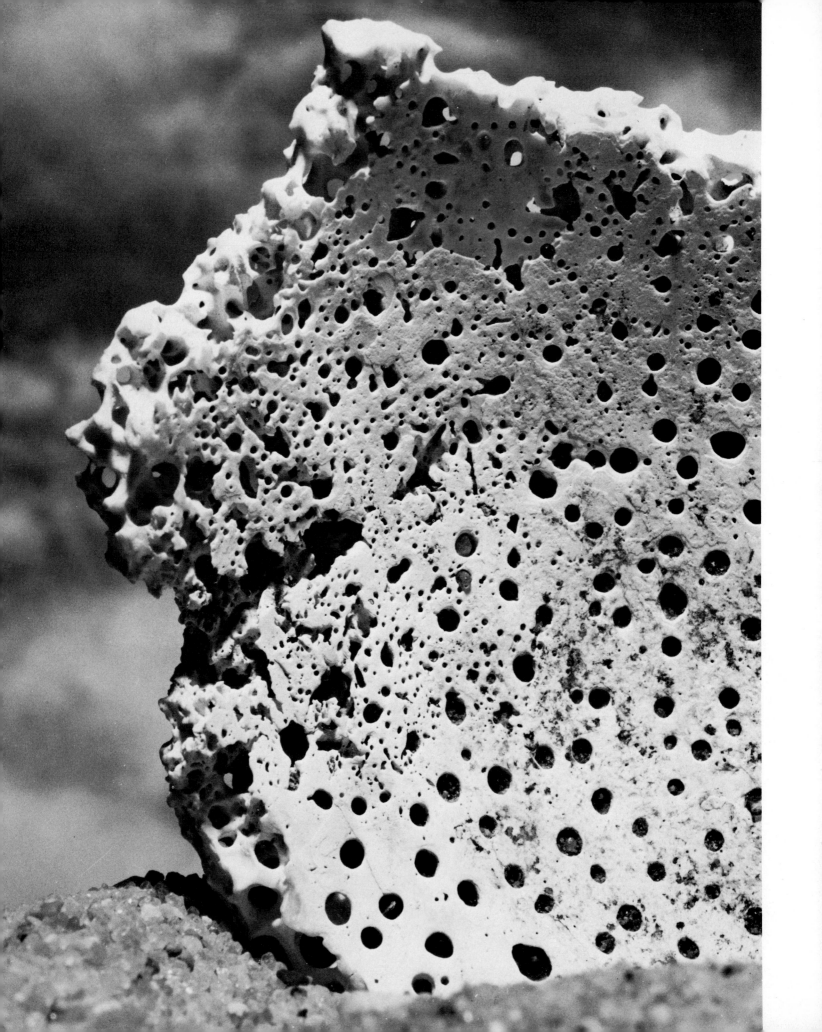

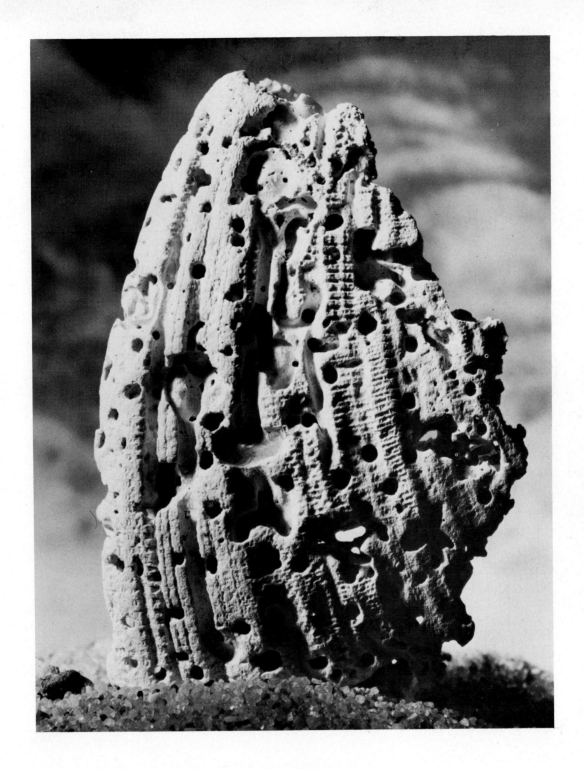

To me, shells are beautiful even in decay. As a matter of fact, in the process of dissolution, internal details of structure are brought to light which don't show up in a perfect shell. Studying bits of shell like these minutely with a magnifier can give me priceless moments of insight, during which I see, with the eye of the mind, the entire life cycle of the shell. I almost become a shell myself, living an underwater life, feeding, growing, reproducing, and finally facing death, commonly by violence. This gives me perspective and makes me feel part of nature without diminishing my status as a man. It makes me approach all living things with respect.

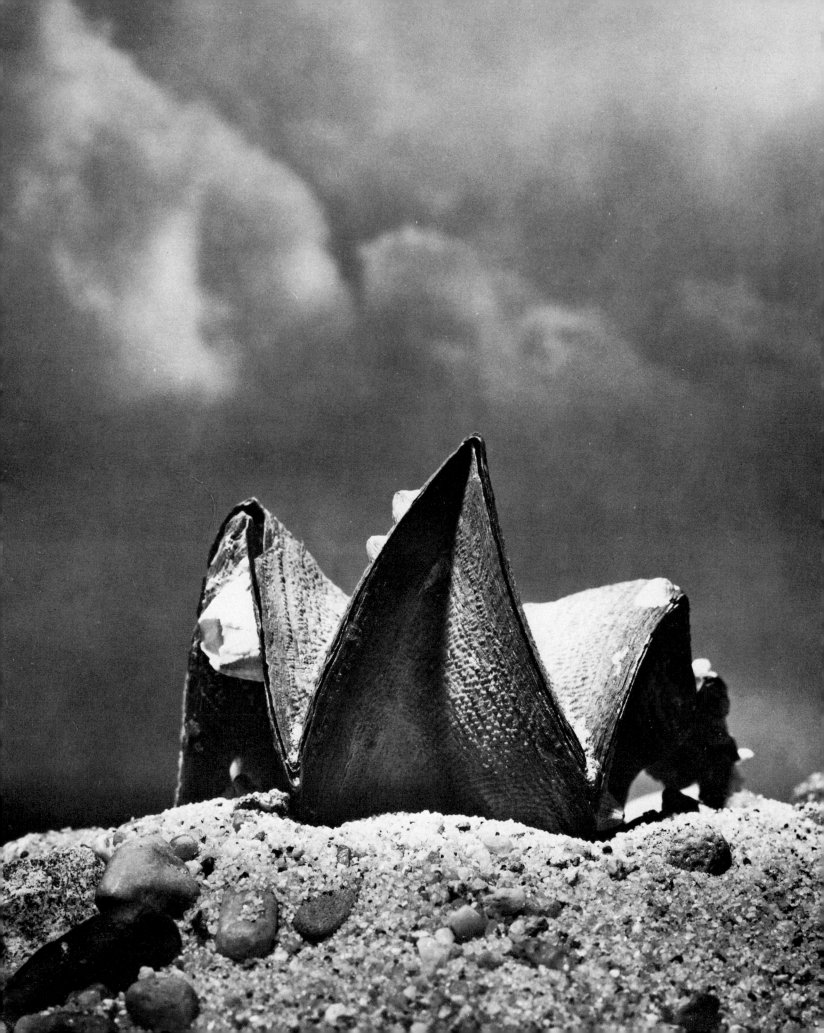

This little A-frame structure is not a modern beach house but a shell, specifically, a cockscomb oyster (*Lopha cristagalli* L.), seen from the viewpoint of another shell. It certainly does not look like any ordinary shell, which may come as a surprise to those who think a shell is simply a shell.

The number of known species of gastropods and bivalves (snails and shells) is probably somewhere around 37,000, with another estimated 10,000 or so as yet undescribed species living today. In other words, the variety is enormous, evoking the obvious question: why so many? And again the answer is specialization, adaptation. Each species of shell is an exquisitely tuned creature designed to make the most of one specific habitat of the marine environment— a combination of water temperature and depth, turbidity (water quiet or more or less agitated), substrate (sea bottom, sandy, pebbly, rocky, etc.), type and abundance of food, and so on. And since the possible combinations of these factors are extremely numerous and almost unlimited in regard to degree, the number of different species is very large, presenting us with an almost overwhelming wealth of differently sized, shaped, and colored shells.

The opposite and following ten pages contain photographs of some of the world's most interesting shells which I encountered on my imaginary beach walk (actually, a leisurely browsing through the shell collection of the American Museum of Natural History in New York, preparatory to the compilation of my book *Shells*). They are convincing proof that a shell does not necessarily have to look like an oyster or a clam, that it can be as interesting, beautiful, and thought-provoking as any of the more spectacular creations of nature.

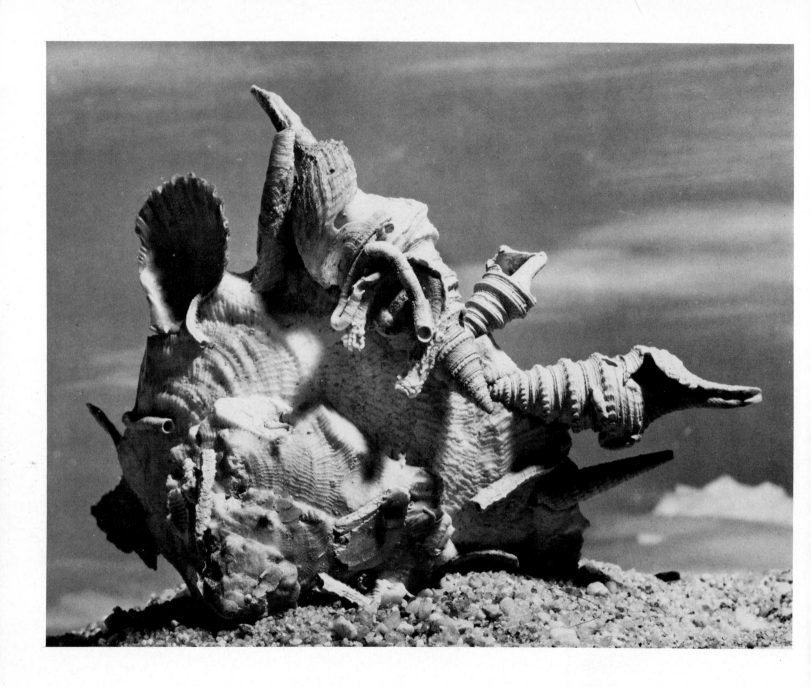

These are carrier shells (*Xenophora pallidula* Reeve), the junk collectors of the sea. Periodically, as the mollusk grows, it picks up a dead shell or a piece of stone or coral from the sea bottom and cements it to the periphery of its shell where these objects serve to strengthen the valve and camouflage the home of its owner. Because of the random nature of this process, no two individuals of the same species are ever exactly alike.

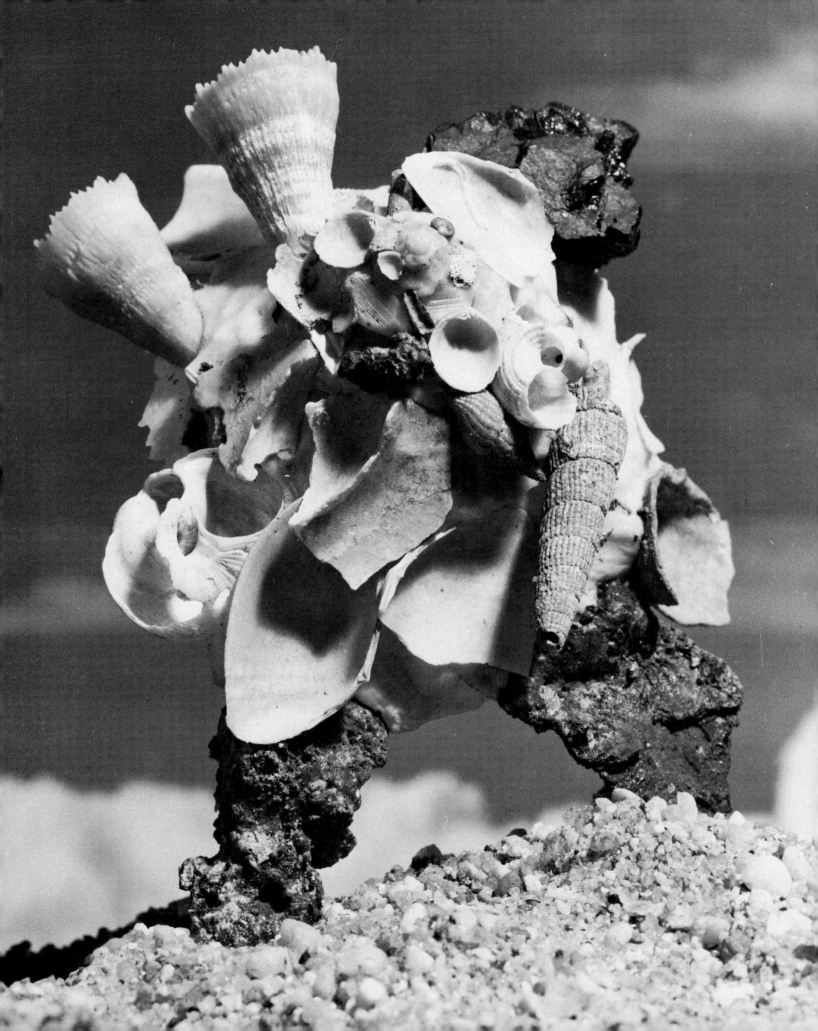

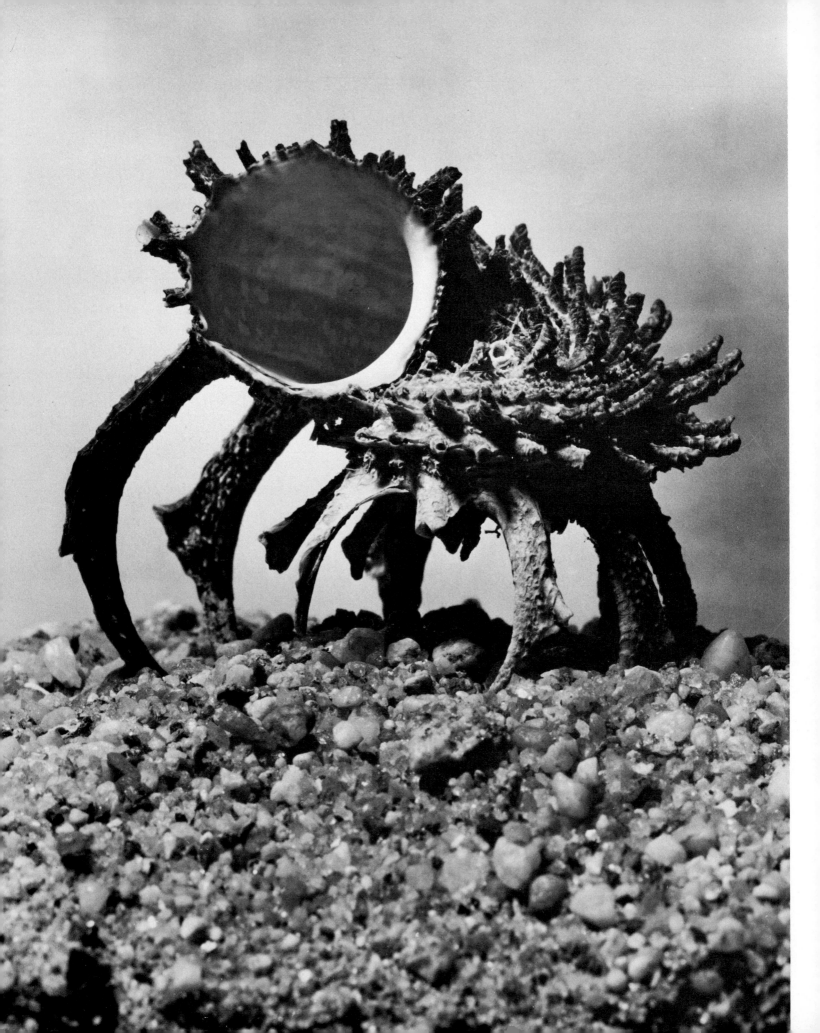

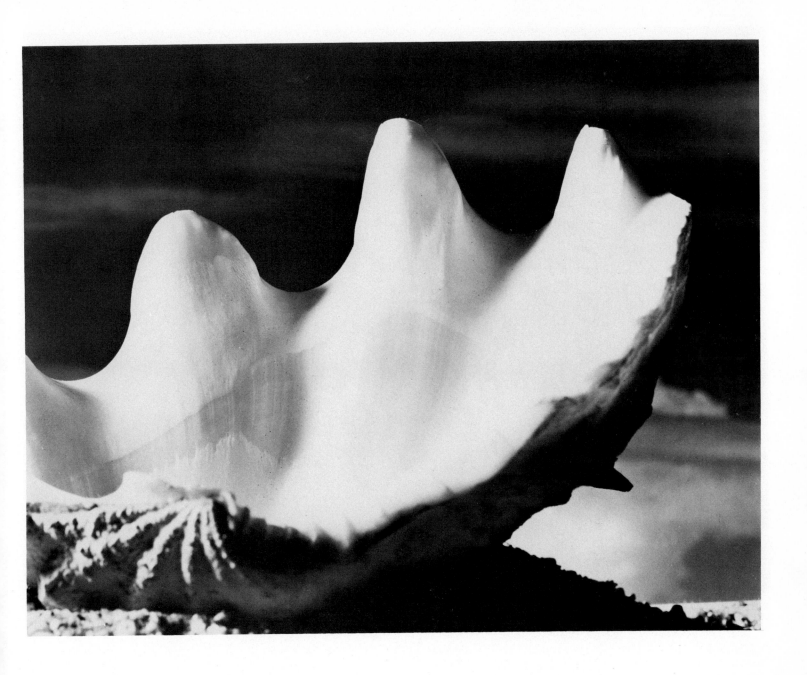

Left: A Tarantula Dolphin shell (*Angaria melanacantha* Reeve). *Above*: A Giant Clam (*Tridacna gigas* L.). The first—a gastropod, a snail—is small and spiny (here shown in 5x magnification); the second—a bivalve of which only part of one of its two shells is shown—is massive, may reach a length of four feet, and exceed 500 pounds. At the other extreme, the smallest snails, when fully grown, are no larger than the head of a pin, and it would take several thousand specimens to fill a thimble.

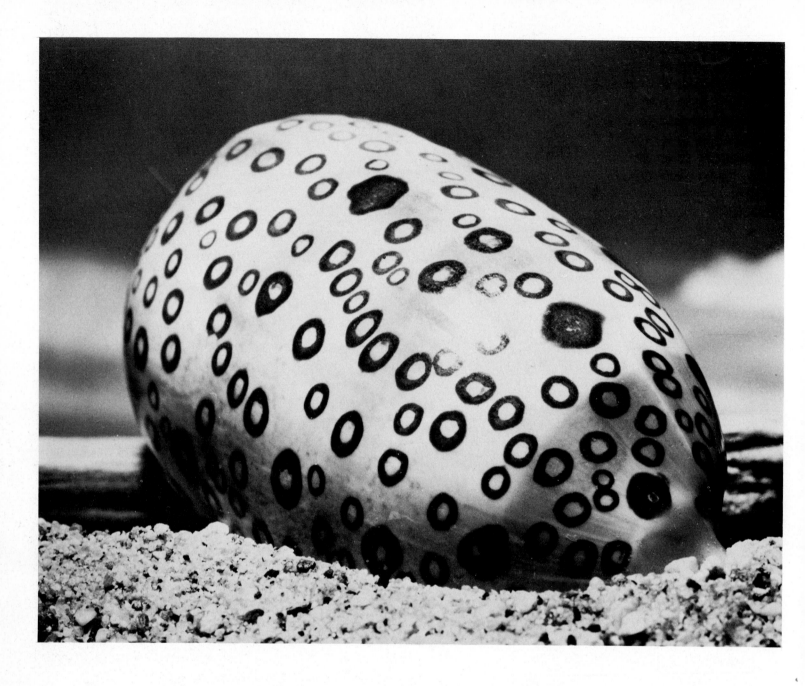

Above: An Eyed Cowrie (*Cypraea argus* L.). This beautiful shell comes from the Indo-Pacific Ocean, has a surface like painted porcelain, is two and a half inches long. It looks like a miniature piggy bank without the slot when lying on my desk and like a fantastic stranded blimp when lying on the beach and seen from the vantage point of another shell.

Right: A Watering Pot (*Penicillus australis* Chenu), a tube-like shell shown here cast ashore with its bottom end sticking up, justifying its name.

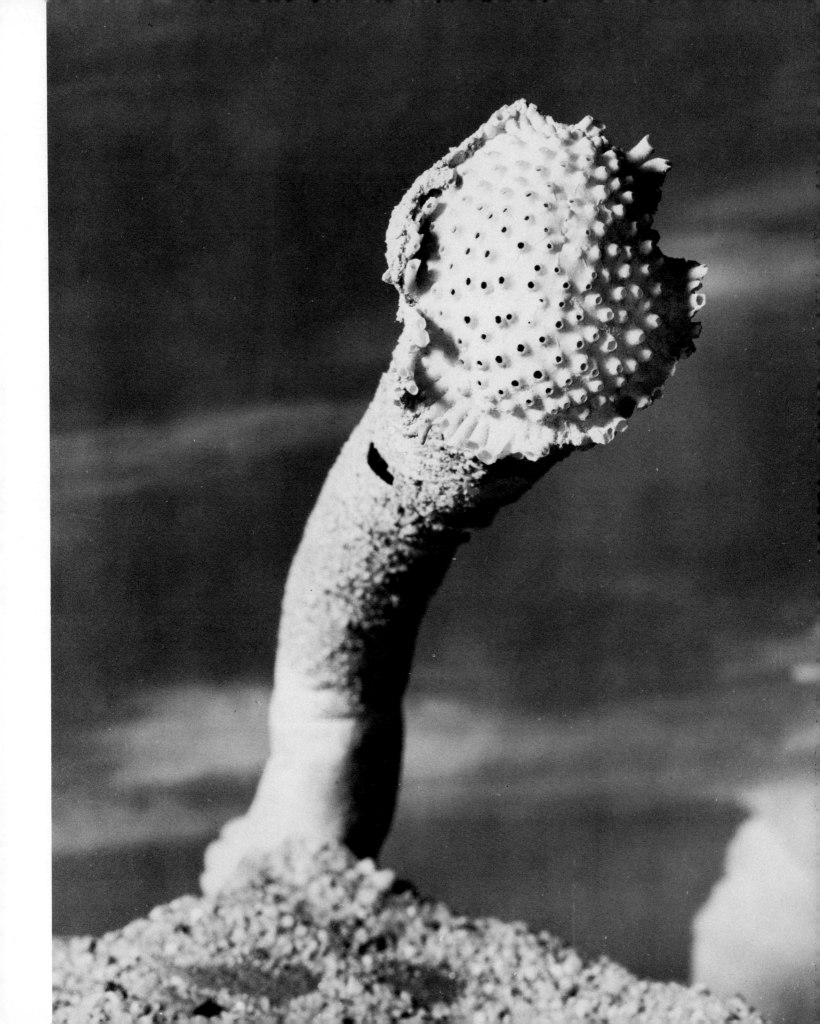

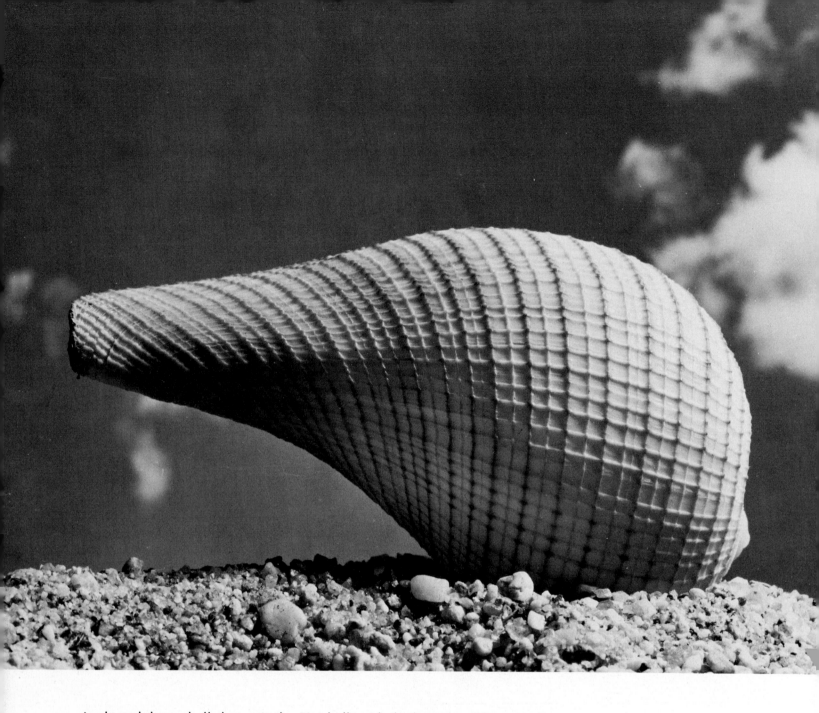

I selected these shells because the Fig shell, with the least possible expenditure of material, strengthens its thin, fragile shell by cross ribbing in a structurally ingenious way, the fantastic spines of the Venus Comb make it resemble a fish skeleton, the blunt shape of the Olla Volute reminds me of a jet engine in flight, and the needle-like Auger shell has an exquisite elegance.

Above: File Fig shell (*Ficus filosus* Sowerby), a rare shell from Japan.
Right: Venus Comb (*Murex triremis* Perry) from the western Pacific.
Page 62: Olla Volute (*Cymbium olla* L.) from Portugal.
Page 63: An Auger shell (*Terebra triseriata* Gray) from the western Pacific.

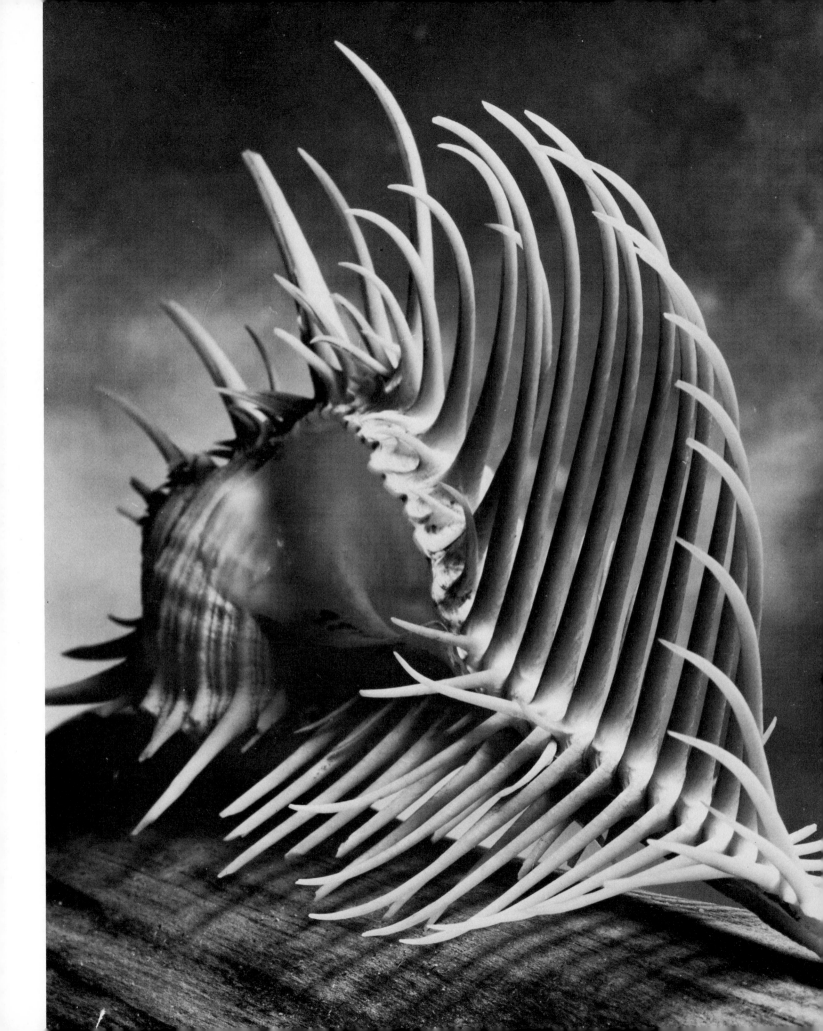

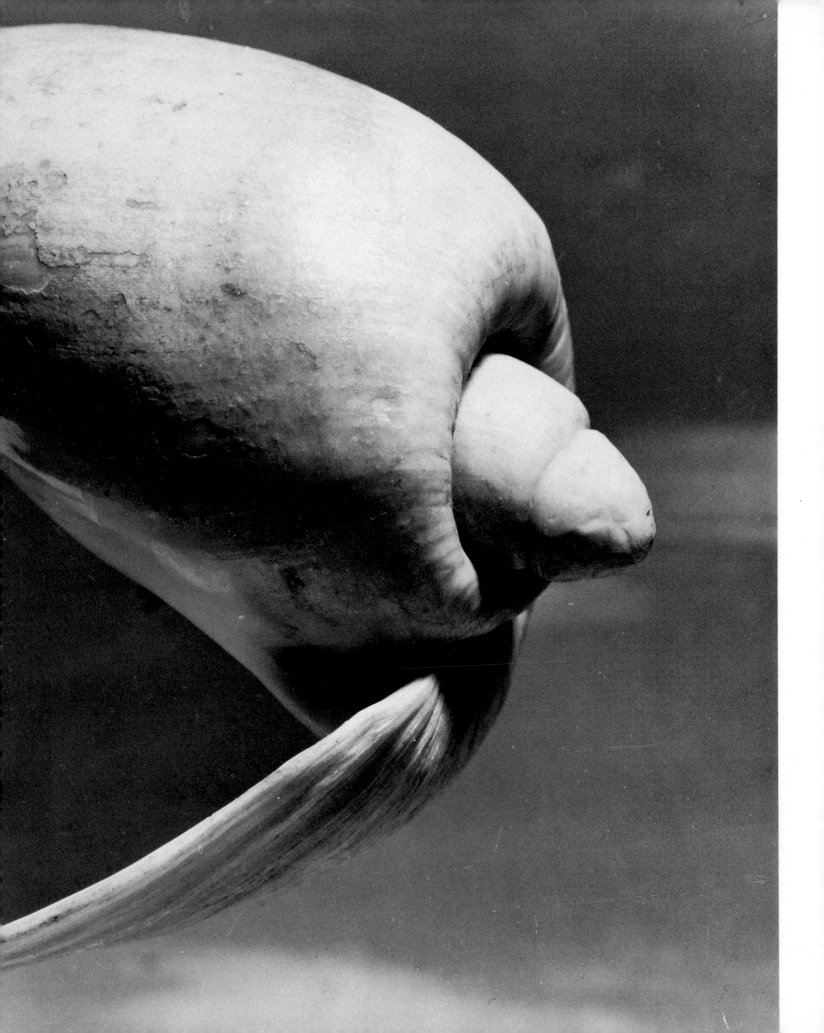

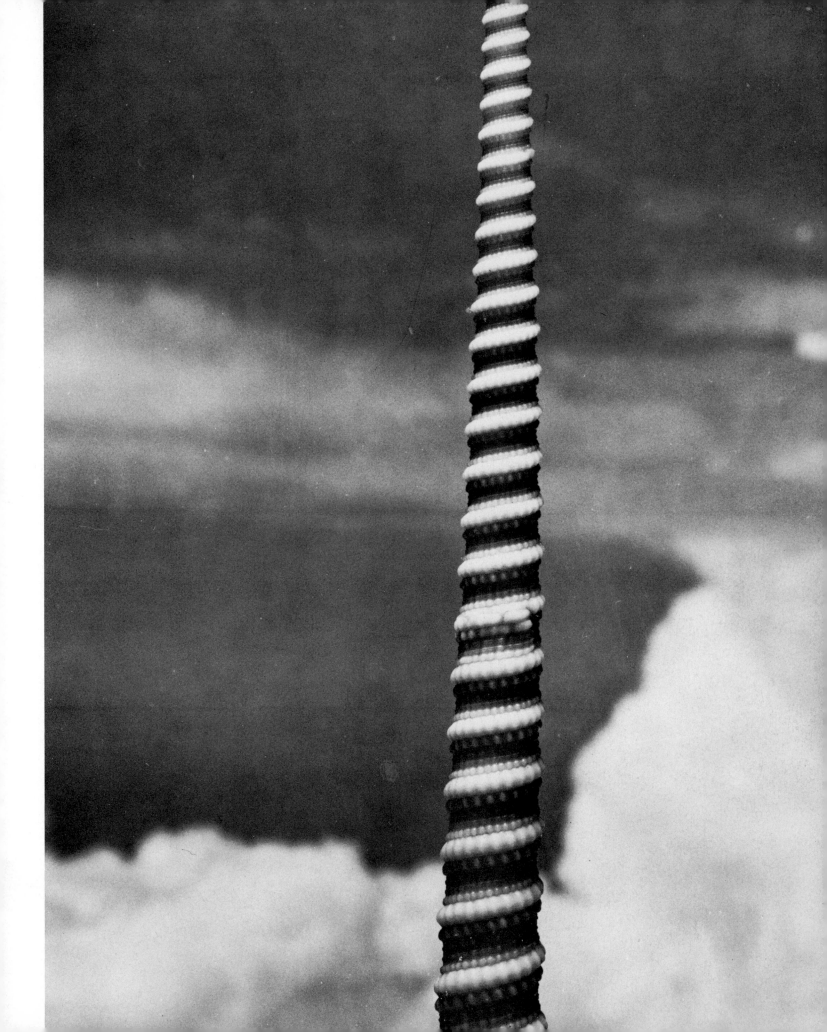

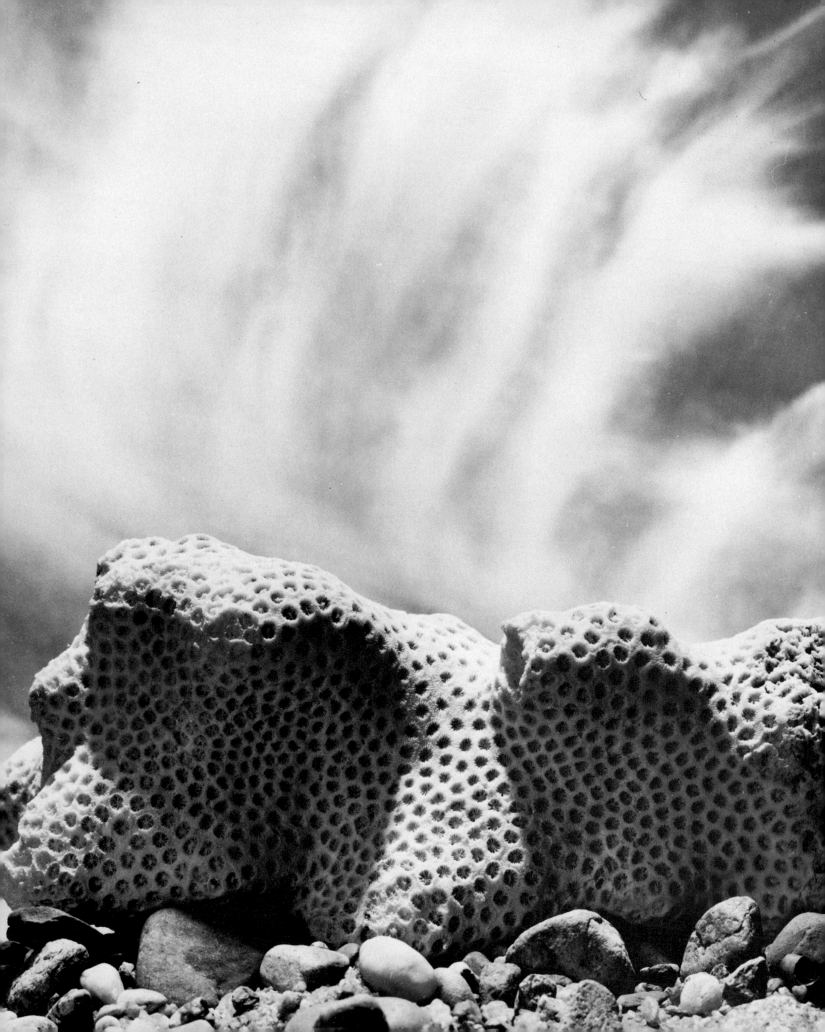

Continuing my imaginary walk along the beach, I suddenly found my way blocked by a wall, a piece of coral three inches high, which, to an eye-at-ground-level traveler, can be a serious barrier. Behind it filaments of clouds, the advancing edge of a storm, rose towering into the sky. The scene — the contrast between the massive white coral and the filmy white clouds — was breathtaking, confirming my belief that it is not *what* I look at but *how* I look at it that decides whether the experience will be ordinary or enjoyable, meaningful or dull.

I found this to be true whether I tramped the streets of big cities, explored the woods around my house, or took a walk along the beach. The worn-out iron steps leading to a subway entrance in New York can tell as much of a story as the water-polished pebbles cast up on the beach. Picking up a string of seaweed, I saw — literally — thousands of little limy coiled shells clinging to the kelp, the homes of serpulid worms (*Spirorbis*), and the closer I looked, the more I saw smaller shells among the larger ones, tiny ones among the smaller, and almost microscopic ones next to these — a triumphant display of the irrepressible abundance of life in the sea.

I don't regret that the majority of shells I find on the beach are broken or worn, because, by this very fact, they offer me a glimpse into their structure which I could not get from perfect shells. The carapace of a crab or sea urchin can tell me a story as interesting, though different, as that told by the living animal. A fish skeleton, though often smelly, can make my day because of the exquisite design of its bones, sculpture in miniature but just as enjoyable as works by Brancusi or Henry Moore. All of which has convinced me that it is not so much the eye as the mind that sets the tone of my life. Even if I were blind, I still could hear the thunder of the surf, feel the warmth of the sun, smell the salt and the kelp, and enjoy through my sense of touch the perfection of a pebble polished by the sea.

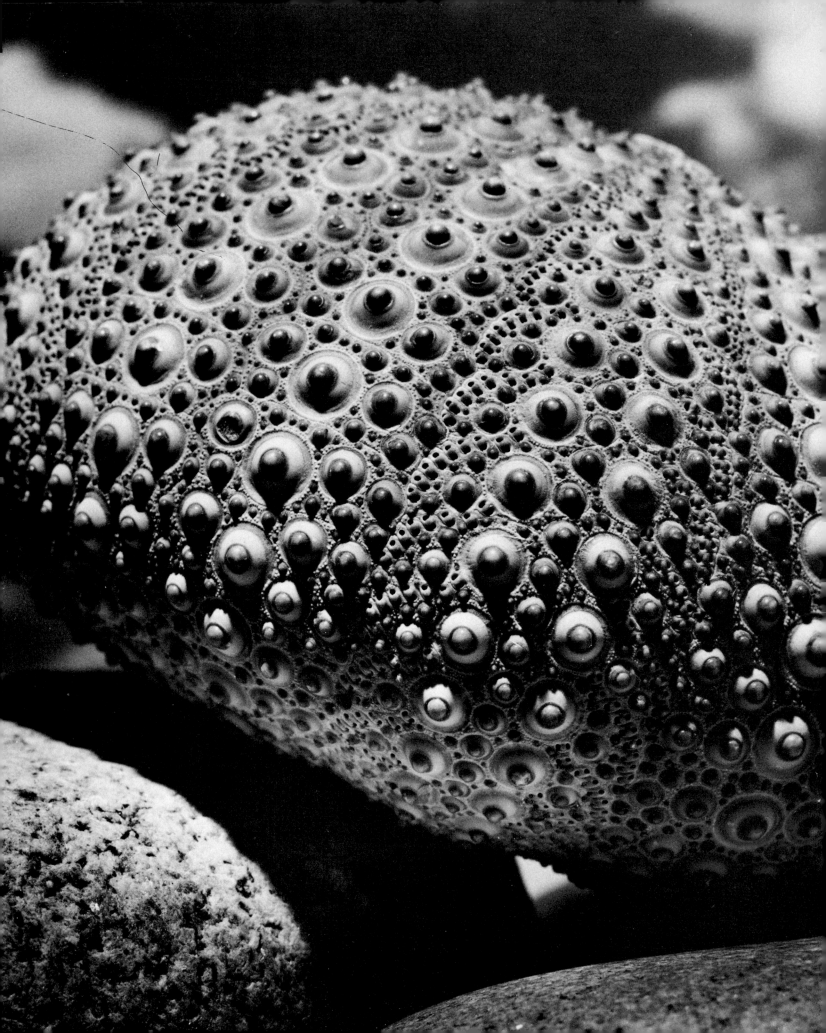

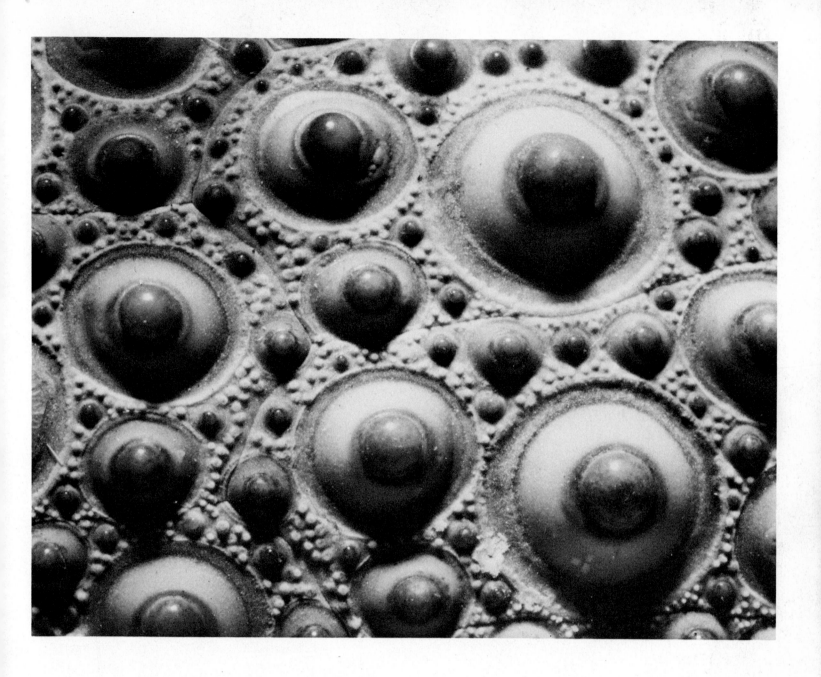

A sea urchin from the coast of Cornwall and a close-up of its shell. Together, they confirm what Dr. Roman Vishniac, superb interpreter of everything minute in nature, once expressed so eloquently: "Everything made by human hands looks terrible under magnification—crude, rough, and unsymmetrical. But in nature every bit of life is lovely. And the more magnification we use, the more details are brought out, perfectly formed, like endless sets of boxes within boxes."

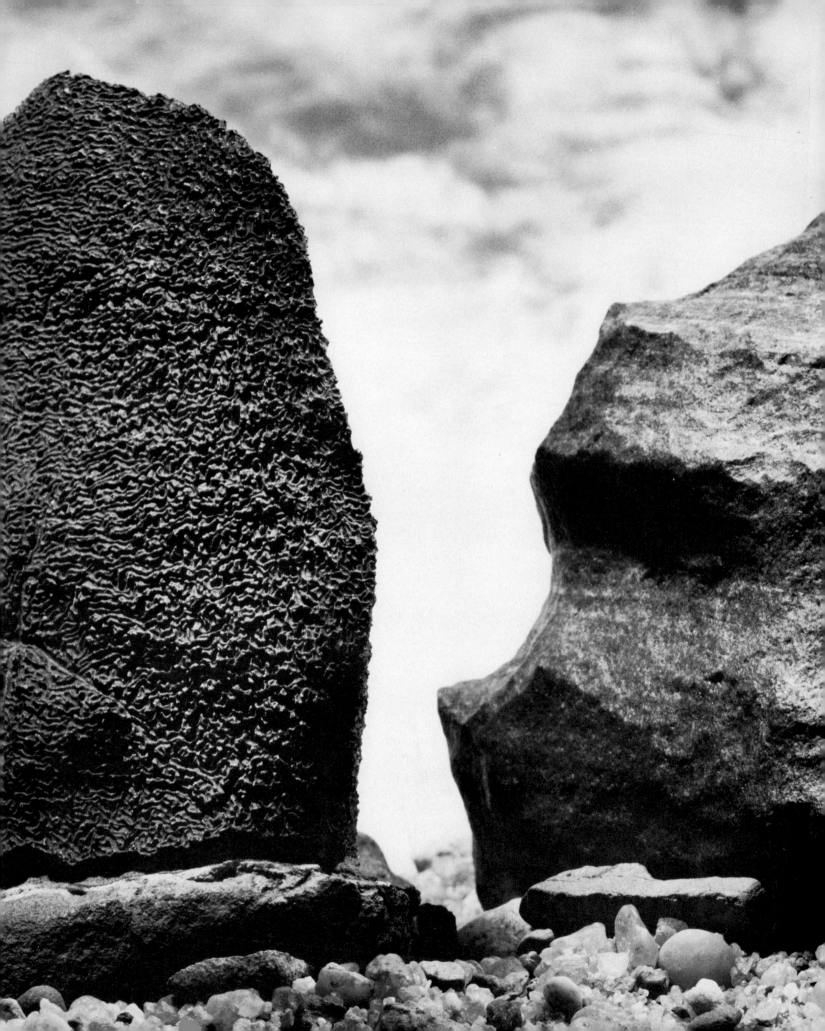

A walk in the desert

I love the desert. It is clean, healthy, a paradise of sunshine and fresh air, empty of people but not devoid of life. It is also a place where the stars are brighter than in any other sky and where one can learn much about life and its true values, about what is ephemeral and what is permanent. And I found that only change is permanent.

I contemplate the stones of the desert (pages 68, 70, 73) and see on them the mark of permutation, perceive them as symbols of change. I know they once formed part of the bordering mountain range, were split from the mother rock by solar heat and frost, swept from their height by rain and gravity, then were carved by ceaseless sandstorms to the forms I see today. But in the end they will be ground to dust by wind and sand and rain and floods, swept out to sea by rivers, compacted and cemented into beds of rock, uplifted by the heaving crust of the earth to form new mountains, only to be leveled again in the timeless cycle of birth and growth, maturity, decline, and death. The whole drama of life—of the universe—can be seen mirrored in an ordinary piece of stone.

The stones on pages 68 and 70 are called ventifacts—rocks shaped by the wind. This is literally true: the crinkle finish, the rills and grooves, the knifelike edges were all wrought by wind-driven sand that abraded the stone—more where its components were relatively soft, less where they were harder. The place is Death Valley, California, the lowest place in the United States, 276 feet below sea level.

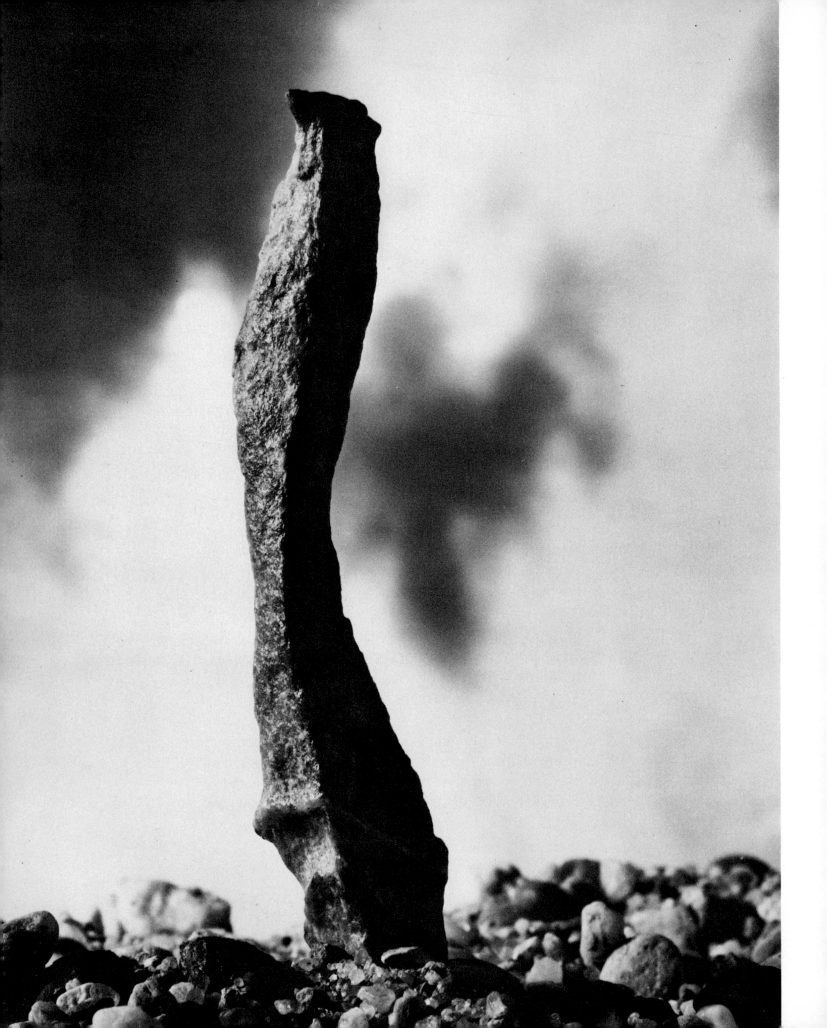

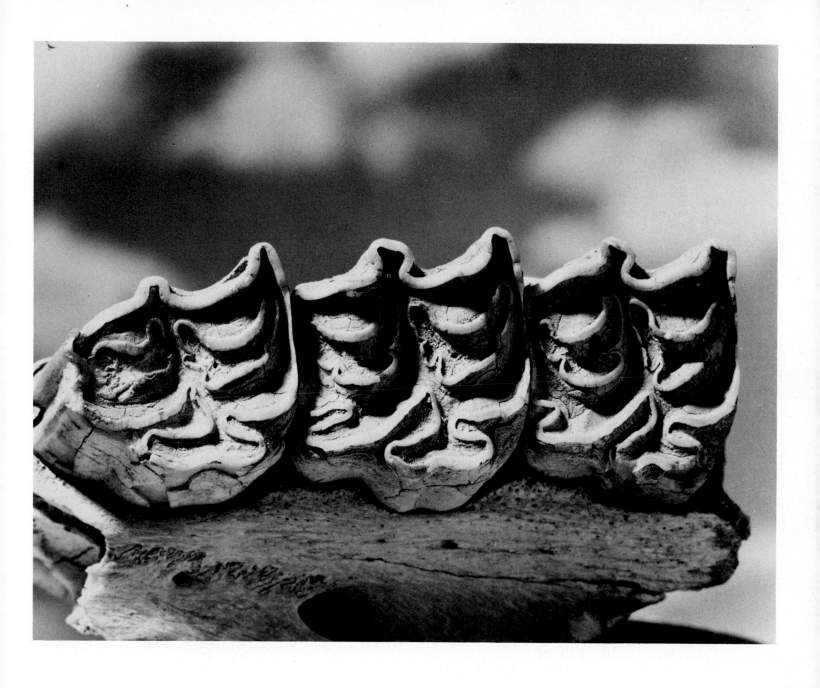

Above: Three teeth and part of the jawbone of a cow that died on the range. In the harsh overhead light of high noon, the pattern formed by the grinding surface of the teeth looks like ancient script, like cuneiform characters, like a message coded in runes. And indeed, to the initiated, these markings convey a message; they can be read and supply information regarding such facts as the kind, age, size, and food habits of the respective animal.

Left: A ventifact from Death Valley, California, a Cleopatra's Needle in miniature carved by the relentless sandblasting winds of the desert.

The runes of time

We are told that nature is an open book, its pages the different geological formations, which can be read by scientists. This, of course, is true. But it is an analogy that can be extended even further, from the general to the specific: not only do we have a "book" and "pages," but we also have "writing," the marks engraved upon the "pages" are what I call the runes of time.

The number of these runes is endless, and they can be found anywhere. To the initiated as well as the curious, they are a never-ending source of wonder and delight. Decoding them stimulates the mind, expands knowledge, provides insight into the workings of nature, and can become a fascinating hobby. Some of these runes are depicted on pages 68, 71, and 73 through 75.

The picture on the opposite page shows a rock from Death Valley. The deep, runelike incisions are caused by differential weathering—leaching in conjunction with sandblasting by wind—which affected the crisscrossing veinlets of softer material more readily than the less soluble main mass of the rock. A geologist reading these runes would be able to draw pertinent conclusions in regard to the origin and chemical composition of the rock, climatic conditions, rainfall, temperature, and time.

An interesting example of this principle is obsidian hydrating dating, a method used to calculate an age in years for obsidian artifacts by determining the thickness of the hydration rim which had been produced by water vapor slowly diffusing into a freshly chipped surface, manifesting itself in the form of a hydrated layer or rind. This method is applicable to volcanic glasses 200 to 200,000 years old.

Page 74: A lonely beetle track crossing a dune in Death Valley writes an ode to life. Even in the hottest, driest, coldest, wettest, most God-forsaken places on earth fragments of life exist—highly specialized animals and plants adapted to almost any conceivable set of conditions; irrepressible.

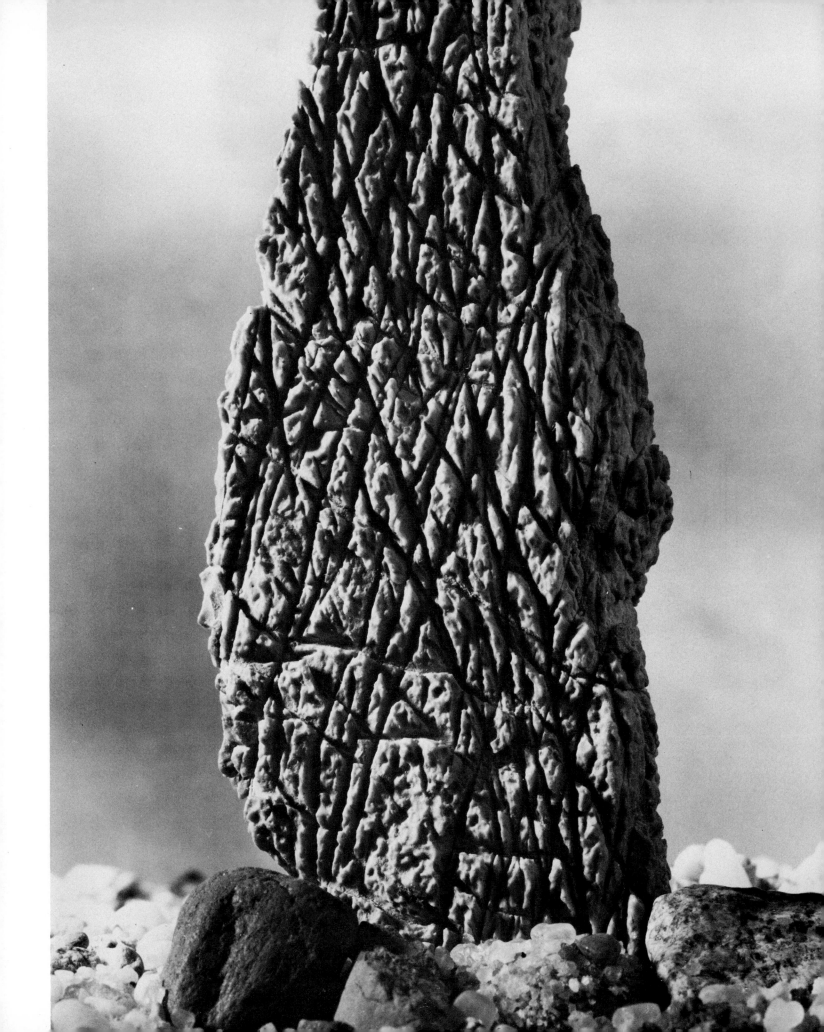

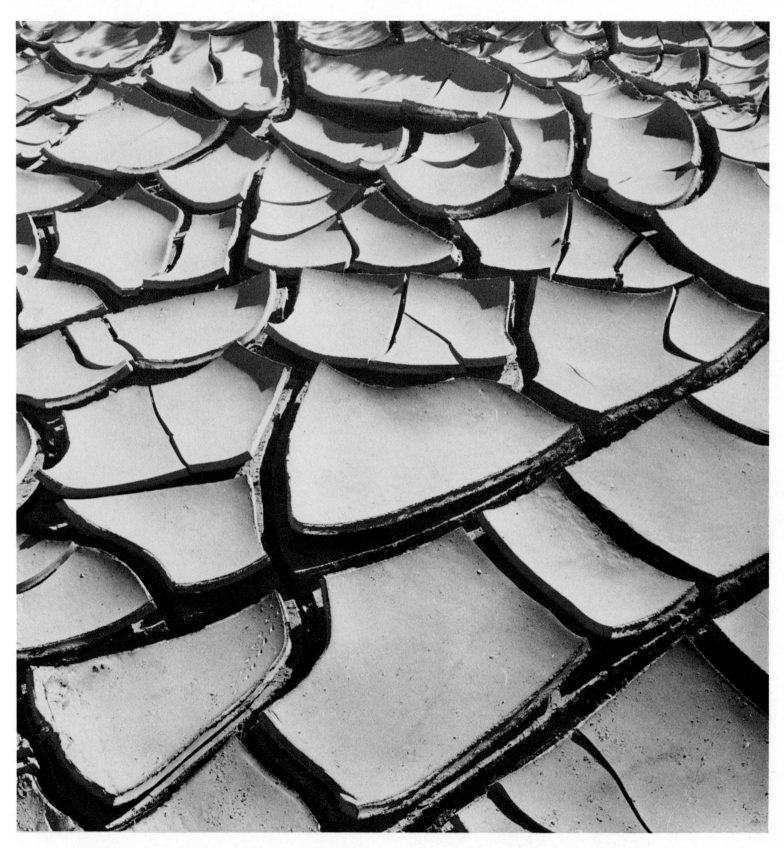

Mud flakes at the bottom of a playa — a temporary, shallow, mostly dry lake in the desert. The runelike cracks tell a story of heat and drought interspersed with sudden flash floods that deposited additional thin layers of silt. And again, there is the sign of life — the delicately incised track of an insect which crossed the flake in the lower left-hand corner while the mud was still damp.

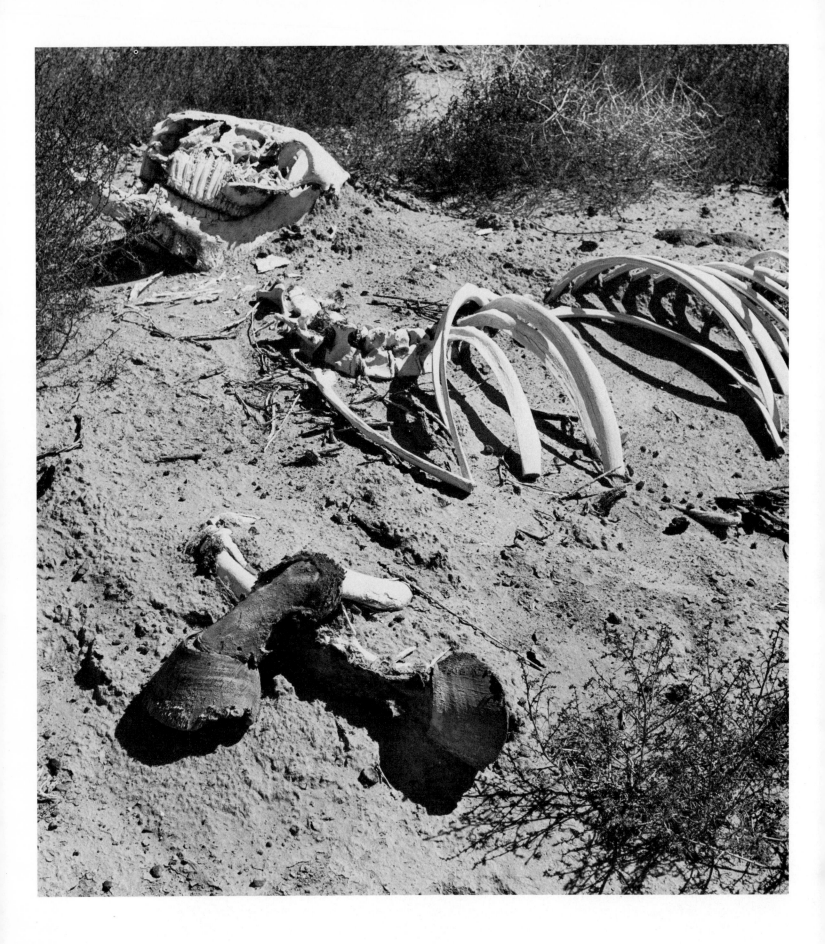

Death and resurrection

A few years ago, traveling in the Mojave Desert, I came upon the skeleton of a horse, resting in the pose in which the final darkness had overtaken it. It turned my mind to thoughts and images of death. The finality of it. Death as merciful release from pain and sorrow. Eternal sleep without morning. Thoughts and images not grim and fearful, but peaceful, acceptable, natural under the boundless sky in the brilliant light. And I thought that if I had a choice, I would prefer to die not surrounded by walls but out in open space in the sun.

I saw with my mind's eye the body of the horse slowly sink into the ground, its tissues dissociated into their basic components by microbes. I saw its molecules and atoms diffuse into the soil, only to be taken up again by plants which might serve as food for cattle, which in turn might be eaten by coyotes or man. And it occurred to me that nothing is ever lost or wasted in nature, and that the nitrogen atoms in my body may well have been part of a Sigillaria tree in a Carboniferous swamp, a dinosaur, or prehistoric man. And as surely as the sun will rise tomorrow, they will become components of other living beings again.

I do not find this thought disconcerting. On the contrary, I see in it a form of resurrection—not the "pie-in-the-sky" or "glory-glory-hallelujah" kind but a natural recycling on a cosmic scale. Aware of the fact that I live on borrowed matter, I find it only right to pass this substance on to future generations after I am gone. Our planet's resources are finite, which means that they must be used over and over again to sustain the growth potential of life, which is endless. This, then, is the meaning of dying: without natural death, life would proliferate unchecked, the earth would be overcrowded with living things, space would run out, the food supply would fail, and disaster would destroy us all. Death is the price living things must pay for the privilege of living, no matter whether animal, plant, or man.

And yet there is a kind of immortality given to man: immortality of the spirit. Through their thoughts and deeds, great men will live forever, and names like Plato, Socrates, Jesus, Galileo, Michelangelo, Newton, Darwin, Bach, Beethoven, Mozart, Einstein, and countless others will shine as symbols as long as men and women walk upon this earth.

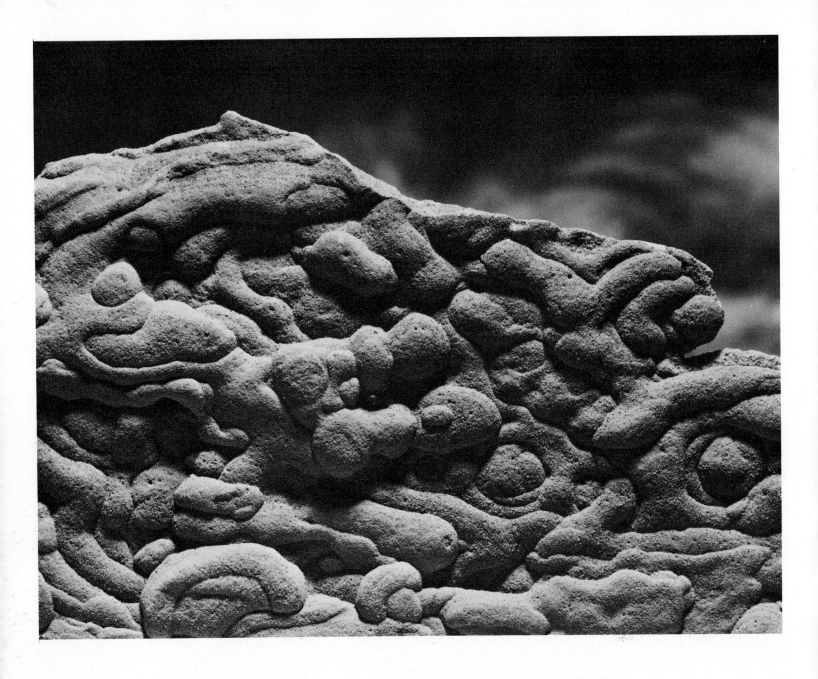

These weird-looking rocks are concretions—natural aggregates of mineral matter formed by orderly and localized precipitation from aqueous solutions (often about a nucleus such as a fossil, a bone, or a leaf) in the pores or fractures of a sedimentary rock. Usually they are of a composition widely different from that of the rock in which they are formed. The effect is enhanced by subsequent erosion that reveals differences in hardness between adjacent concentric layers or shells. No plastic deformation is involved.

I see faces in these rocks, strange forms that mock or mimic life. Could it have been manifestations like these that first inspired primitive man to express himself in the form of sculptural art?

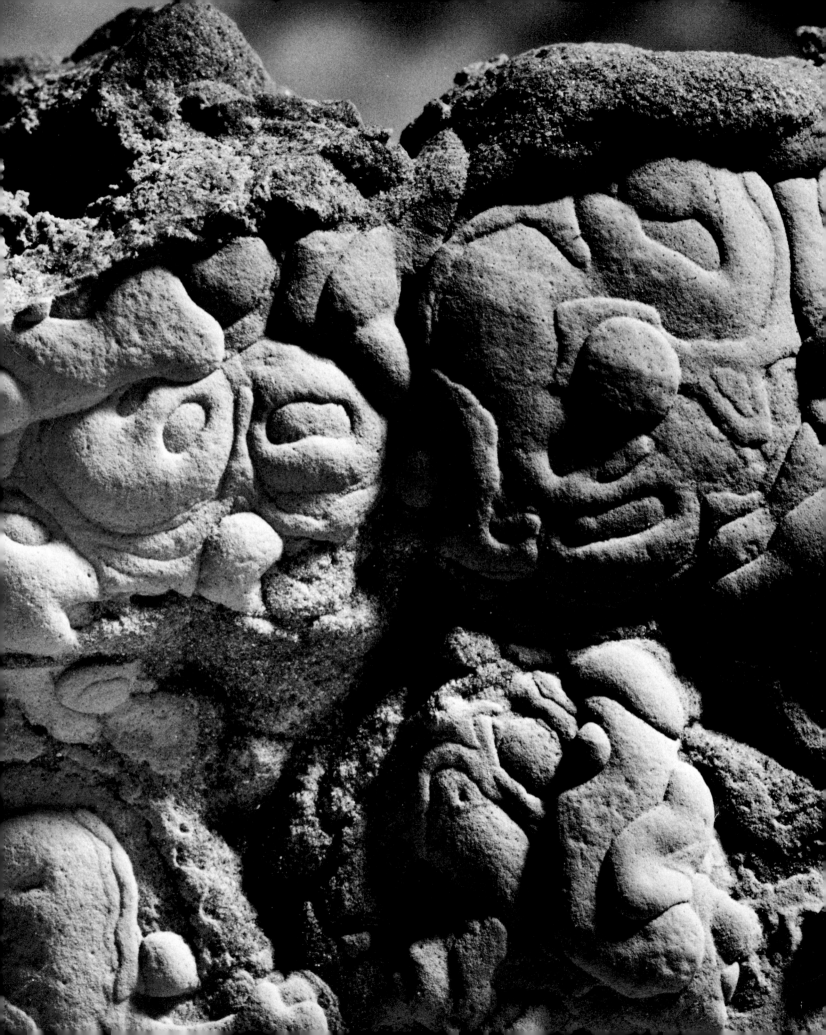

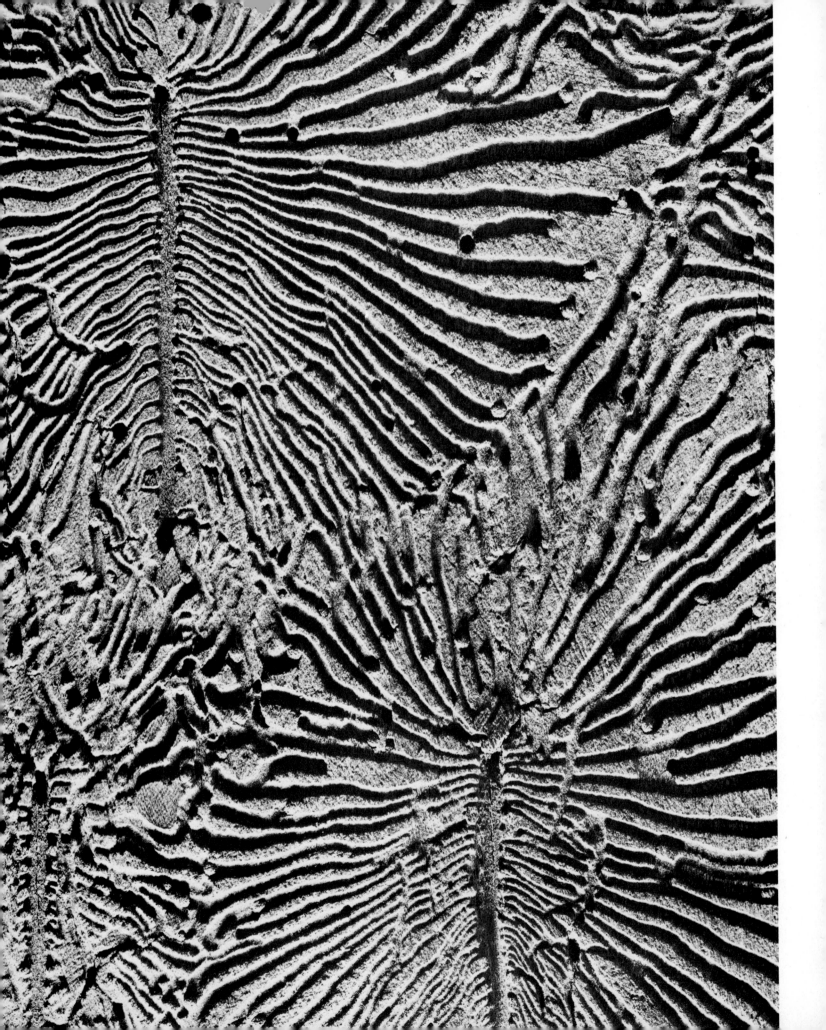

The view from above

Aerial photographs—views from above—are a comparatively recent invention. Before the advent of flying machines, vertical views were the privilege of birds, for even views from high lookout points, such as towers, trees, or mountains, are more or less oblique. But views from above don't have to involve high altitudes to be interesting. As a matter of fact, aerial views on a miniature scale—pictures taken only inches from the ground—can rival in informative power, strangeness, and beauty of design the most spectacular aerial views. Examples of this kind of miniature aerial view are shown on this and the following seven spreads.

Miniature aerial views reveal the world as seen from the viewpoint of small creatures whose horizons are measured in inches or feet instead of miles. This is the world of the near and small, the insect, the myopic. It is not only beautiful in an often abstract way but also offers, at least as far as I am concerned, a surprise: the fact that it frequently repeats on a miniature scale large features of the "normal" world, such as meandering rivers and braided streams, craters, mountain ranges, or large-scale forms of erosion. I see in this further evidence of the universality of nature's laws, which let a river meander like the sutures of a skull, or crystals grow like flowers—a supposition derided by every reputable scientist. But then scientists are of necessity conservative in their thinking and have been wrong before.

The photograph on the opposite page is a close-up "aerial view" of the trunk of a fallen tree. The depicted area, which is approximately three inches wide in actuality, shows the work of wood-boring beetles. The axial tunnels were made by female beetles which deposited their eggs at certain intervals immediately below the bark. The lateral drifts were chewed out by the grubs, their width increasing as the growing larva increased in girth. In this vertical view, the result of the beetles' activity forms roughly symmetrical designs of unexpected beauty.

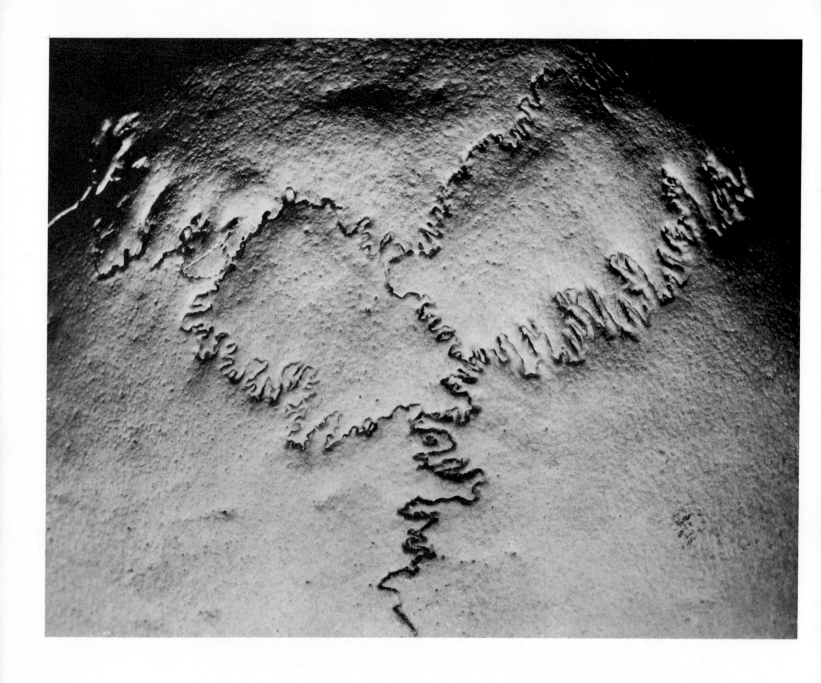

A low-level aerial view of a human cranium—the landscape of a skull.
Rolling, slightly hilly country crossed by meandering rivers—the sutures—
the junctures of the plates of the skull. The meanders increase the length of
the contact surface and, through interlocking, further strengthen the joints.

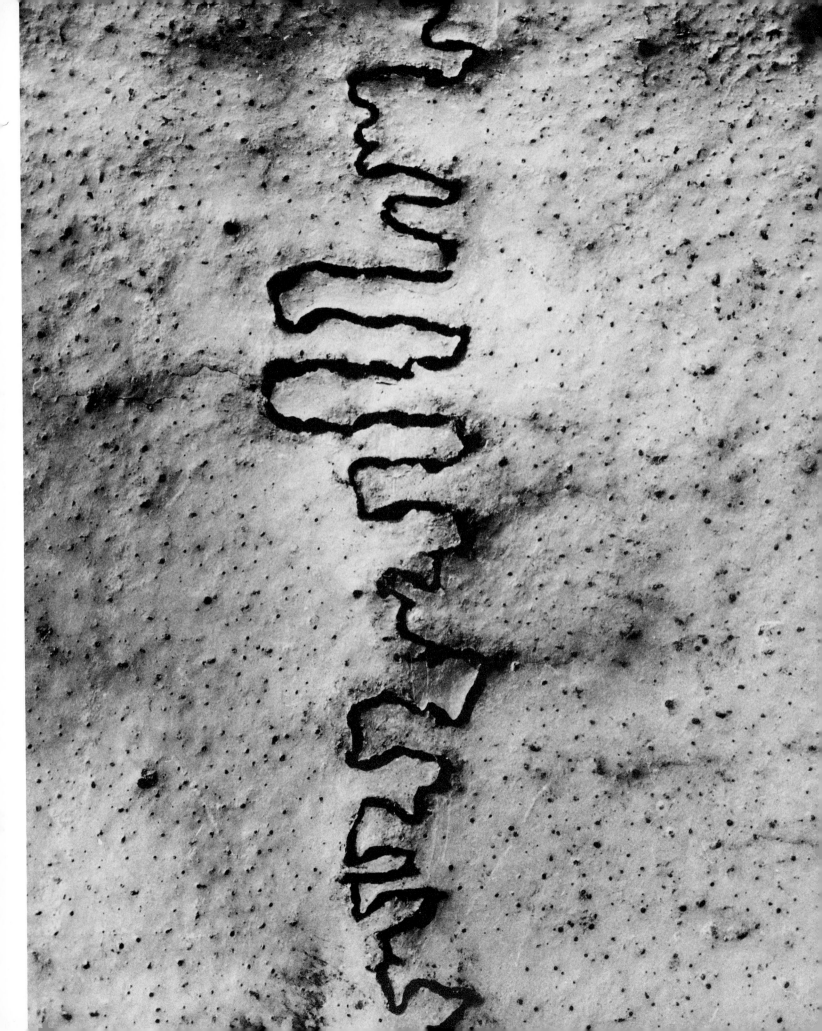

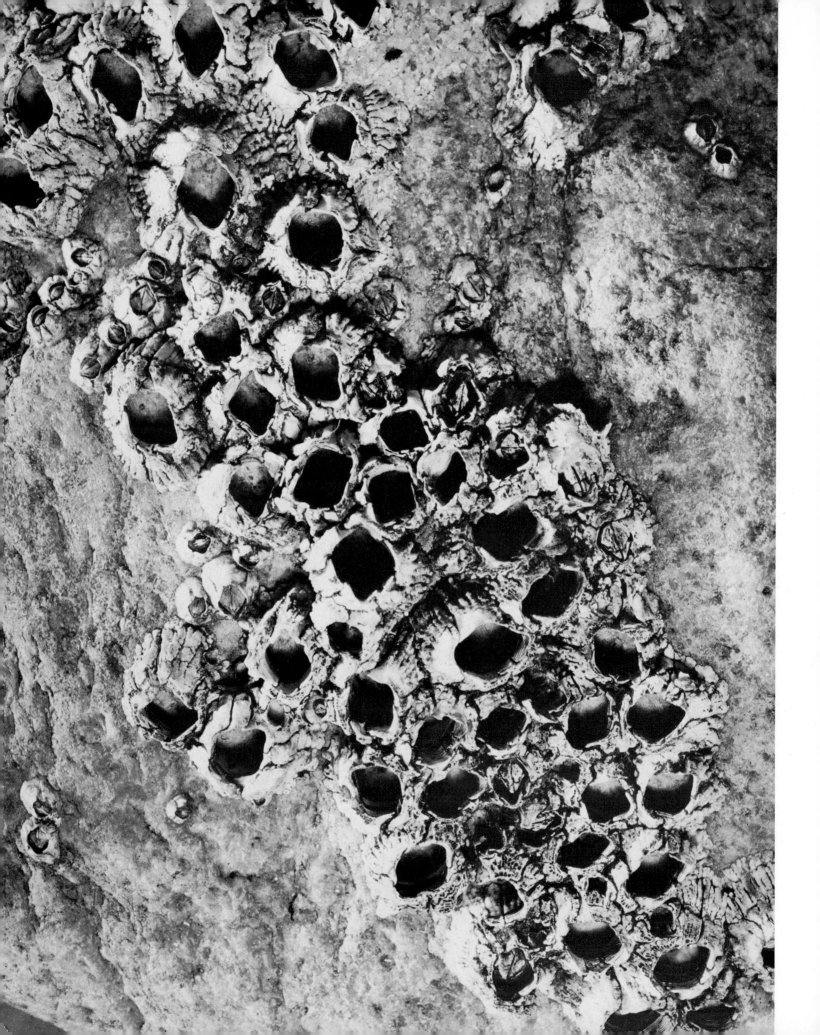

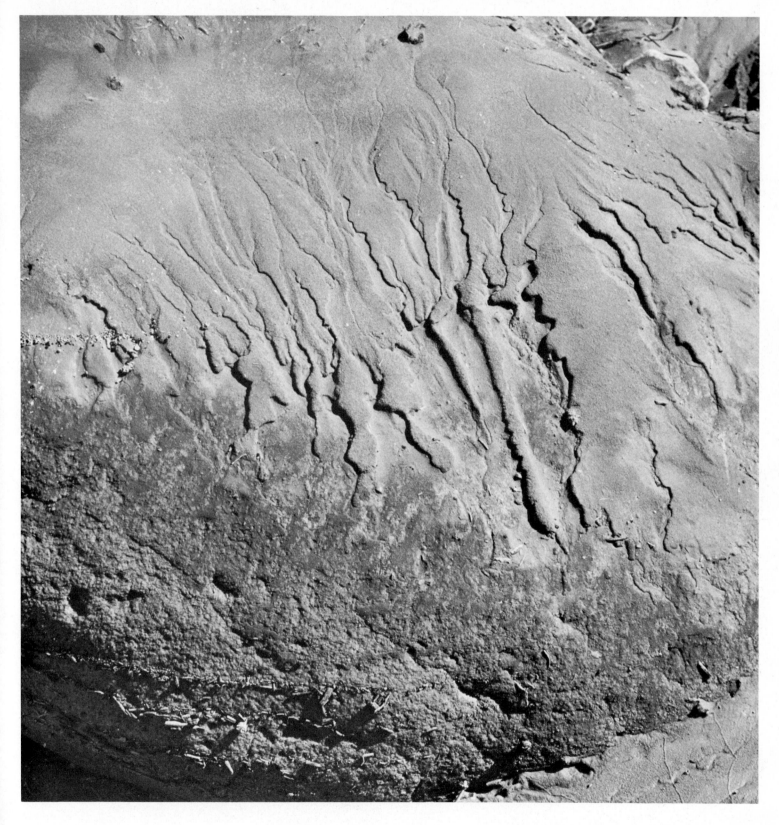

Eroding silt deposit on a stone, shown here in 2× magnification.

Not a close-up of the moon, but a colony of barnacles on a rock.

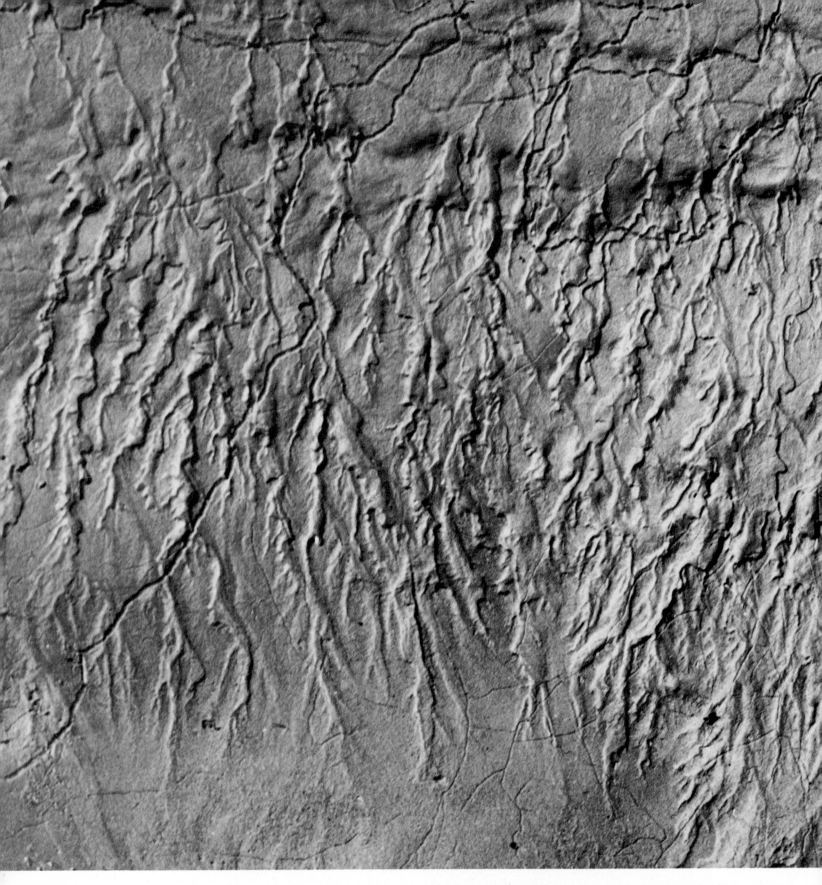

This is not a high-level aerial photograph of a mountain range, but a vertical view of the erosion pattern in silt deposited on the bank of a shallow, sluggish creek.

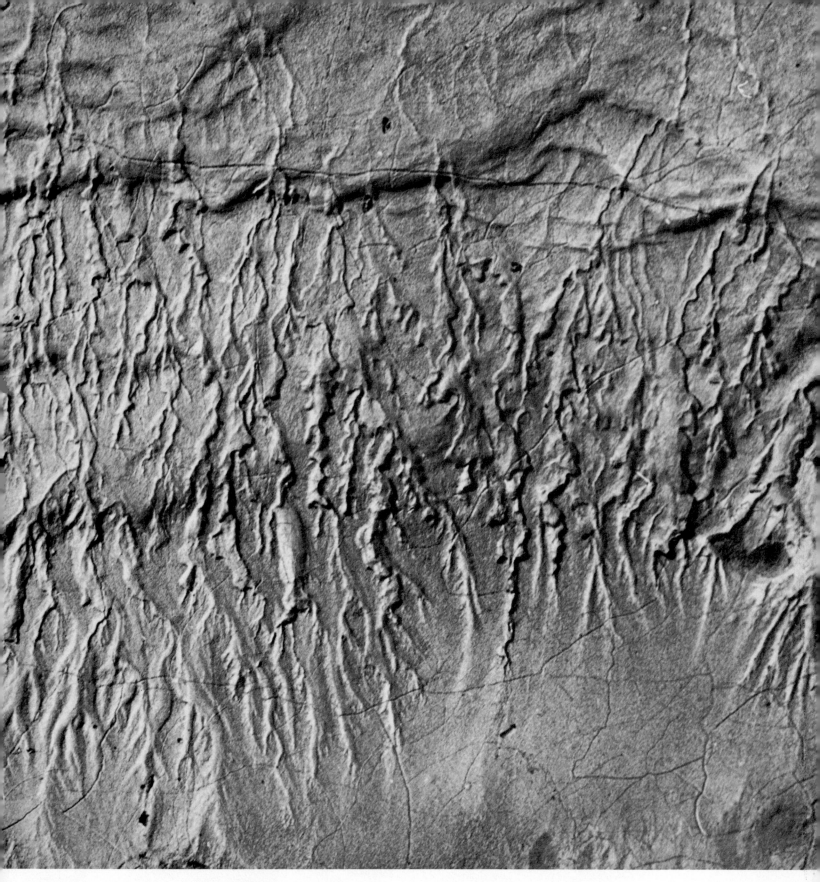

The actual width of the depicted area is less than two feet. The resemblance to large-scale erosion patterns is striking—a replica of a mountainside carved in mud.

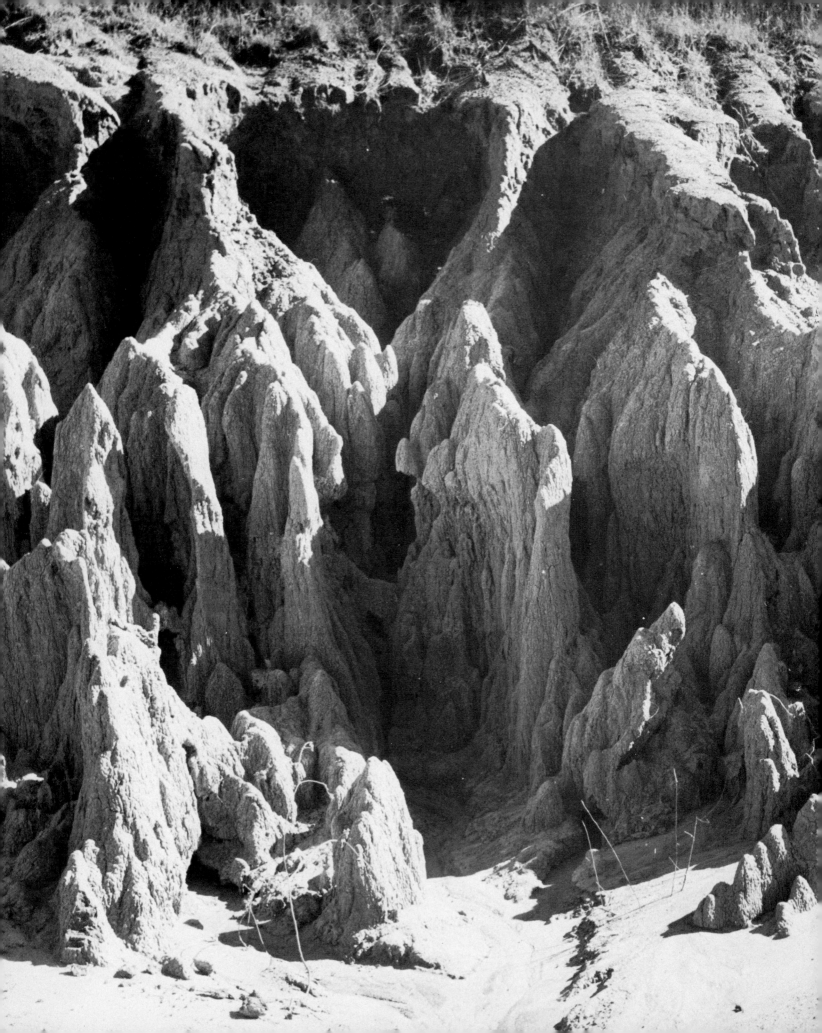

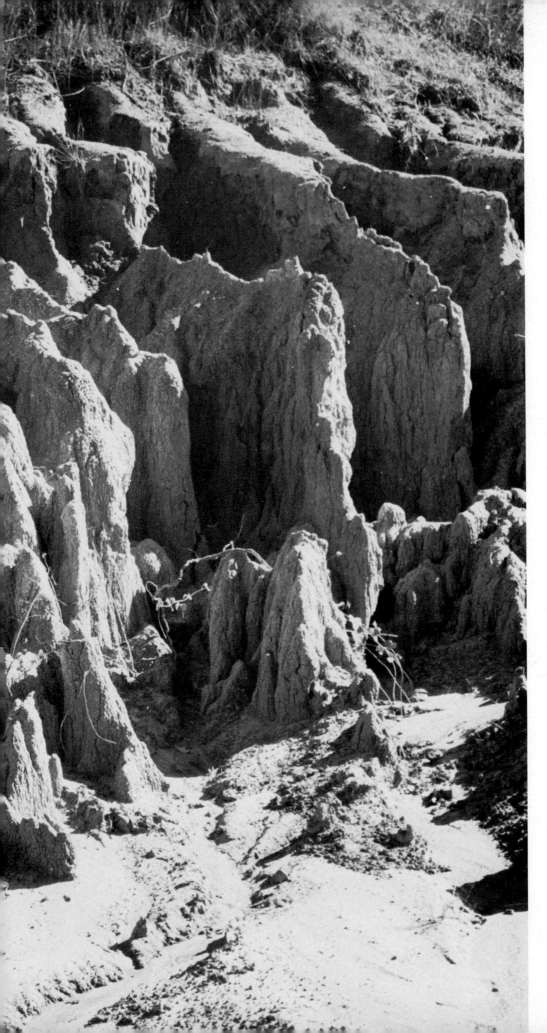

This is not an aerial view of Bryce Canyon in Utah, but an oblique mini-aerial shot of an eroding clay bank all of four feet high. The picture was made from a distance of approximately ten feet. The shape of the canyon walls and riverbanks is identical to that of features hundreds of times as large, demonstrating that erosion, regardless of scale, obeys one universal law.

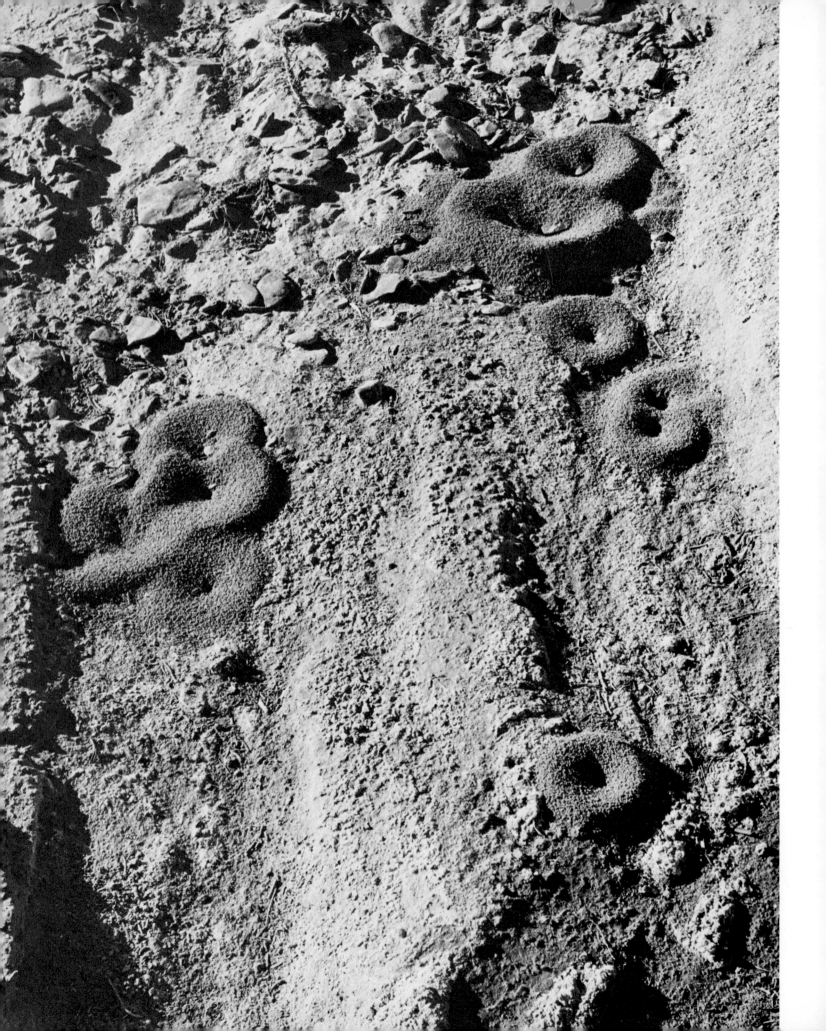

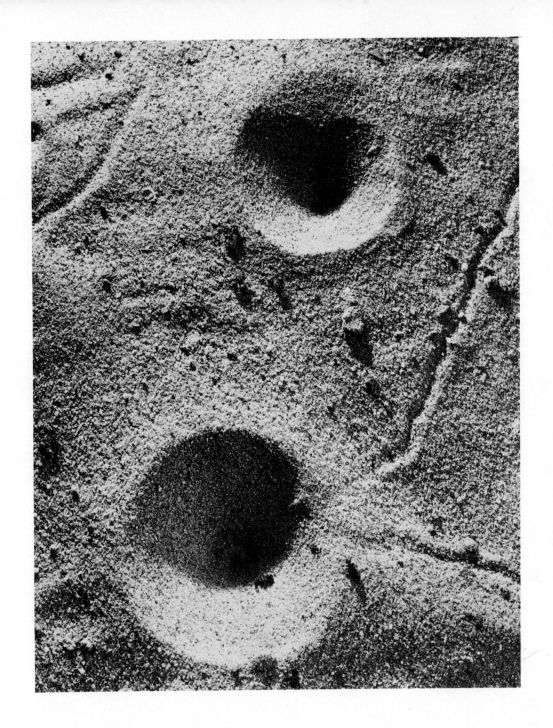

Not impact craters of bombs in a no-man's-land, but the funnels of ant lions—traps dug by the larvae of these insects in order to capture their prey. The diameters of these craters average slightly more than one inch. The altitude from which this mini-aerial view was made is less than one foot.

Not the mountain fastness of some primitive tribe, but the tailings of colonies of tiny ants which dumped the excavated material of their burrowing activities grain by grain in the form of neatly organized circular mounds with an average diameter of two inches.

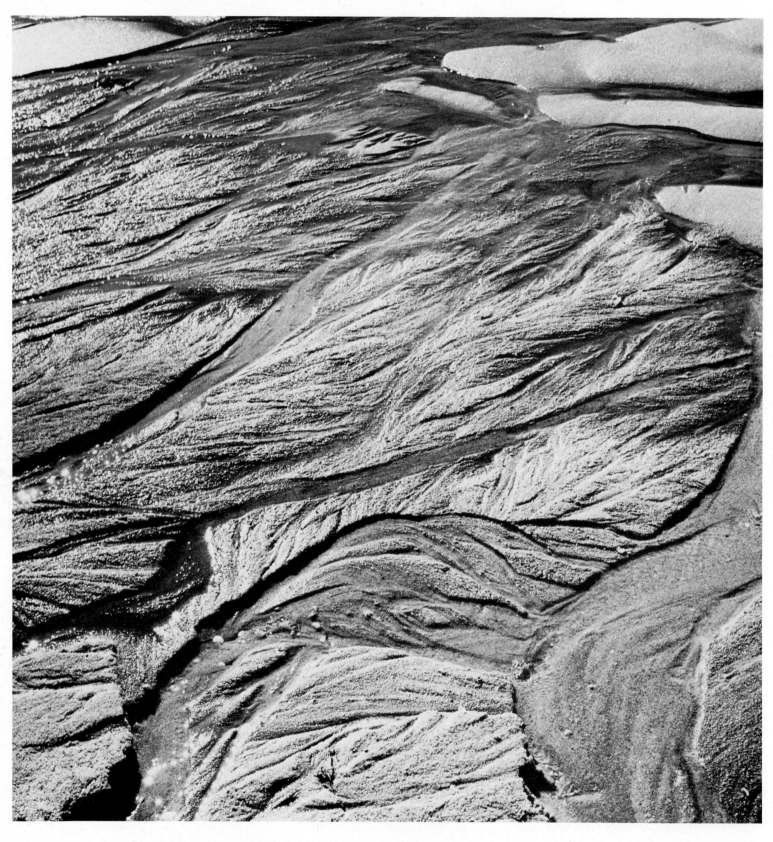

The pattern of a ''braided stream'' replicated in miniature on the edge of a
silt-covered, black top country road and shown here in half its natural size.

Pond water in the process of freezing. A mini-aerial shot from a height of about five feet.

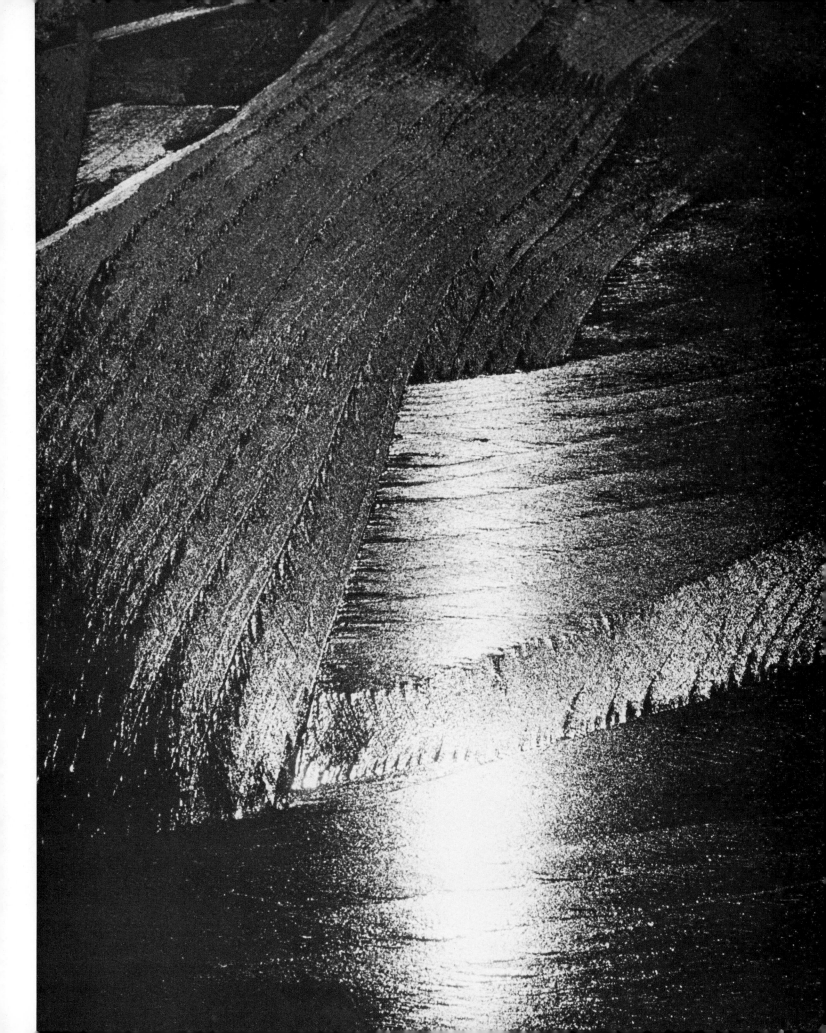

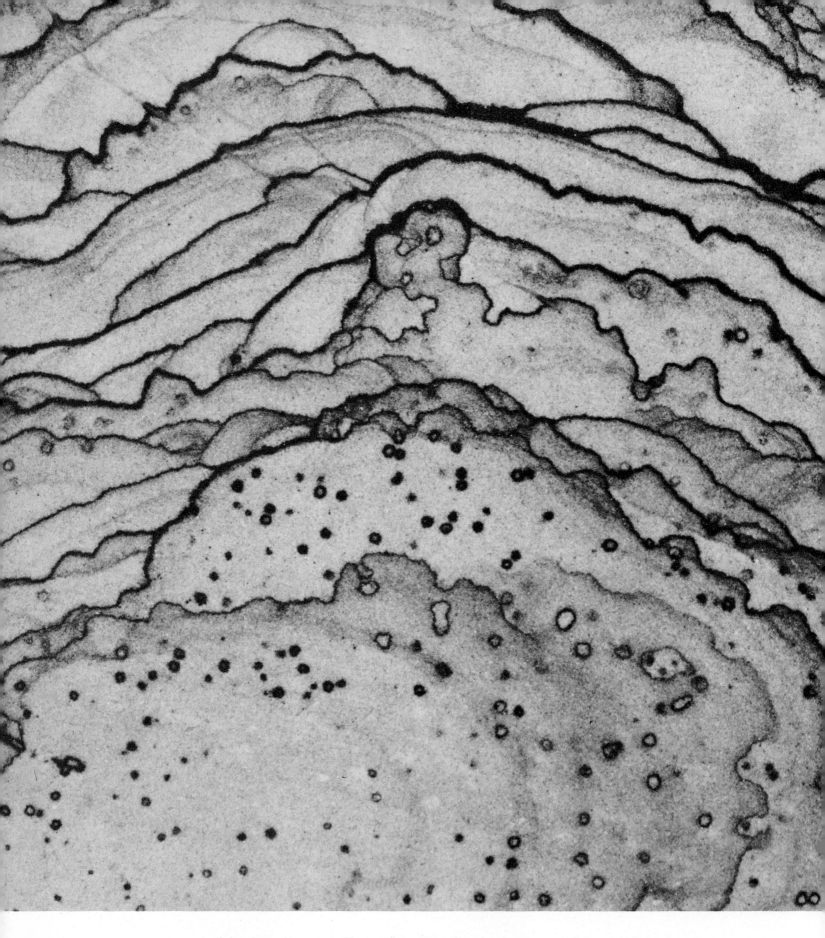

A slab of sandstone, infiltrated by mineralized solutions, makes me think of a view across mountain chains as they would appear from a lofty vantage point, stacked row

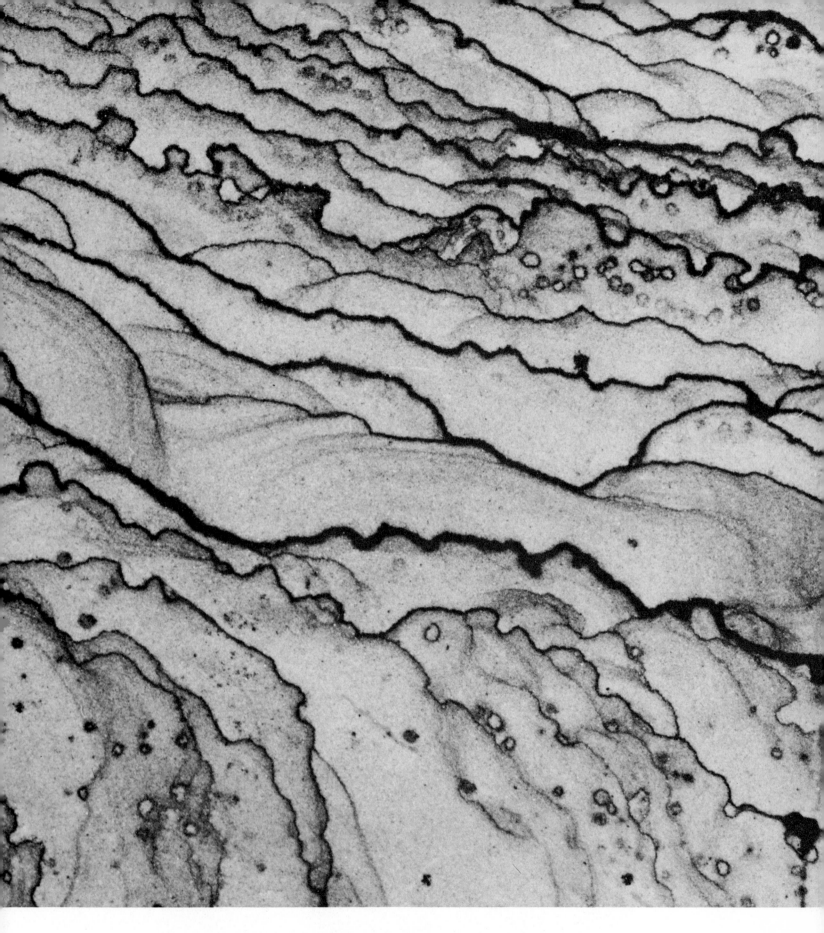

after row in foreshortening perspective. The tiny circles in the foreground might be boulders or the crowns of mighty trees. Magnification is about three times natural size.

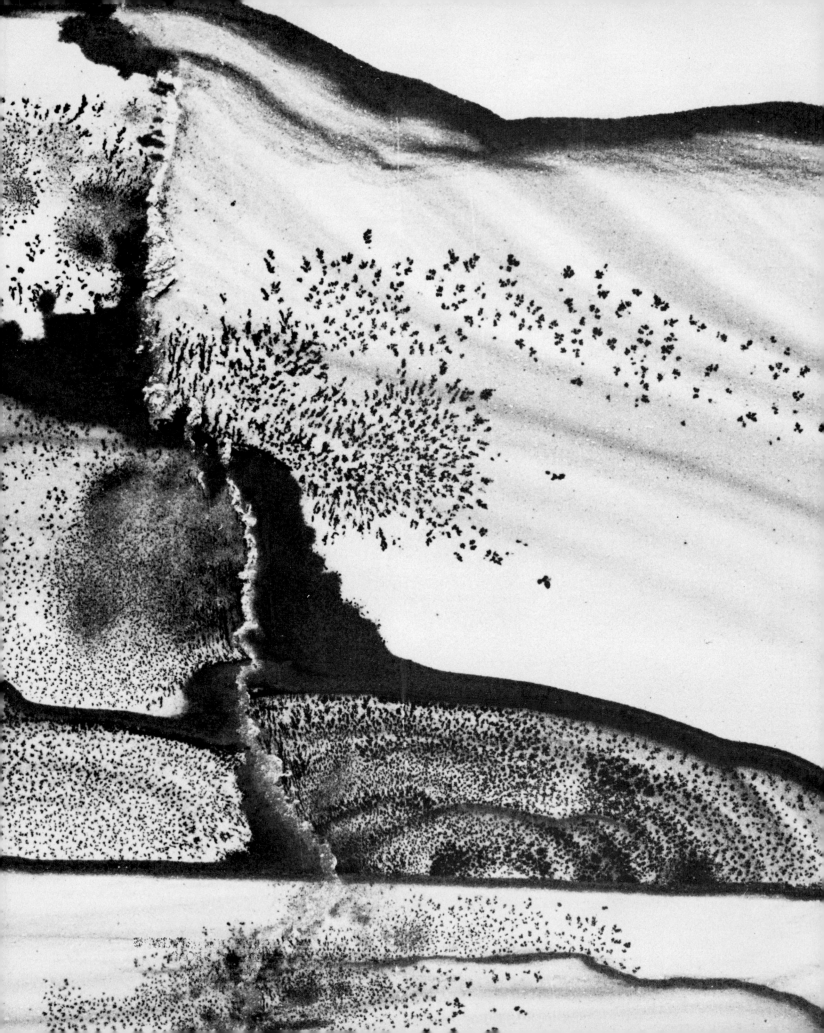

Stone flowers

One of the most striking similarities between unrelated objects of nature — a similarity which science insists is nothing but coincidence — is that between the growth pattern of plants and certain minerals (yes, minerals, in the form of crystals, dendrites, concretions, ice, etc., actually "grow," that is, increase their size not by random aggregation or clumping but in a strictly orderly way).

Stone flowers — stone in the form of flowers — should they be food for thought here for any inquisitive mind? Why do these structures look like flowers, grow like flowers, branch like flowers? Could the explanation lie in the fact that atoms combine to form molecules and molecules combine with other molecules in only a limited number of ways? After all, in the last analysis, it is atoms and molecules which combine to form the cells and organs of a plant. So far, no valid connection between the growth of minerals and plants has been established. Perhaps it does not exist. Perhaps we simply don't yet know enough about the intimate workings of nature. But the puzzle persists, the thought is intriguing, and the tangible results are beautiful as shown by the photographs on this and the following ten pages.

The picture on the opposite page shows a cross section of a piece of brecciated limestone infiltrated by mineral-bearing solutions which crystallized in the form of plantlike structures called dendrites. The similarity to bushy plants growing out of cracks is startling, particularly in view of the fact that dendrites actually *do* grow along cracks in rocks. In the photograph the specimen is magnified 14× linear.

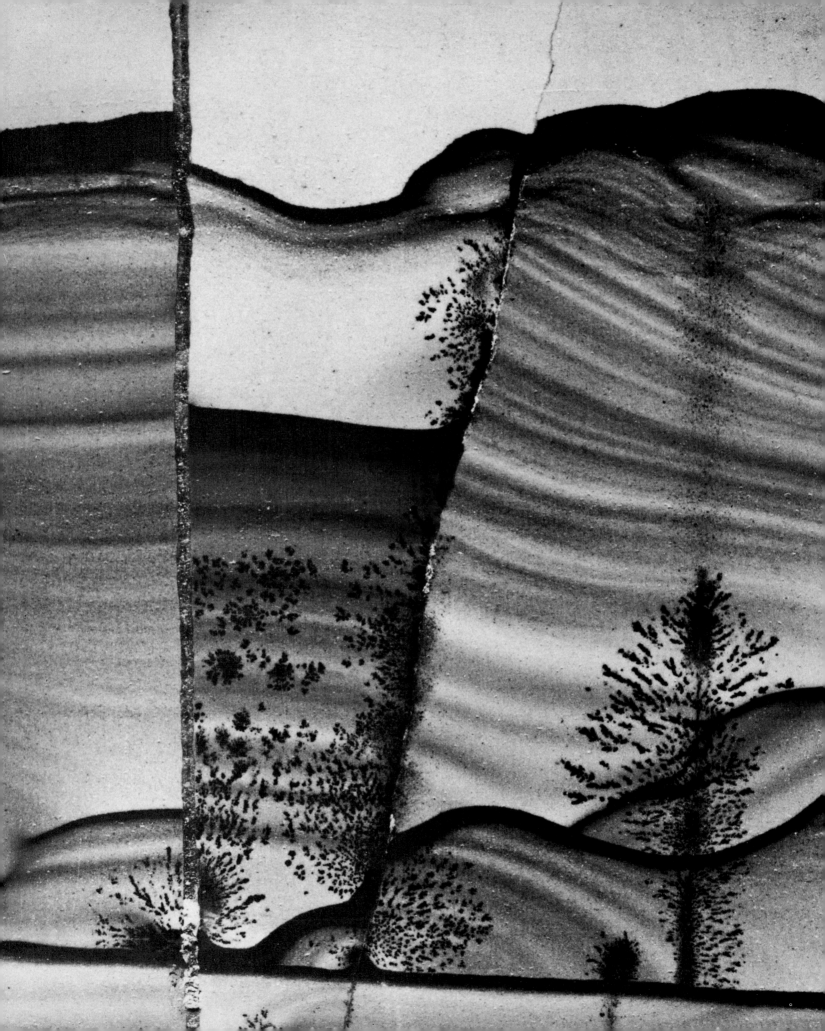

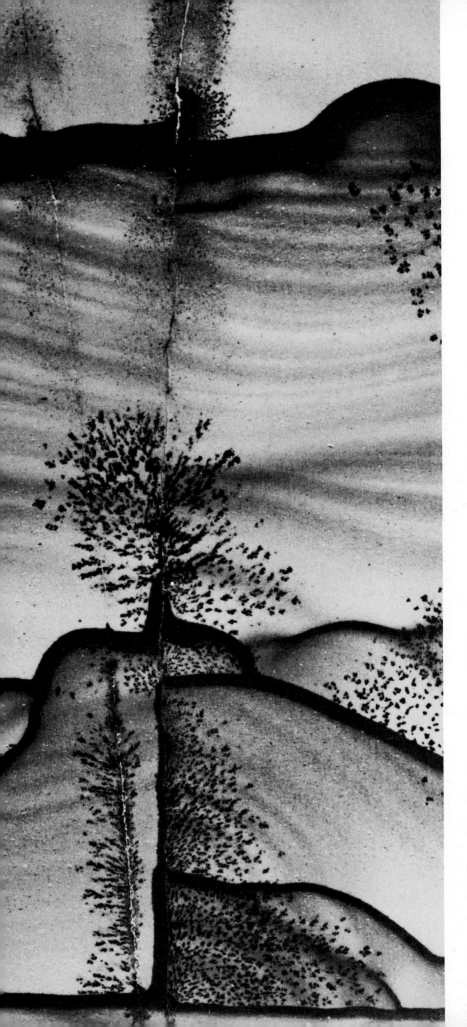

Like the previous photograph, this one shows dendrites in brecciated limestone. But this time, instead of a single "plant," we see an entire garden, a fairyland where everything is stone and nothing what it seems to be. For the three-dimensional effect is an illusion and, in actuality, the entire "landscape," "sky" included, lies in the flat plane of a polished slice of stone. Magnification is 12½× linear.

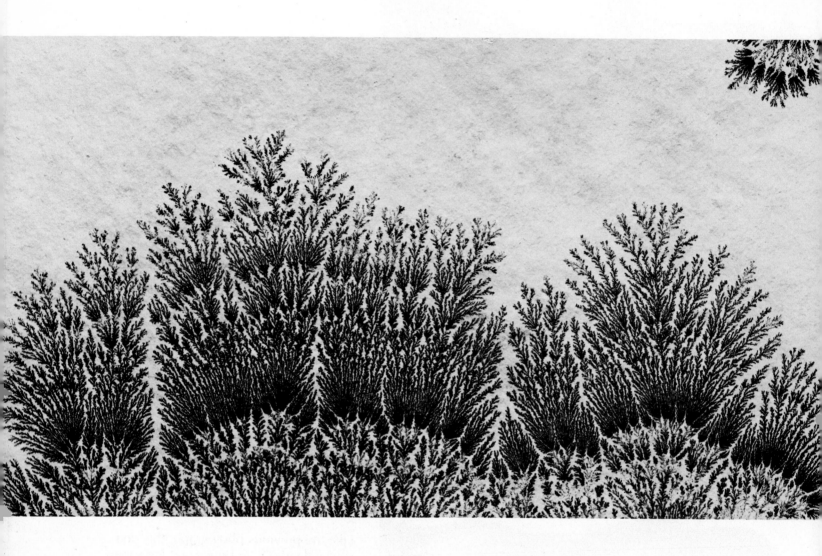

Dendrites formed along bedding planes of shale from Solenhofen, Germany. These plantlike structures consist of crystallized manganese oxide which, while still in solution, penetrated along a parting plane in the rock, advancing on several fronts. Although the process of dendrite formation is still not fully understood, it can be said that the ebb and flow of this solution, in conjunction with variations in its concentration and temperature, probably modulated by interatomic electrical forces and crystal nucleation, controlled the growth rate and manner of branching of the dendrites shown in these two photographs and the one on page 102. Magnification in all three cases is approximately 3½× linear.

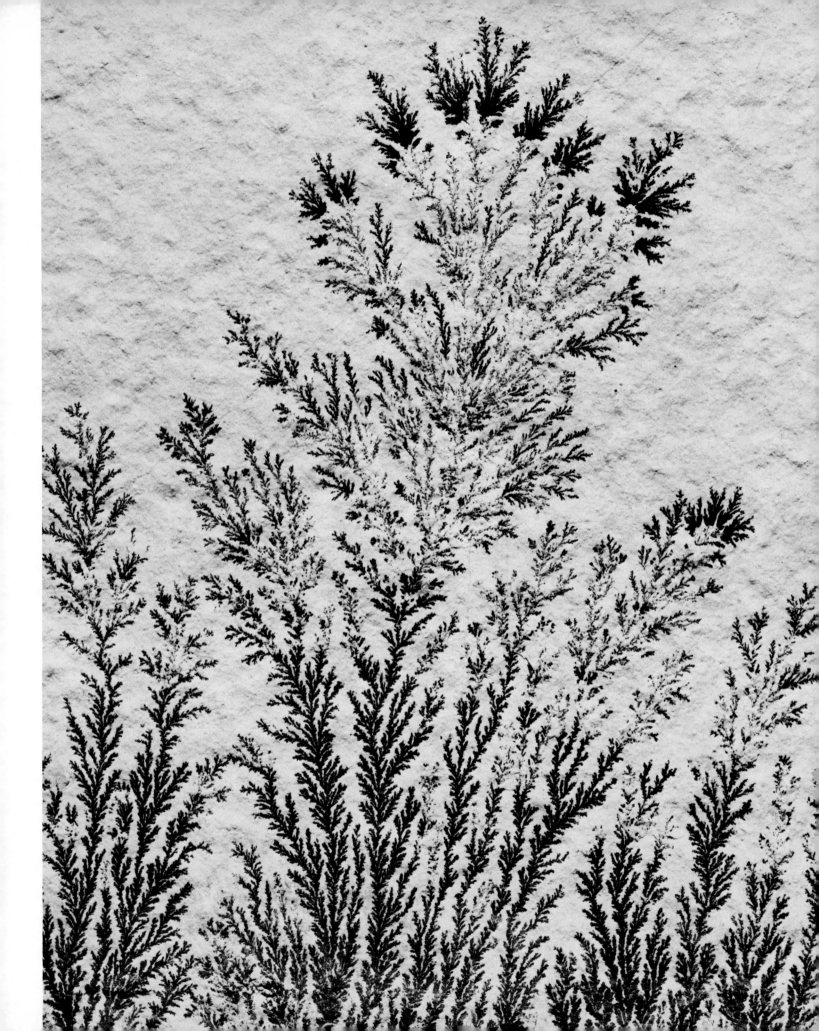

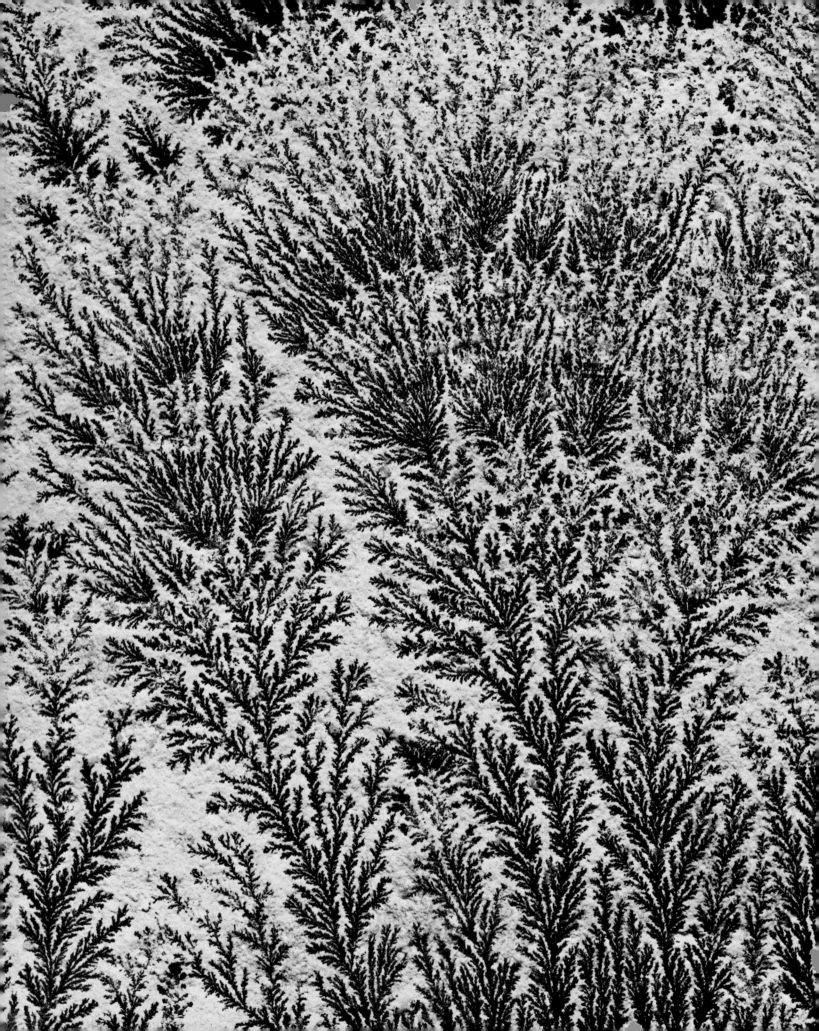

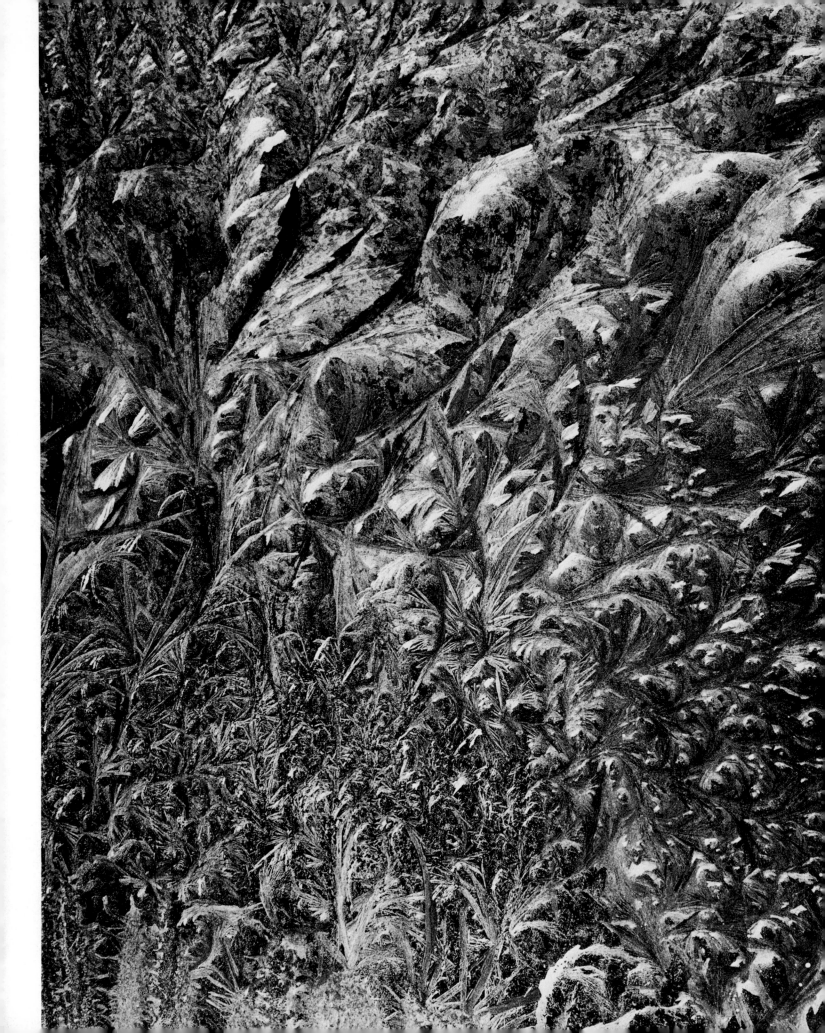

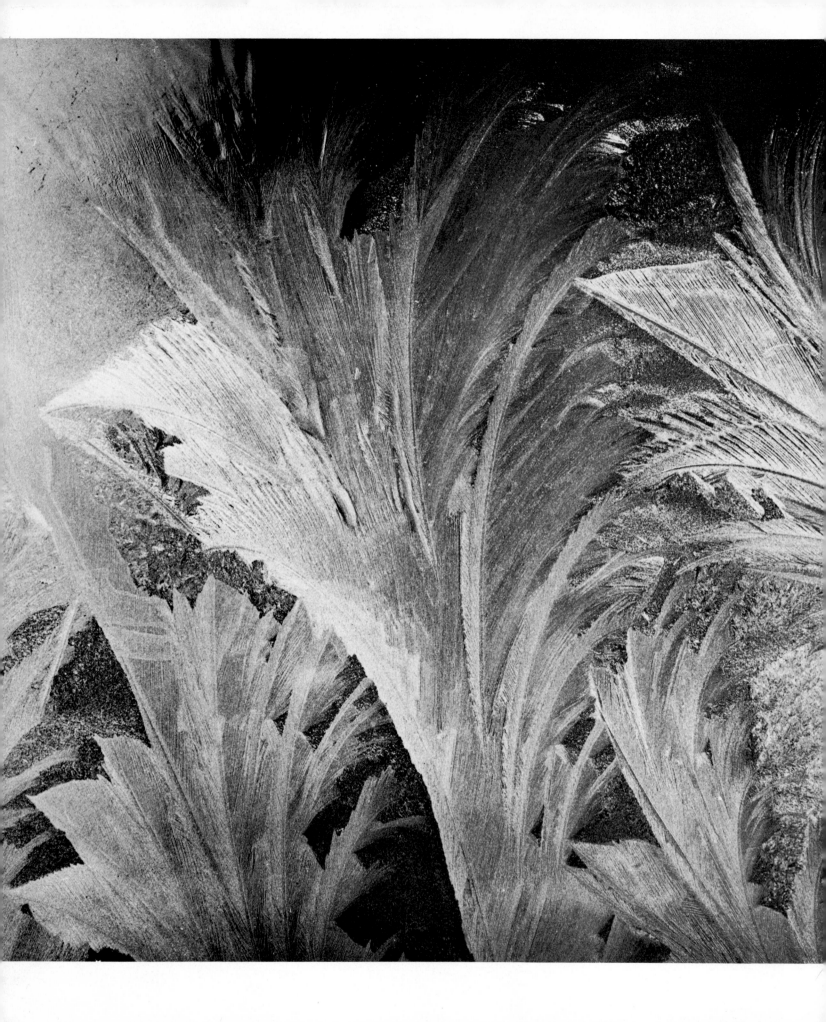

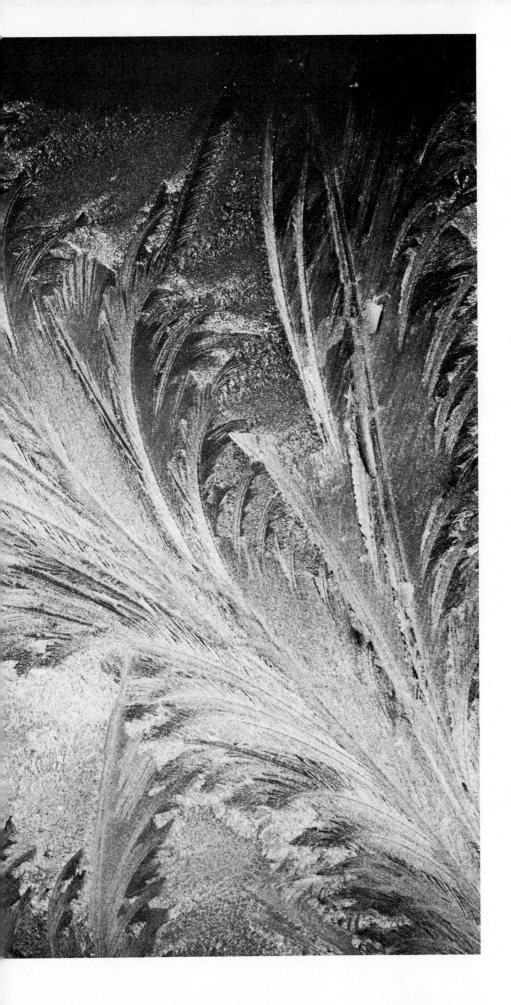

The pictures here and on page 103 show frost patterns on a window pane in 10× and 7½× magnification linear, respectively. The similarity to plant forms or feathers is thought-provoking and, when the photographs are studied carefully, rewarding.

On the following two pages are structures which, despite their plant-like appearance, consist of calcite, a mineral. These crystals grew in an open cavity by precipitation from solution, each crystal developing from a separate nucleus.

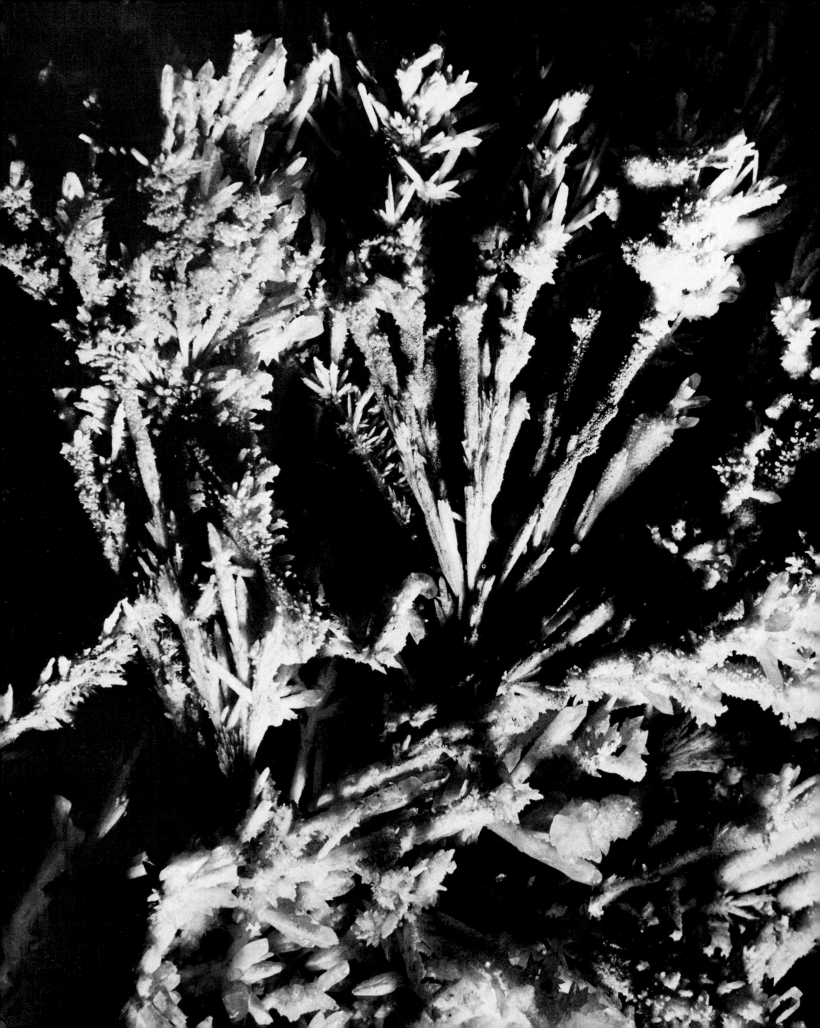

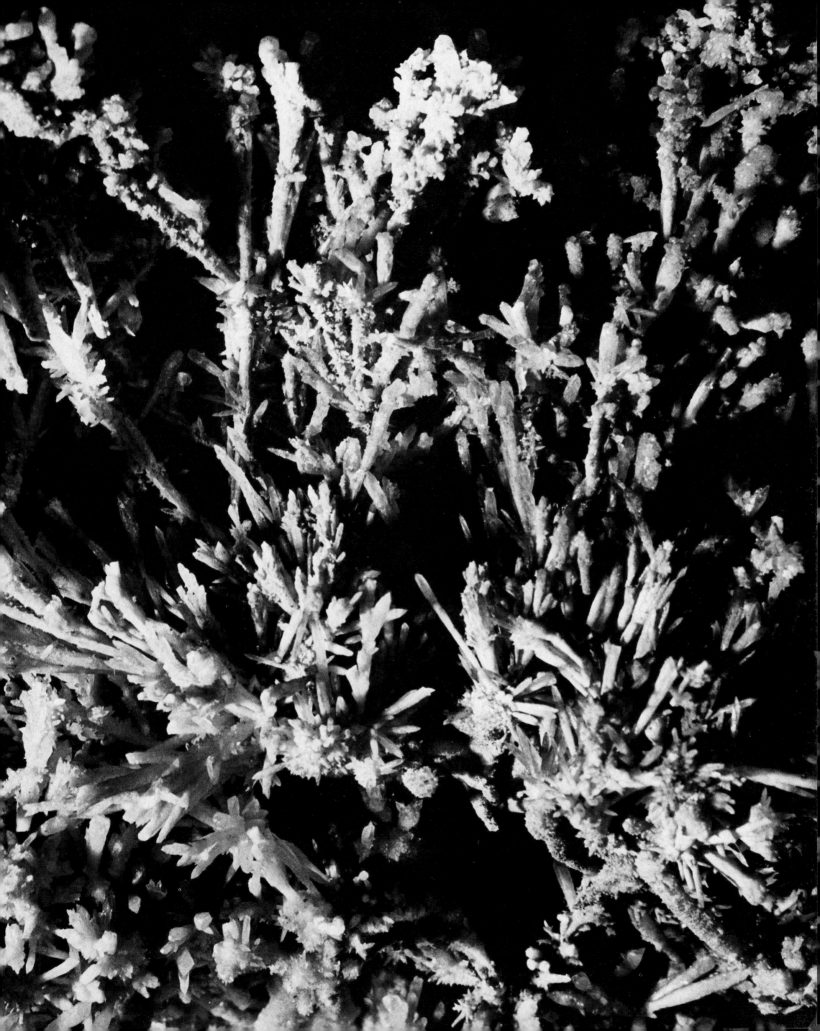

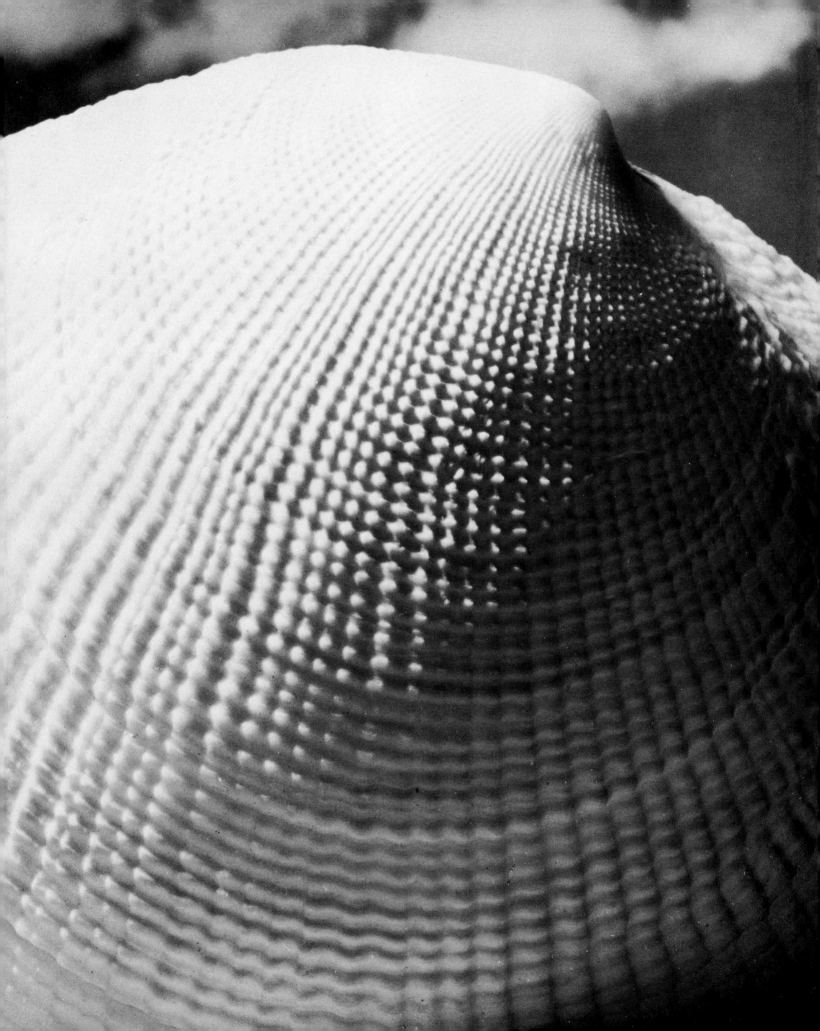

The mountains of the mind

Everything is relative, a matter of perspective. To an ant, a molehill is a mountain; to a man, it is a trifle; one kick and it is gone. Conversely, what is a mountain to us means nothing to an ant; the ant is not even aware that the mountain is there. Yet a stone the size of half a pea can be an object of enormous importance to a man—a mountain—if this stone happens to be a diamond (which, as far as the ant is concerned, is merely a minor boulder). It all depends not only on *who* looks at *what,* but also on *how* he looks at it. It is in this sense that in the following pages I present some objects of nature which I consider "mountains."

Seen on the beach by the average person, the shell depicted opposite is not particularly interesting. It is actually less than two inches across. From his height of five to six feet, the average person would hardly notice it if it were lying at his feet on a beach, and if he did, he would see it only in "people perspective." Here, however, the shell is shown not in human but in "shell perspective"— the perspective of the little creatures of the beach—making it look gigantic; it suddenly acquires the monumentality of a mountain. In addition, it also reveals details of unexpected beauty too fine to show clearly under "normal" viewing conditions. The gain, of course, is ours. Thanks to the magnifying power of the lens, we now can see something which we couldn't have seen before because of limitations inherent in our vision. But let's not forget that there are two ways of seeing—with the eyes and with the eye of the mind; often, the first kind of vision leads to the second. If this is the case, seeing can lead to contemplation and stimulation, which in turn can give us insight and thereby help us scale new mountains of the mind.

The following pages contain photographs of small objects of nature which bring to mind landscapes, mountains, and caves. Resemblances of this kind are, of course, entirely fortuitous. But, like semi-abstract paintings, photographs of this kind stimulate the receptive mind and give wings to the imagination. However—and this is true of any work of art—the viewer can get out of these pictures only what he sees in them. Whether or not they will give him pleasure, stimulation, and insight therefore depends entirely on him.

I am occasionally asked: what is the meaning of these pictures? To which I can only reply: what is the meaning of art? Not that I am presumptuous enough to believe that my photographs are "art." That is beside the point and also of no interest to me because, no matter whether or not a photograph can be art, my pictures must speak for themselves. No—the reason I make this kind of photograph is probably the same that compels a painter to paint: I am attracted by the subject, I see in it something that moves me, I want a record of it, and I wish to share my experience with other people.

I am also romantic, and my imagination sometimes gets the better of me. Being able to see in the form of a shell the shoulder of a snow-covered mountain requires imagination—and being blessed with this quality, I want to kindle its flame in others. Why? Because a mind that can perform the transformation from a shell to a mountain is creative; it is capable of ridding itself of prejudices and able to give its possessor a degree of insight inaccessible to other, imaginatively less gifted minds.

Imagination, however, is often latent in people who might not even know they possess this magic quality. To awaken it is the purpose of this book. Because imagination is freedom of the mind, an absence of preconceptions, the courage to be different if a situation demands it. Imaginative people live richer lives than unimaginative ones. They are capable of deriving joy and stimulation from things which to others seem ordinary, valueless, and dull—a broken shell, a fallen leaf, a piece of common rock. They find beauty where others see nothing but drabness. They are spiritually awake and able to reach the summits of thought, while others, though physically awake, are mentally asleep.

The picture on the opposite page shows a polished slice of brecciated limestone from Italy called "ruin marble." Magnification is 4× linear. I see in it in miniature a cross section of the crust of the earth complete with fracture planes, faults, and grabens, not to forget the sky, which here, of course, is also stone. This is not merely an analogy but a true small-scale replica of conditions as they might exist in the interior of a real mountain.

110

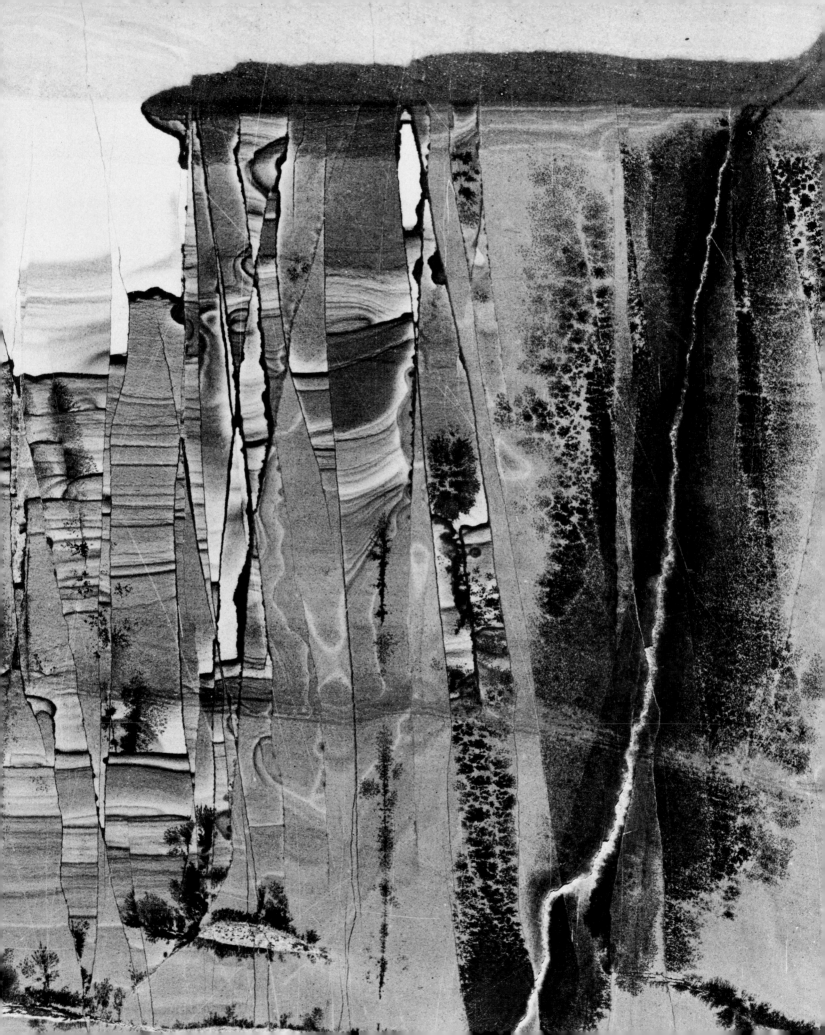

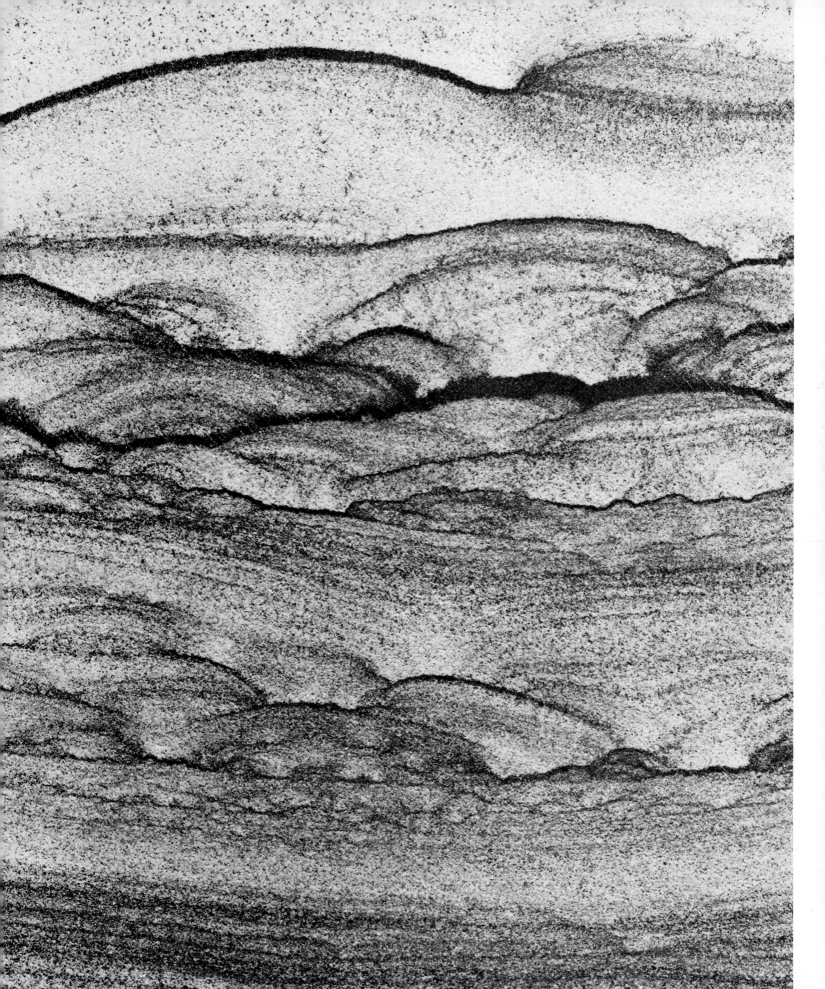

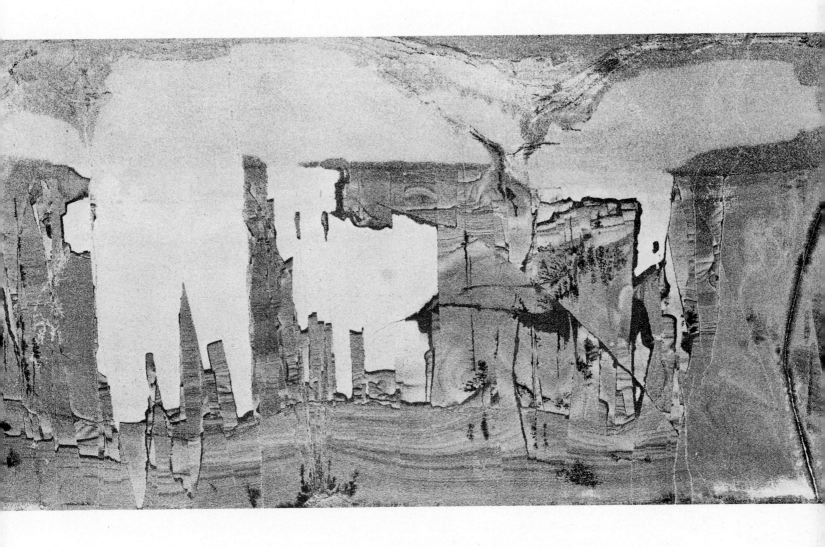

This is the reverse side of the slice of "ruin marble" shown on pages 136-137, ground but not polished. The effect is that of a still more devastated landscape shrouded in early-morning mist.

Rolling hill country in California? Pastureland in the foothills? No—it's a slice of sandstone ground flat and photographed in my studio. The pattern that resembles hills is caused by diffusion through the stone of iron-bearing solutions which advanced at different rates along different fronts, depositing varying amounts of iron oxide. Magnification is approximately 2× linear.

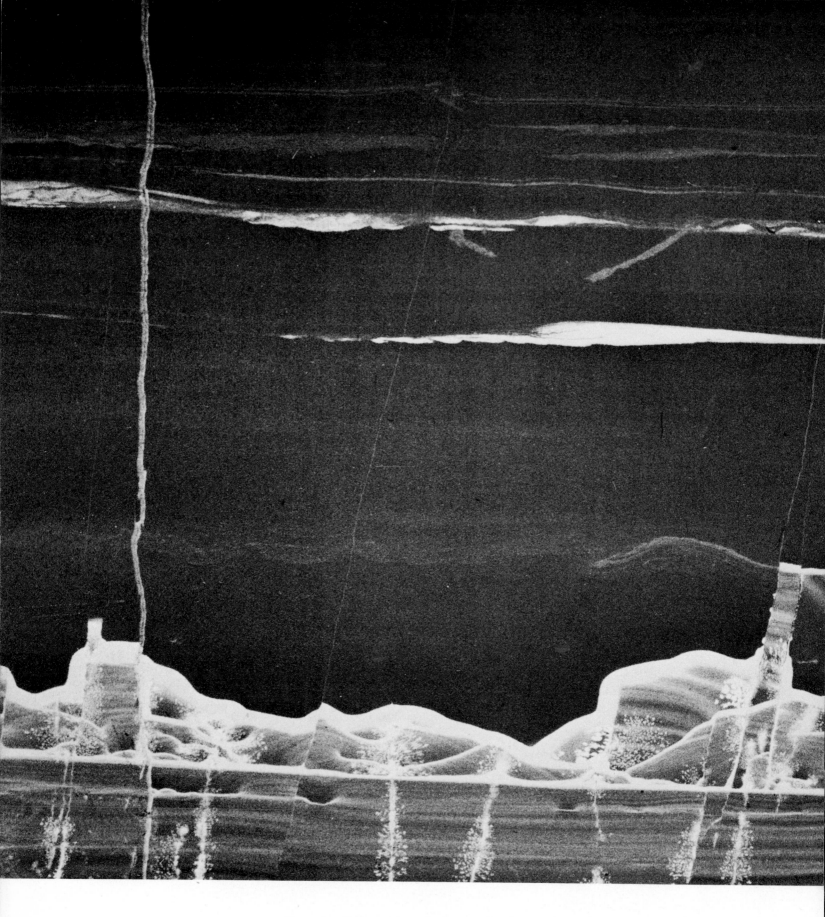

Brecciated limestone shown in the form of a negative print. Magnification is

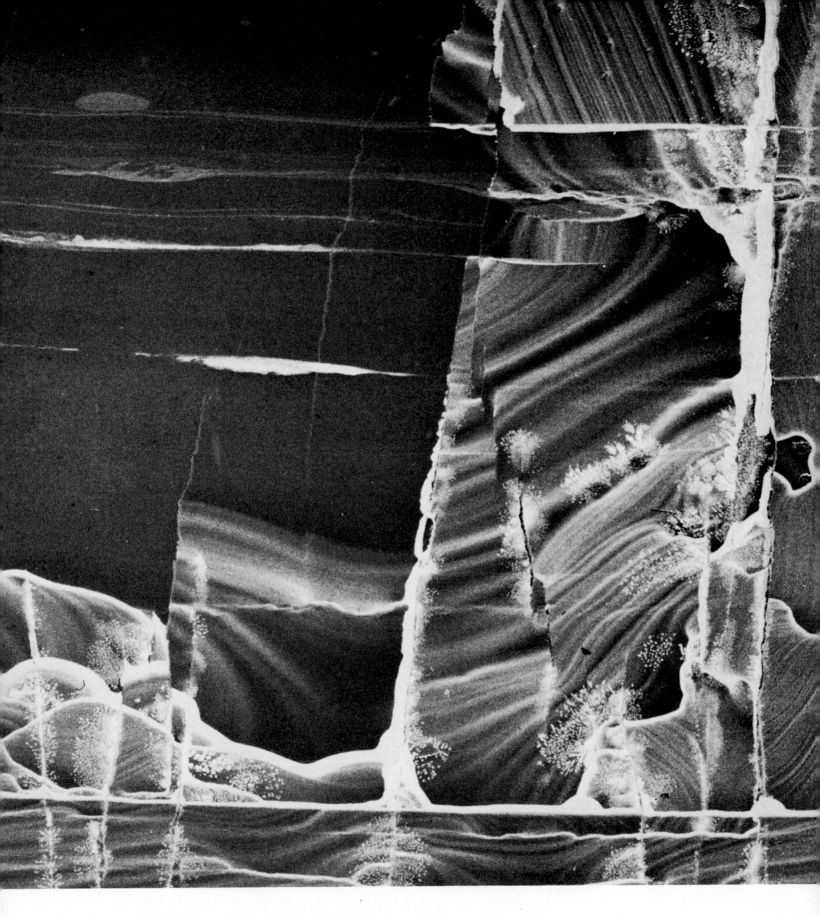

3.6× linear. Nightfall over the buttes and mesas that rim a valley on Planet X?

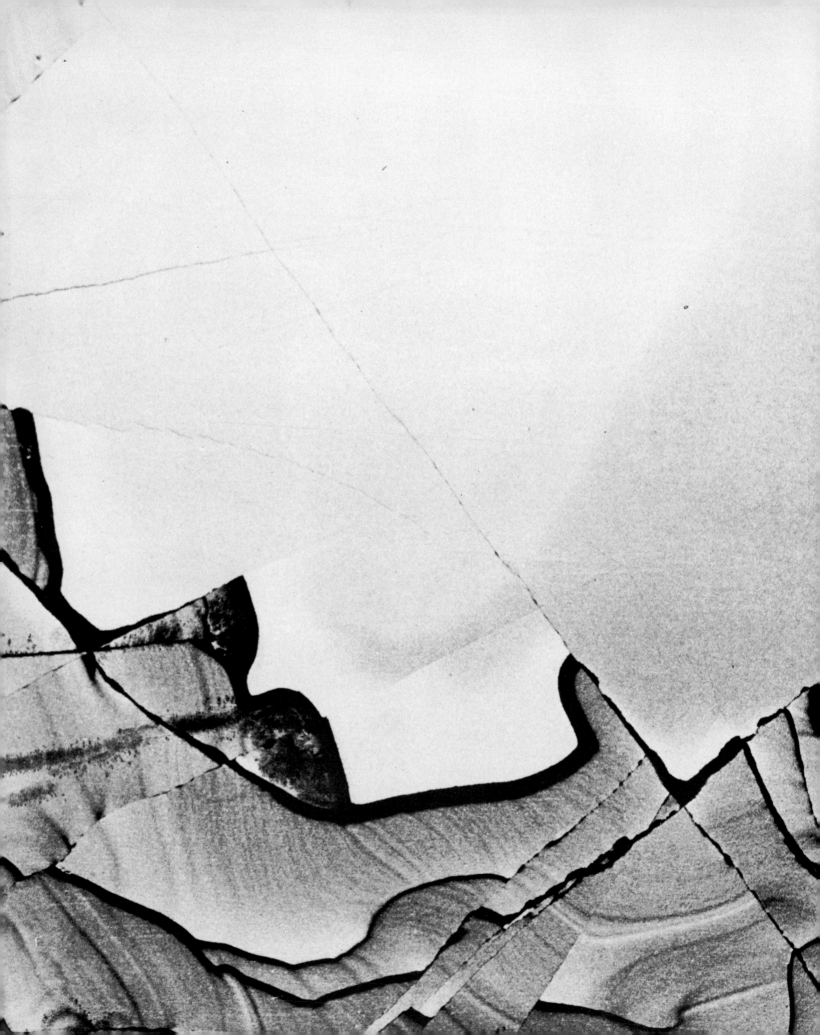

Brecciated limestone, magnified approximately 3½× linear. A chaotic landscape of fracture planes and tumbled rocks, the aftermath of an earthquake? I see violence in this picture, but also organization and beauty, as in a work of modern abstract art.

117

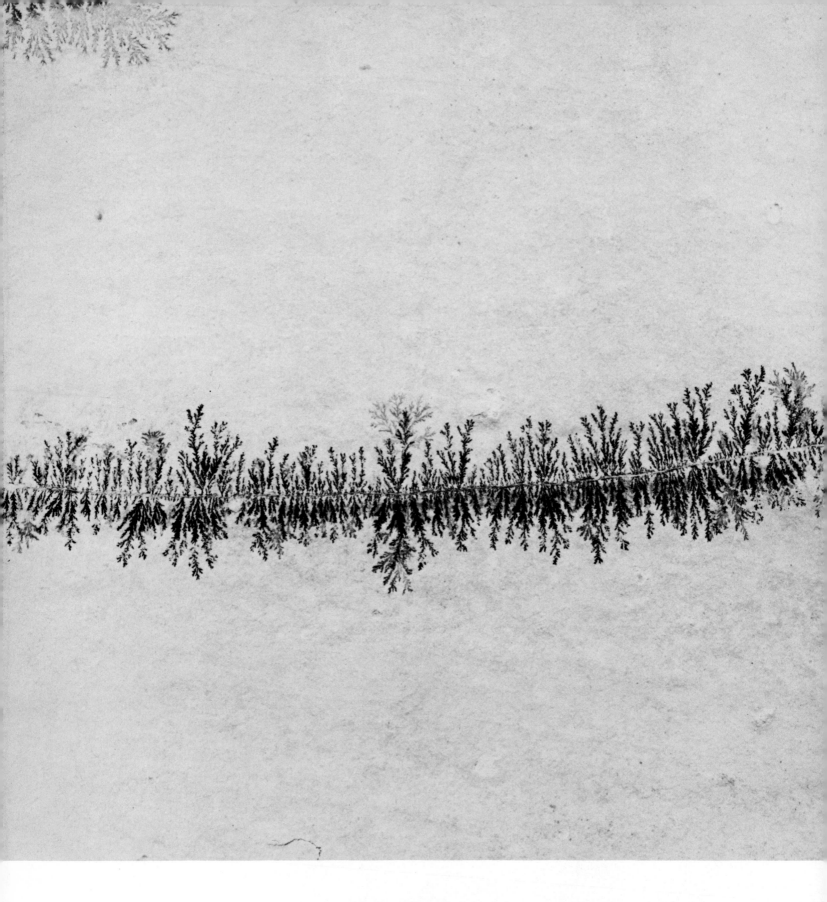

Dendrites spreading from a crack in sandstone form a pattern
which creates the illusion of plants growing along the shore

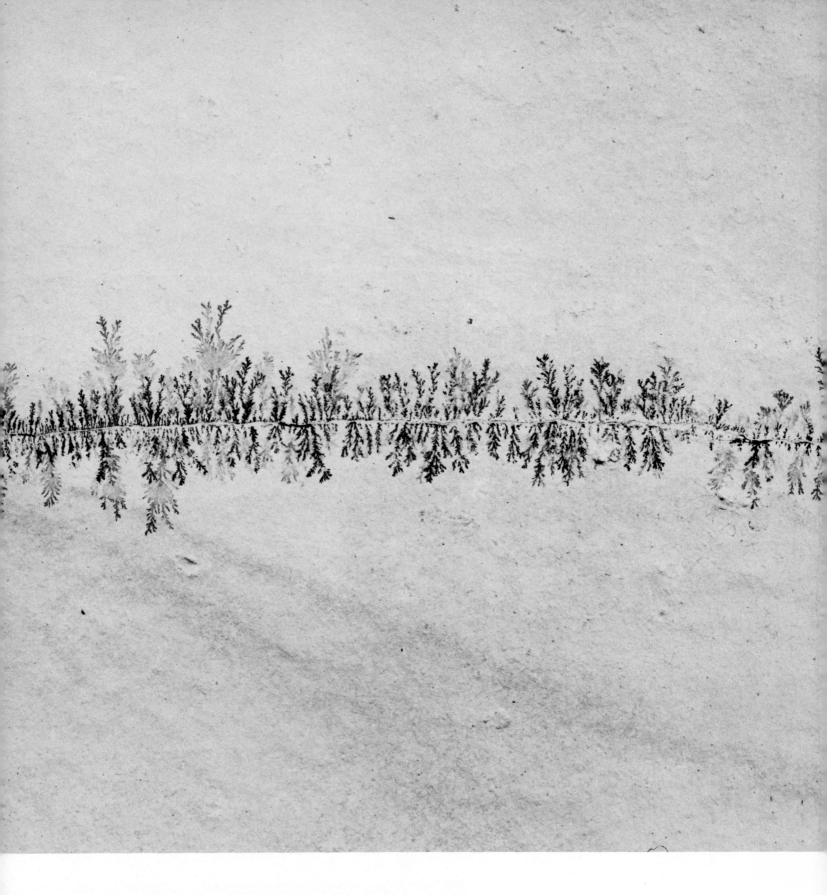

of a pond and reflecting in its water. A peaceful, thought-provoking scene where plants, water, and sky are stone.

Cross section through an amygdule—a gas cavity (vesicle) in an igneous rock filled with a secondary mineral—here, chalcedony. Magnification is 4× linear. I see in it a primeval seascape emerging from chaos, vapors above the water, a glimpse of things to come.

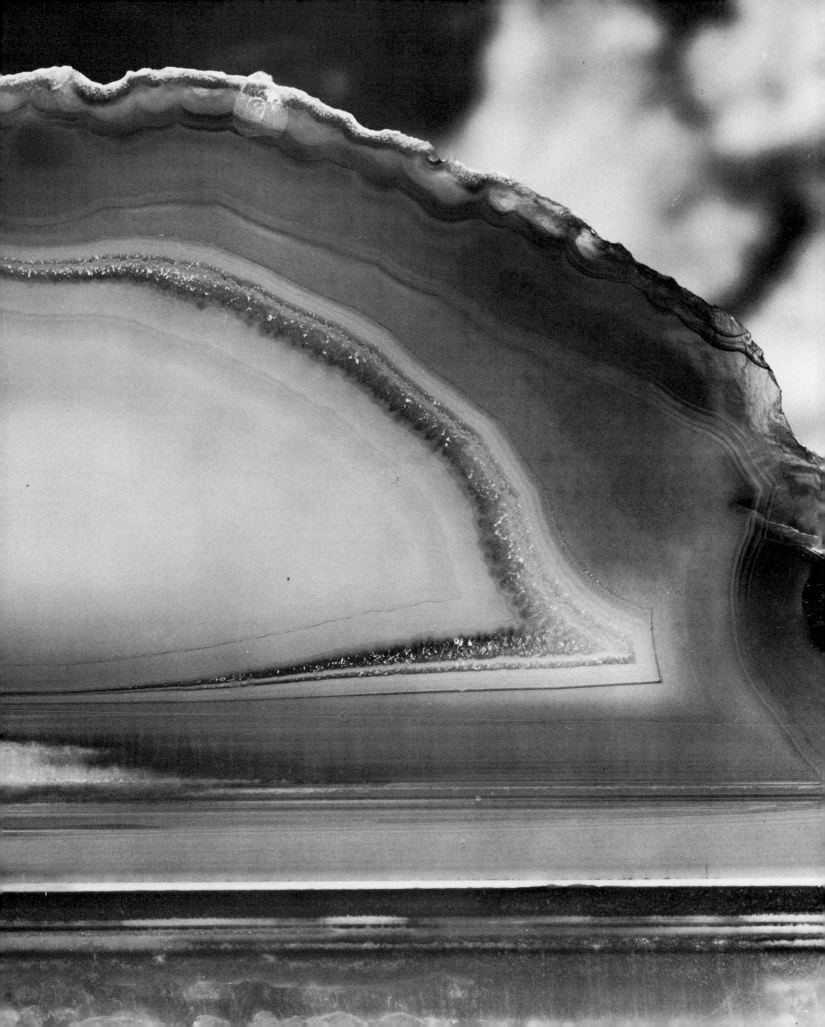

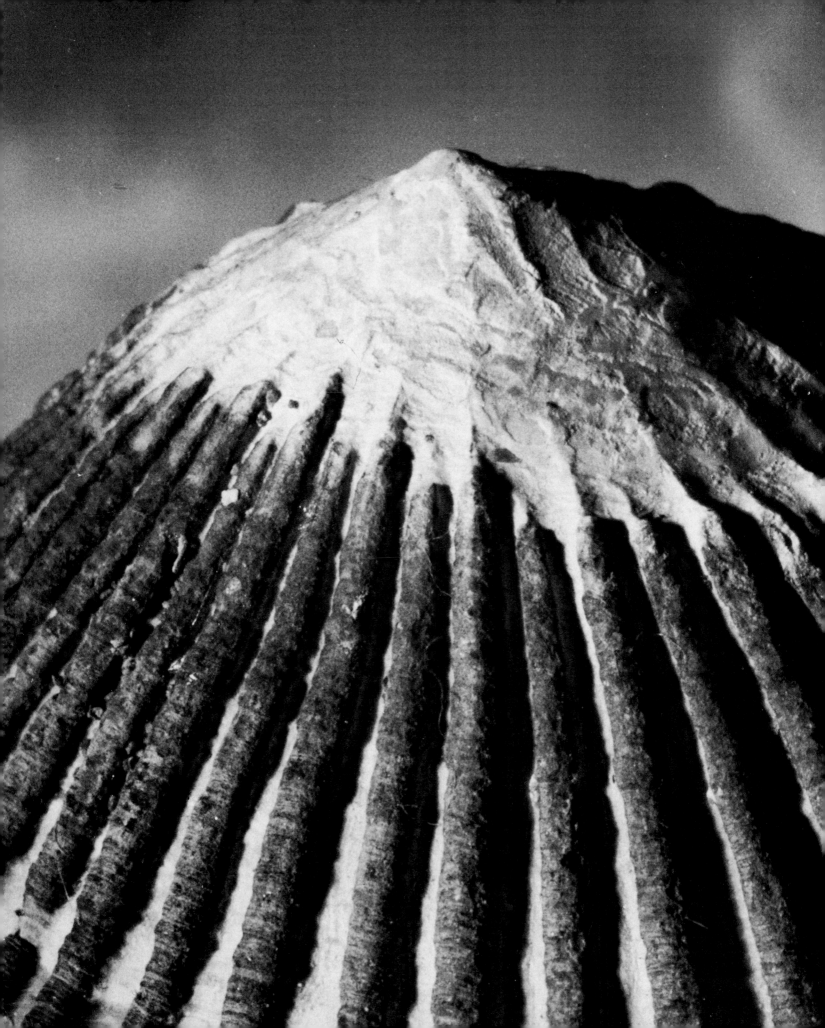

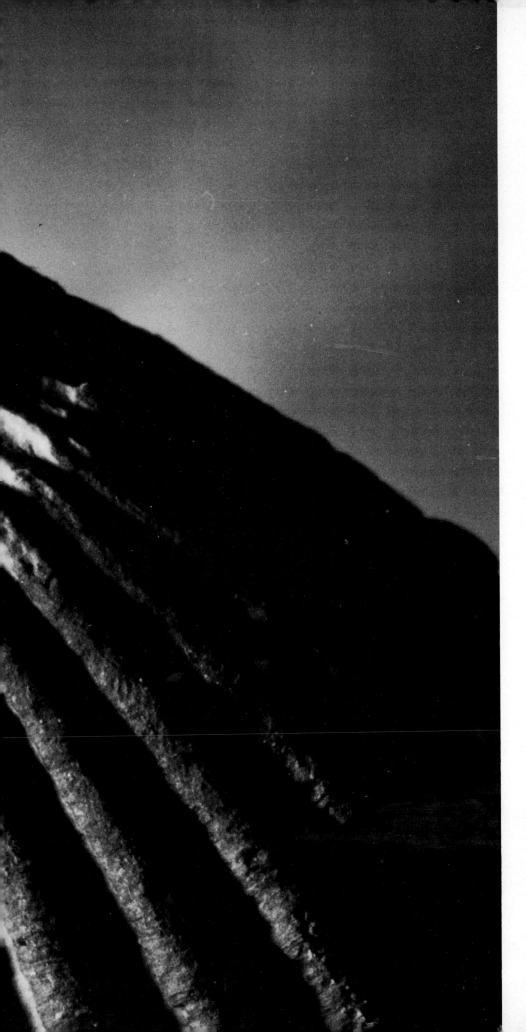

A shell — a Hawaiian limpet (*Cellana exarata* Nuttall) shown here magnified 9.2× linear. I see with my mind's eye the mighty cone of a volcano, a newly fallen snow covering the summit, and hear the lordly names: Vesuvius, Fujiyama, Aconcagua.

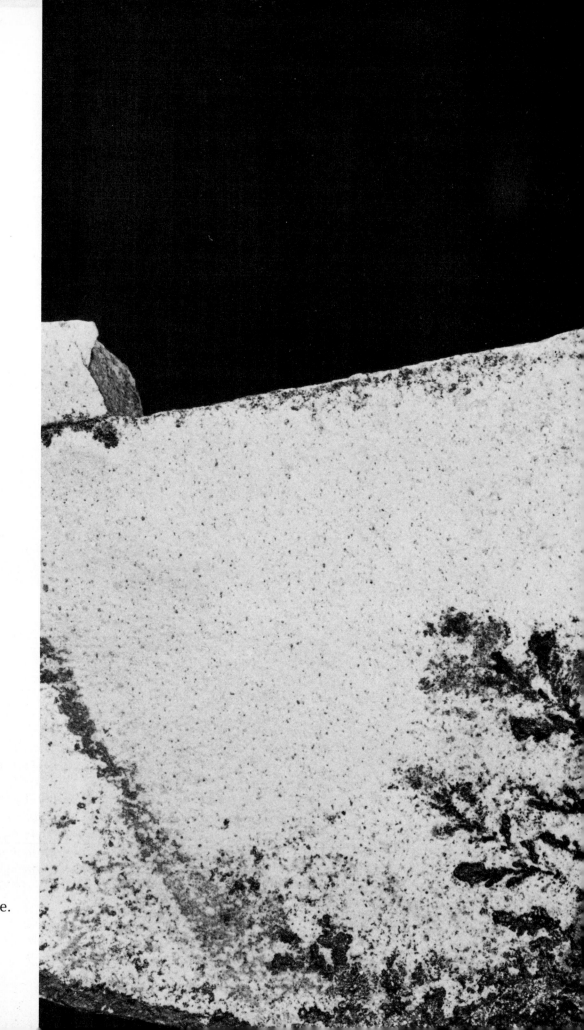

Dendrites resembling miniature trees stand in front of a snow-covered mountain under a midnight sky, a vision from another world. Actually, of course, both "trees" and "mountain" lie in the same plane—the fracture plane of a stone.

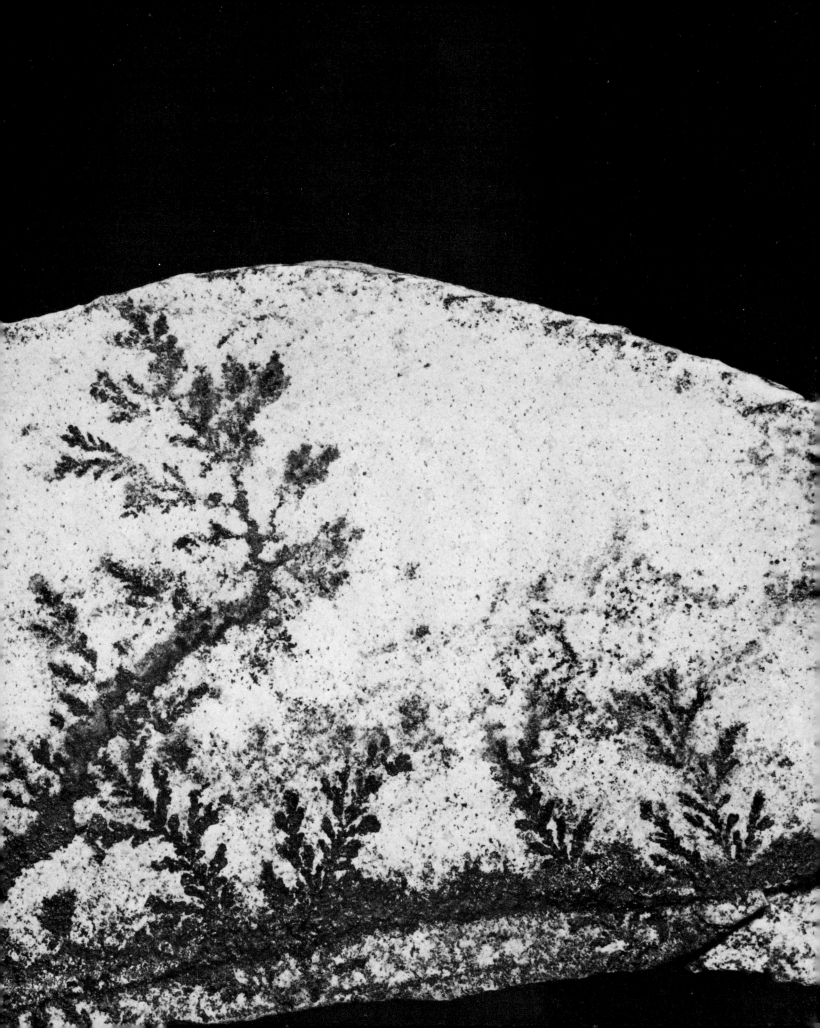

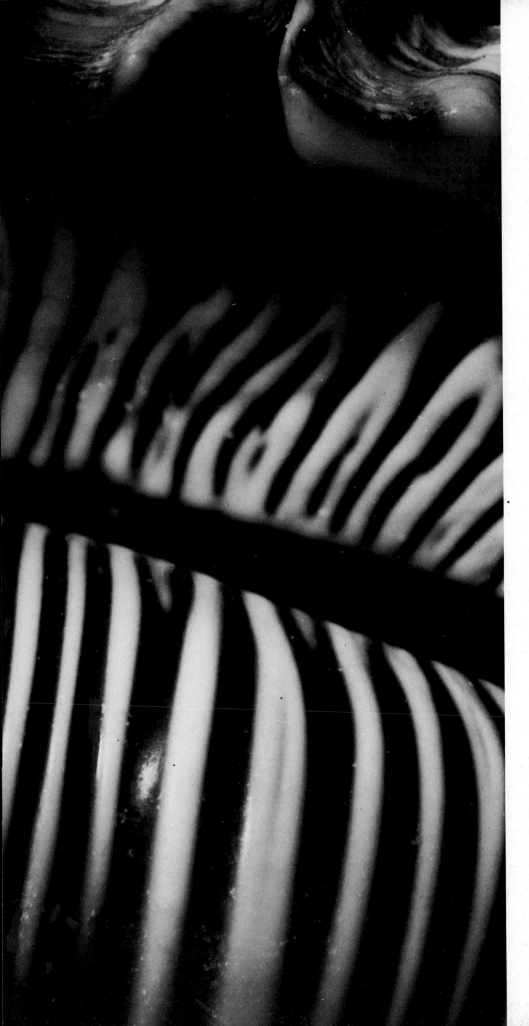

The aperture of a Spider shell
(*Lambia chiragra* Röding),
magnified approximately 9 × linear
The entrance to a magic cave
deep in the forest of
fairyland?

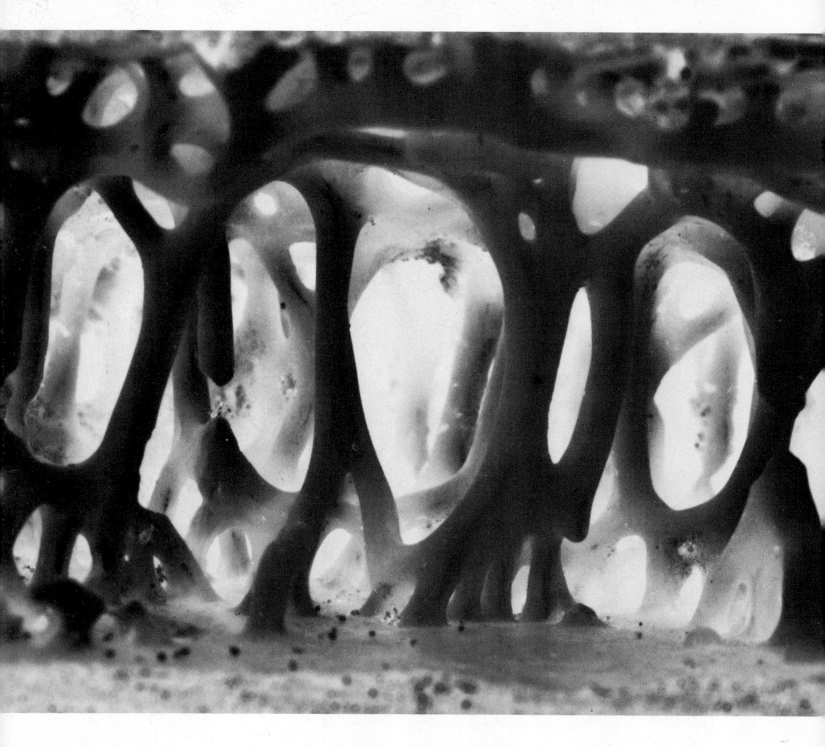

Above: The space between the dorsal and ventral carapaces of a horse-shoe crab near their juncture, shown here in a negative view magnified 10× linear. I see a jungle of banyan trees at night, or stalactites and stalagmites in a cave, mysteriously transluminated from within.

A thin slice of agate seen in transmitted light. Magnification is 11× linear. A promonotory and an ice-filled sea, a strange and ominous sky—on Planet X?

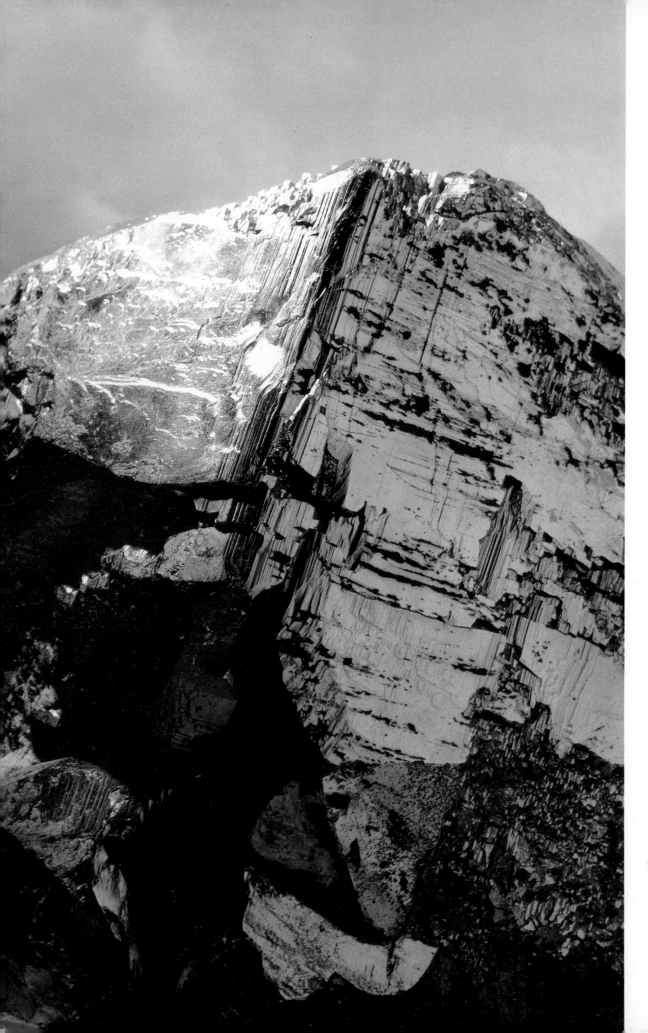

Left: Not a mountain of gold, but a close-up of a large crystal of pyrite.

Right: Brecciated limestone. The ''sky'' is also a part of the stone.

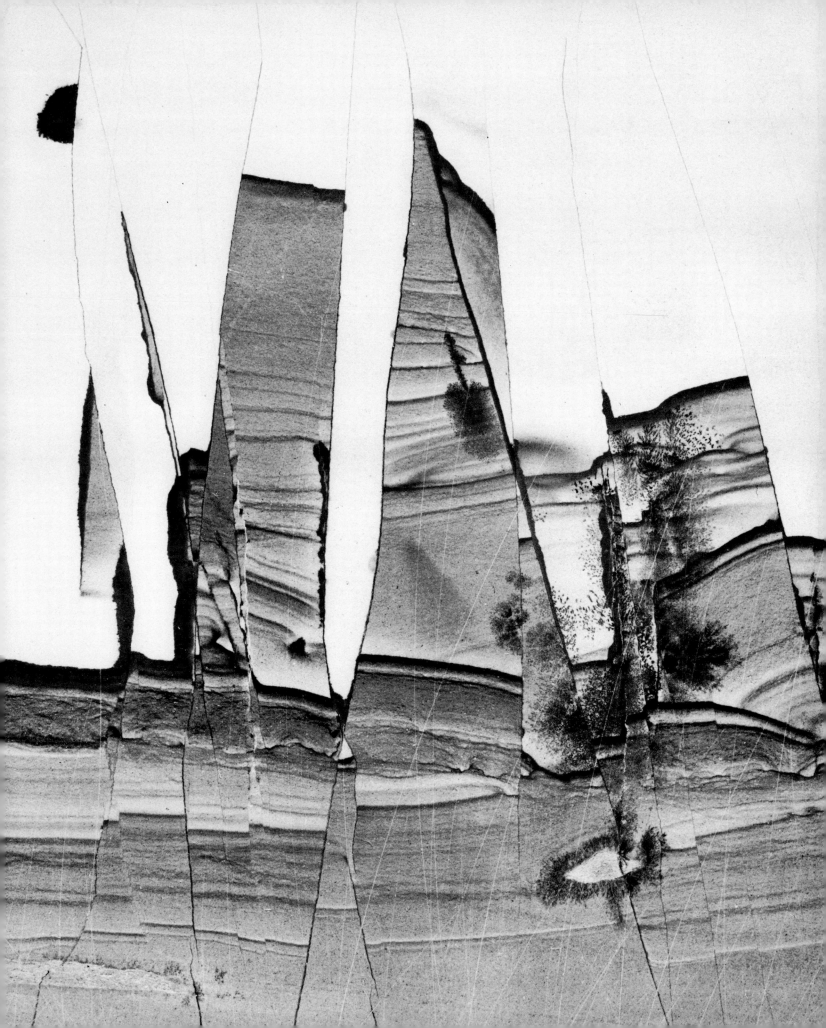

A thin slice of polished chalcedony seen in transmitted light, magnified 17× linear. This is the same specimen as that shown on page 129, transluminated from a different direction. As a result, due to polarization by the fibrous structure of the mineral, the colors are different, now giving the impression of a hot and sultry sky above a cool blue sea.

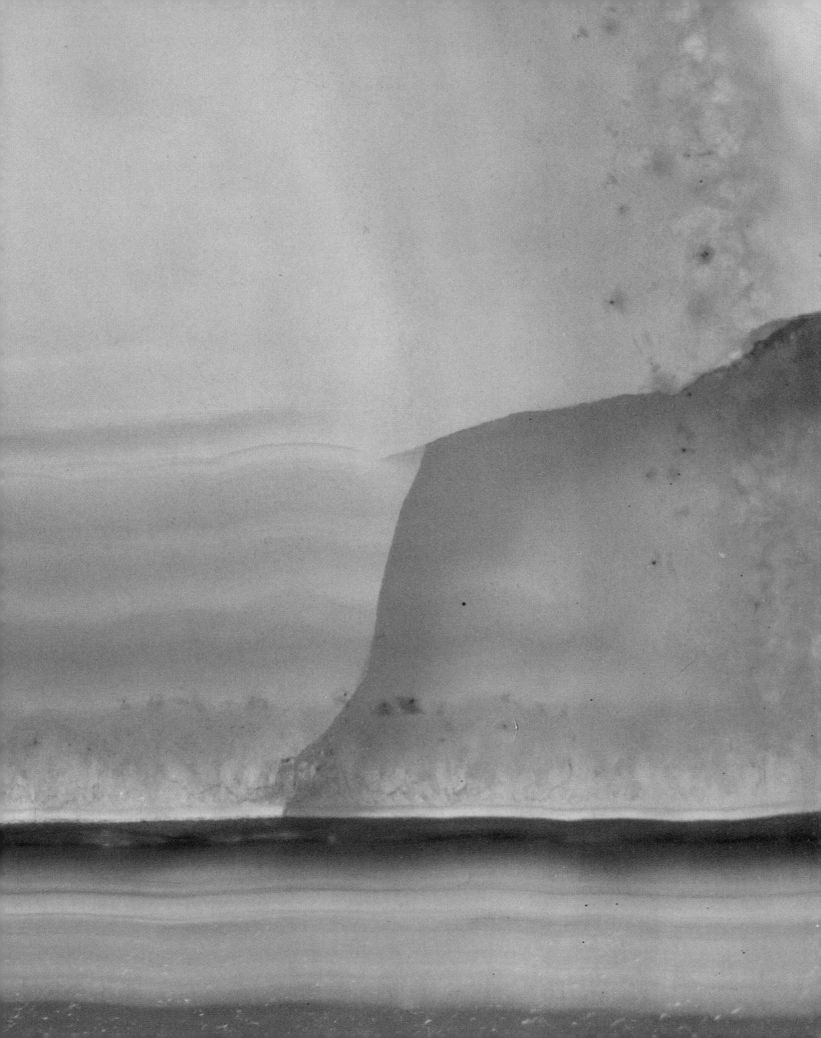

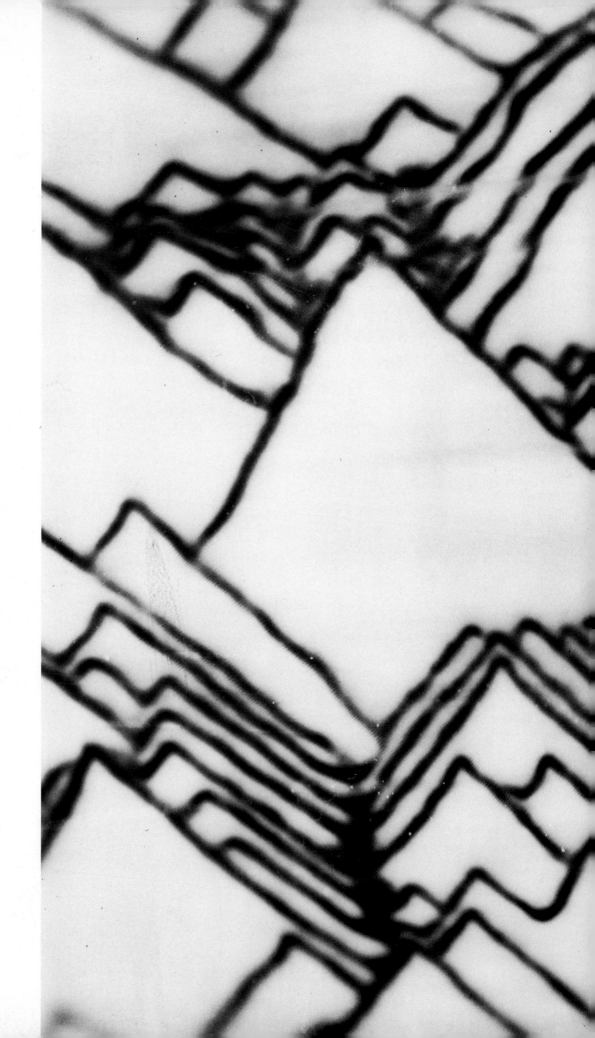

Detail of the shell of a Tent Olive or Royal Purple shell (*Oliva porphyria* Linné).

I see icebergs drifting in a polar sea, stacked row upon row in a space-compressing tele-perspective.

Overleaf: Ruin marble from a quarry near Florence, Italy. Magnification is 3½× linear. Shades of Piranesi. . . .

134

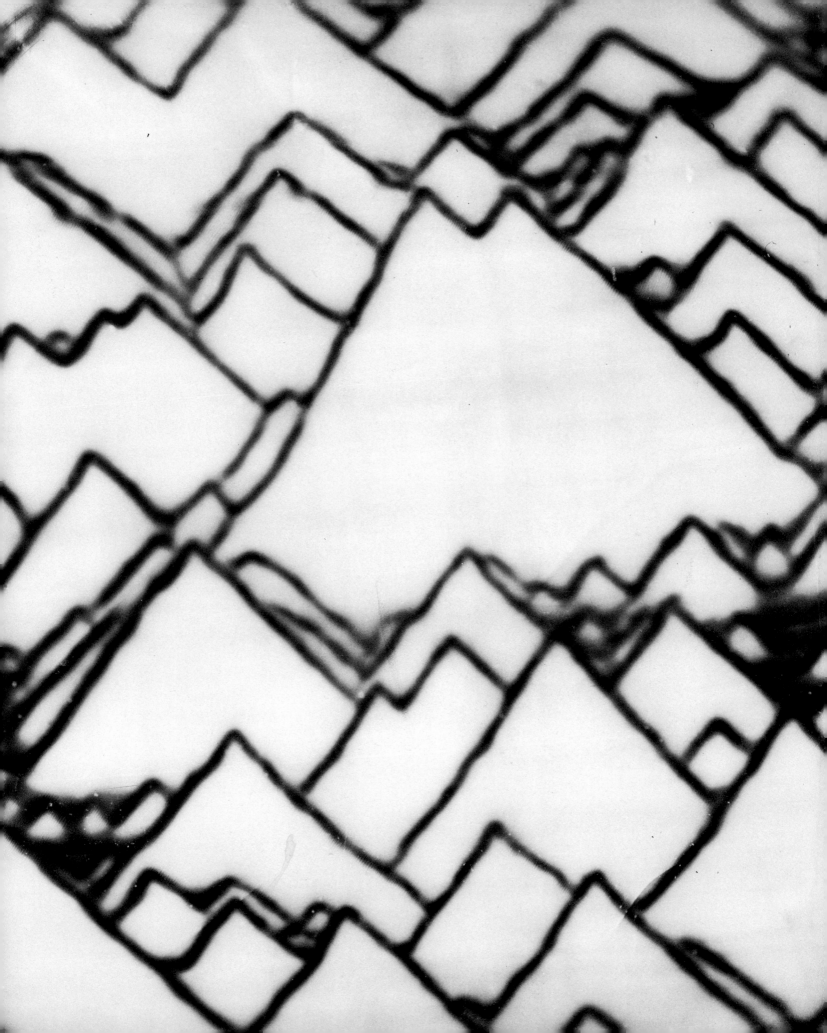

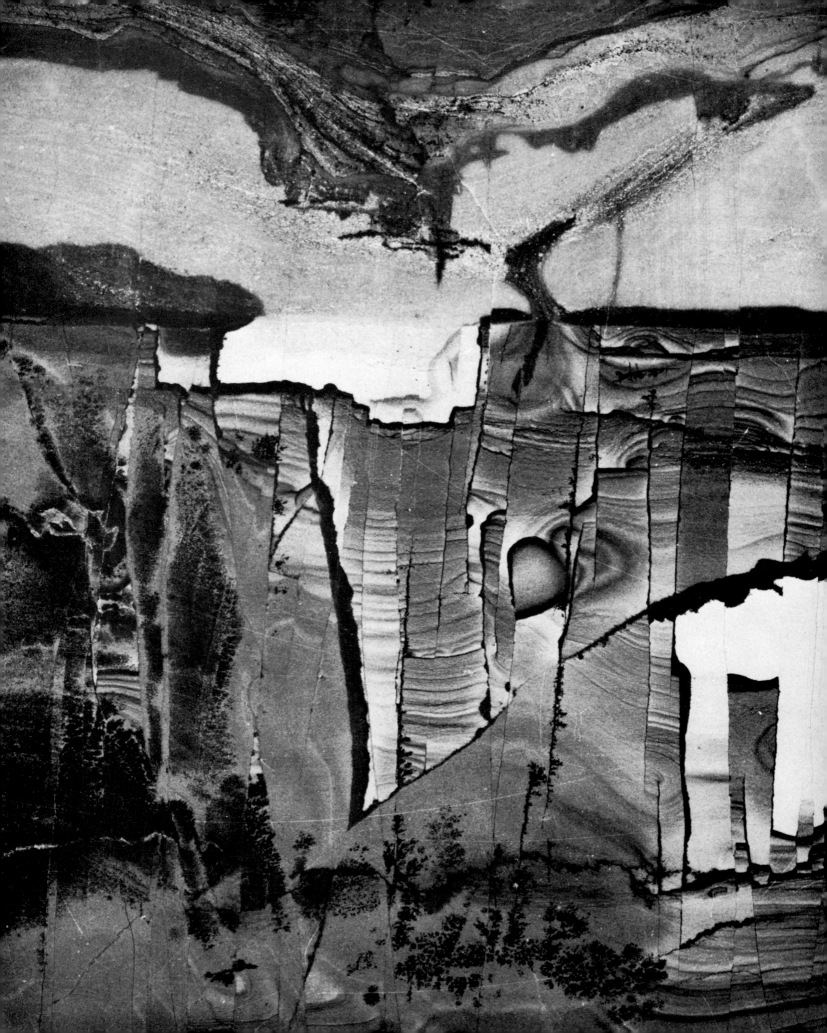

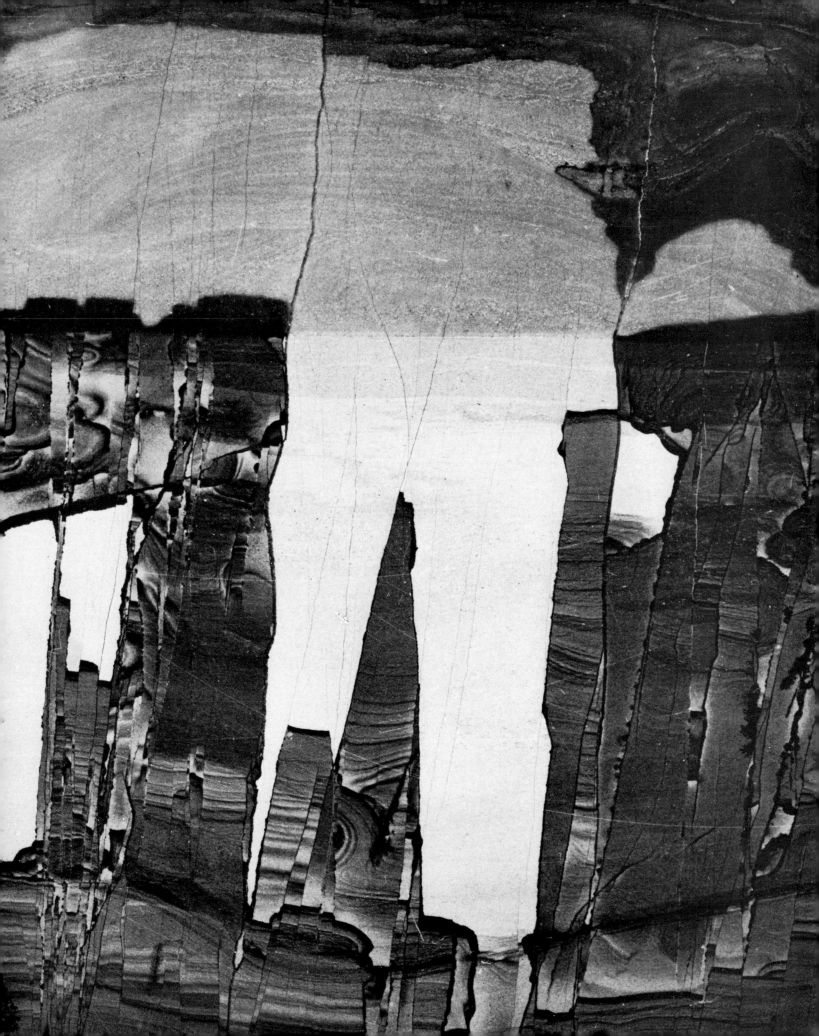

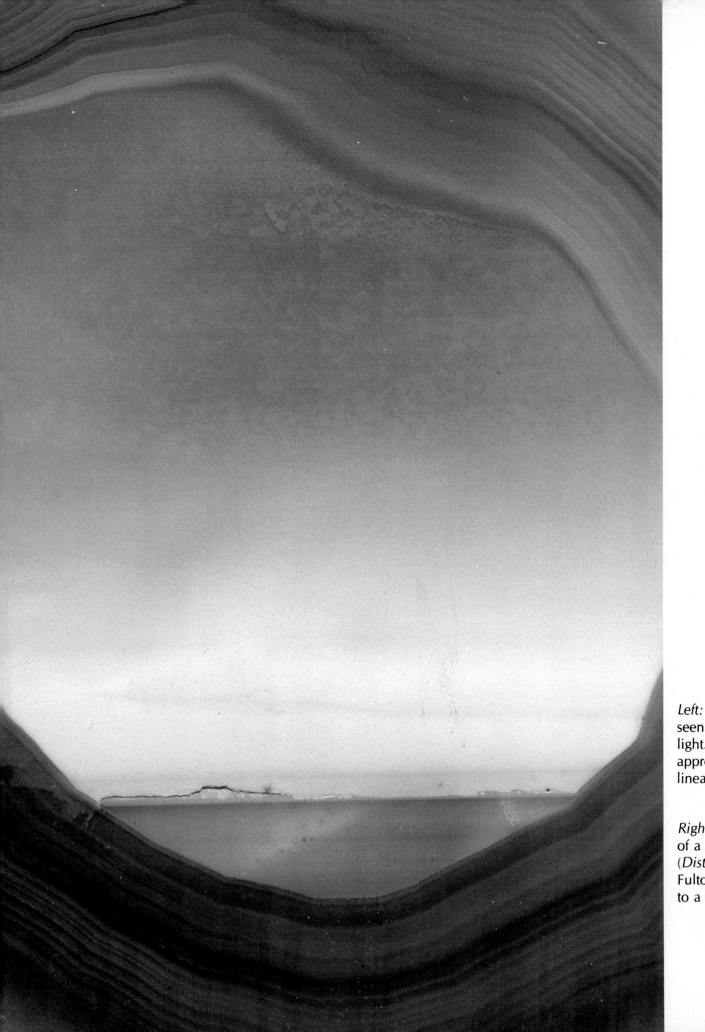

Left: A slice of agate seen in reflected light. Magnification is approximately 5× linear.

Right: The aperture of a shell from Japan (*Distorsio perdistorta* Fulton). The entrance to a sacred cave?

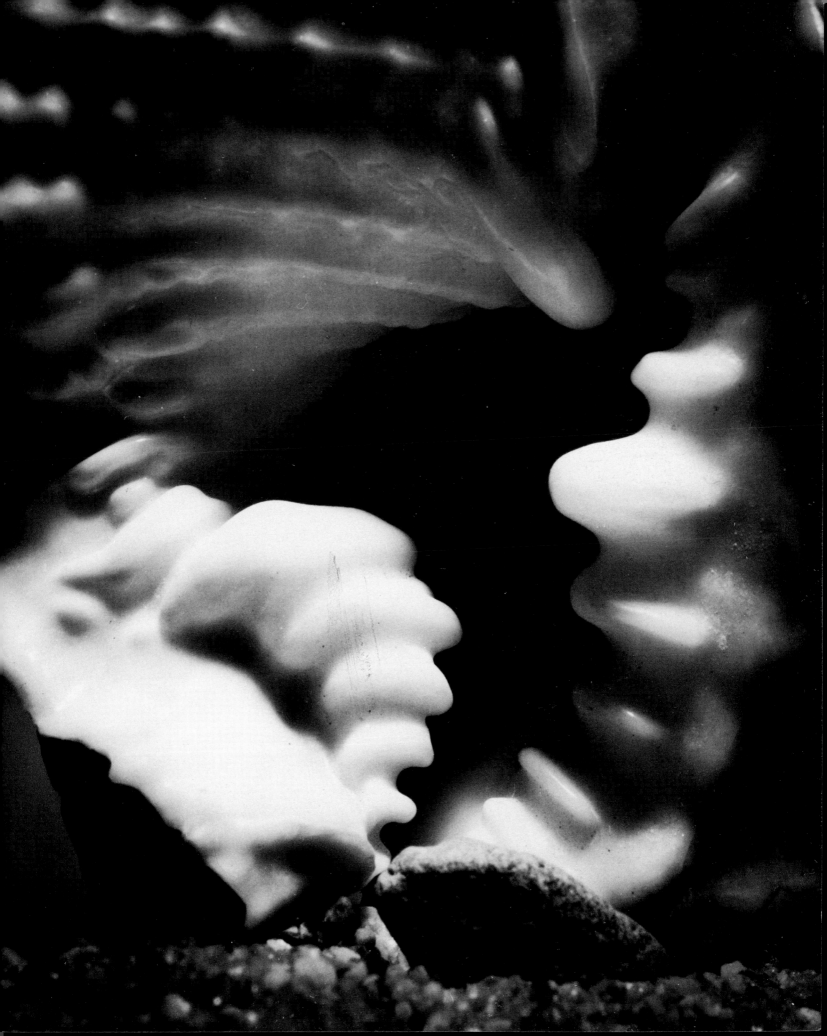

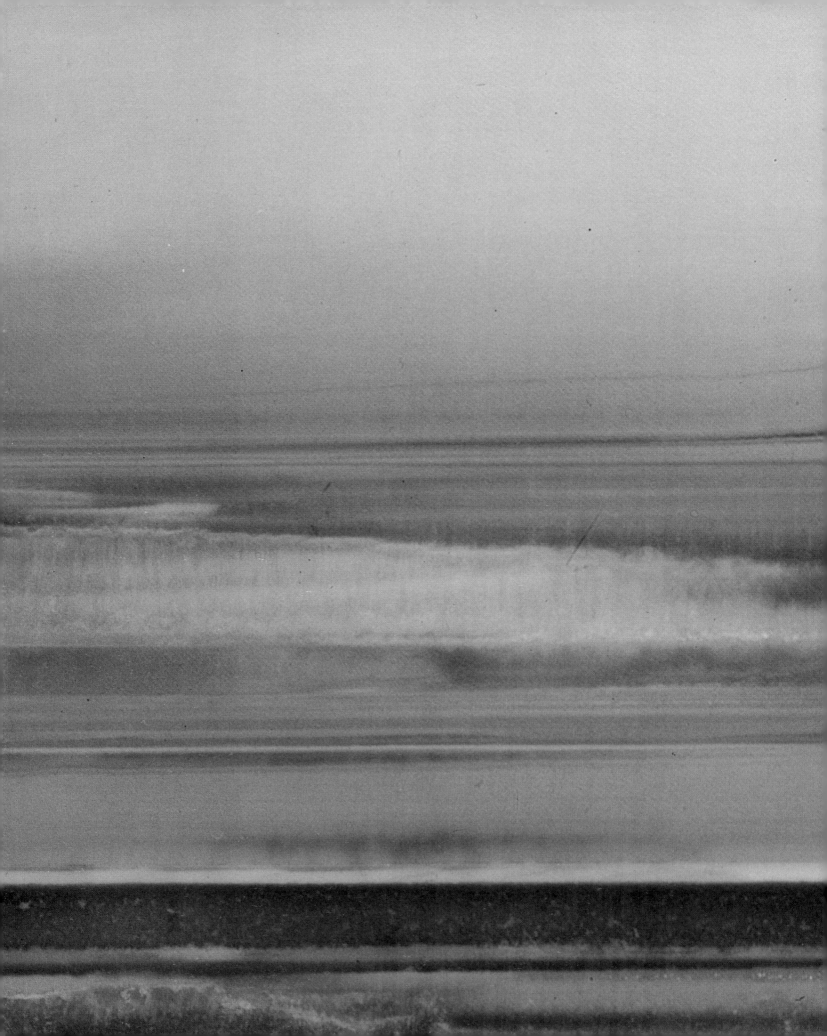

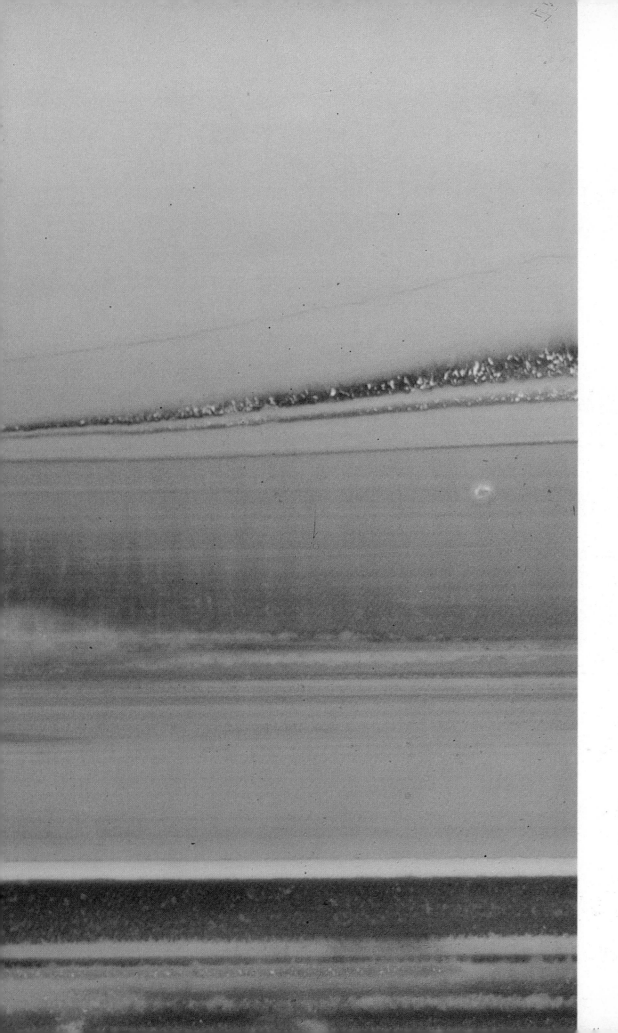

A polished slice of agate shown in reflected light. Magnification is approximately 5½× linear. A view across an unknown sea?

These two photographs show thin slices of mica with inclusions of hematite (red) and pyrolusite (black) seen in transmitted light. Magnification is approximately 1½× linear. The orderly arrangement of the designs is due to the crystalline structure of the mica, but the variety of detail of execution is infinite.

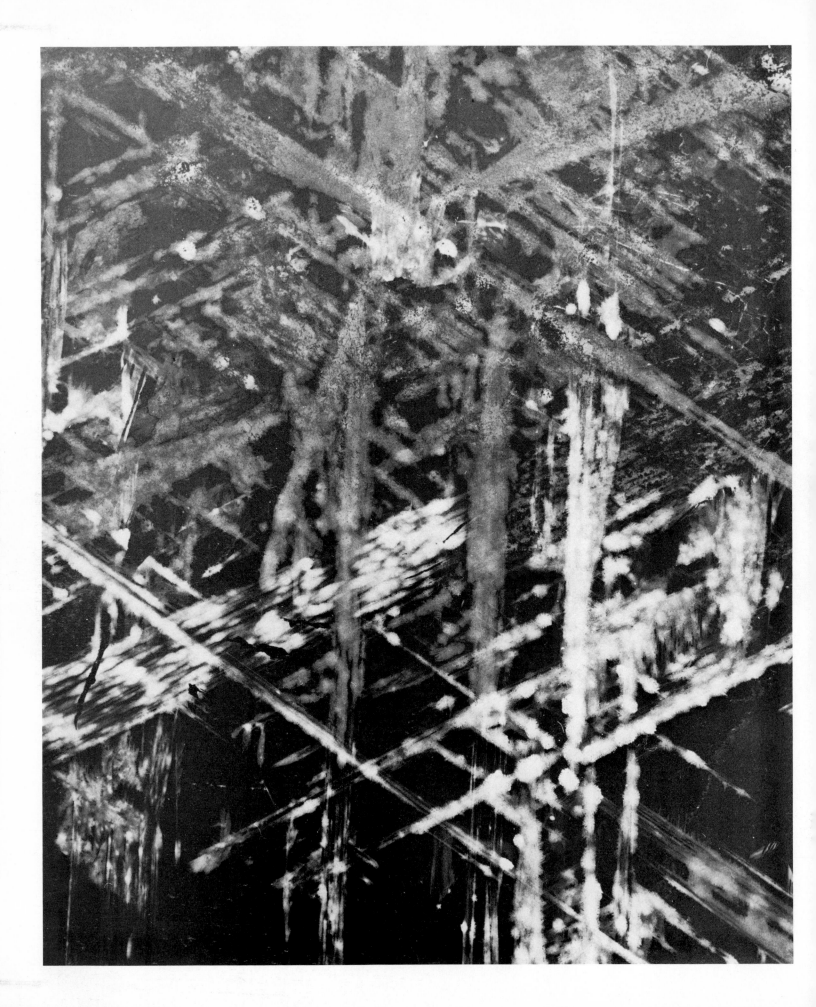

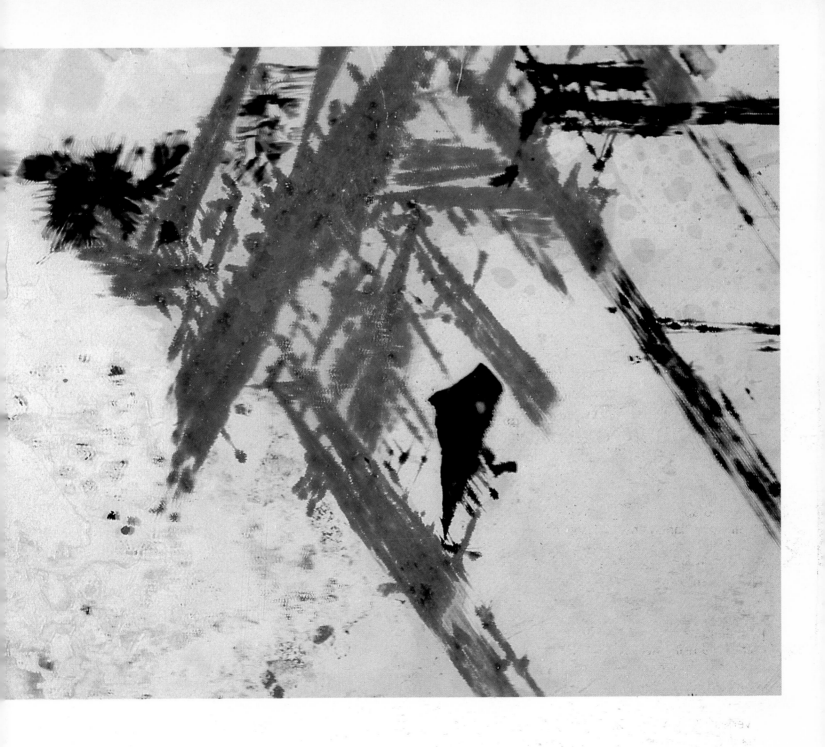

Mica with inclusions of hematite and pyrolusite. Contemplating these beauti-
tiful abstractions, I cannot help but wonder to what extent modern abstract
artists are influenced by conscious observation of this kind of natural design.

Brecciated limestone, magnified approximately 4× linear. A landscape, superficially similar to that shown on pages 116-117 and yet how different. There, chaos and violence; here, serenity and calm, a summer cloud rising near the horizon—a cloud of stone.

Overleaf: A thin slice of chalcedony seen in transmitted light. Magnification is approximately 6½× linear. A dramatic sunset in a dramatic landscape not of this world.

A finely ground slice of sandstone infiltrated by solutions of iron oxide, magnified 1.3× linear.

Rolling foothill country, a summer sky, a gentle breeze. The only question is: Where?

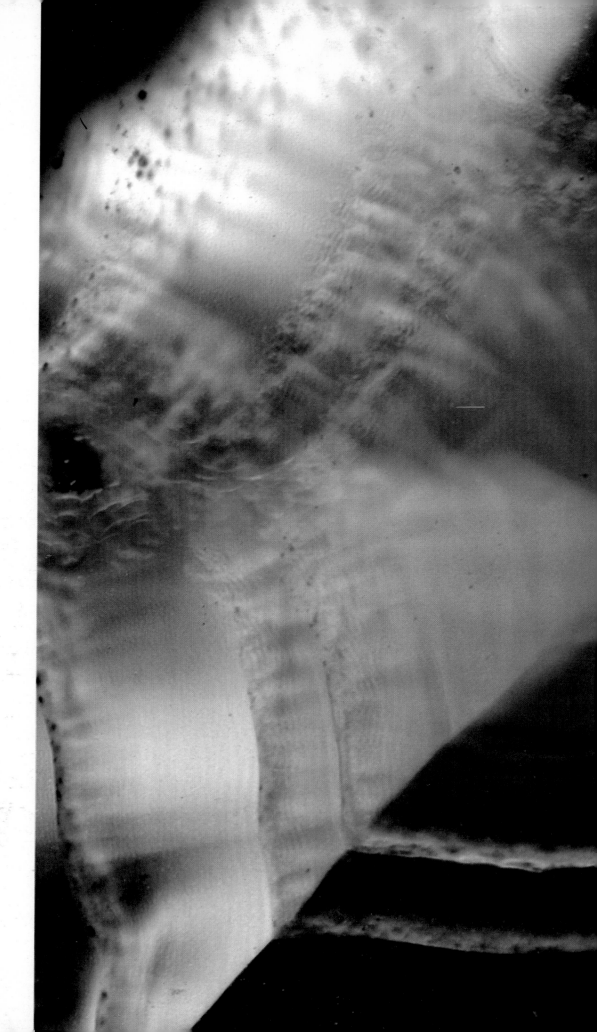

A thin slice of chalcedony shown in transmitted light, magnified approximately 6× linear. I see an erupting volcano belching fire and smoke.

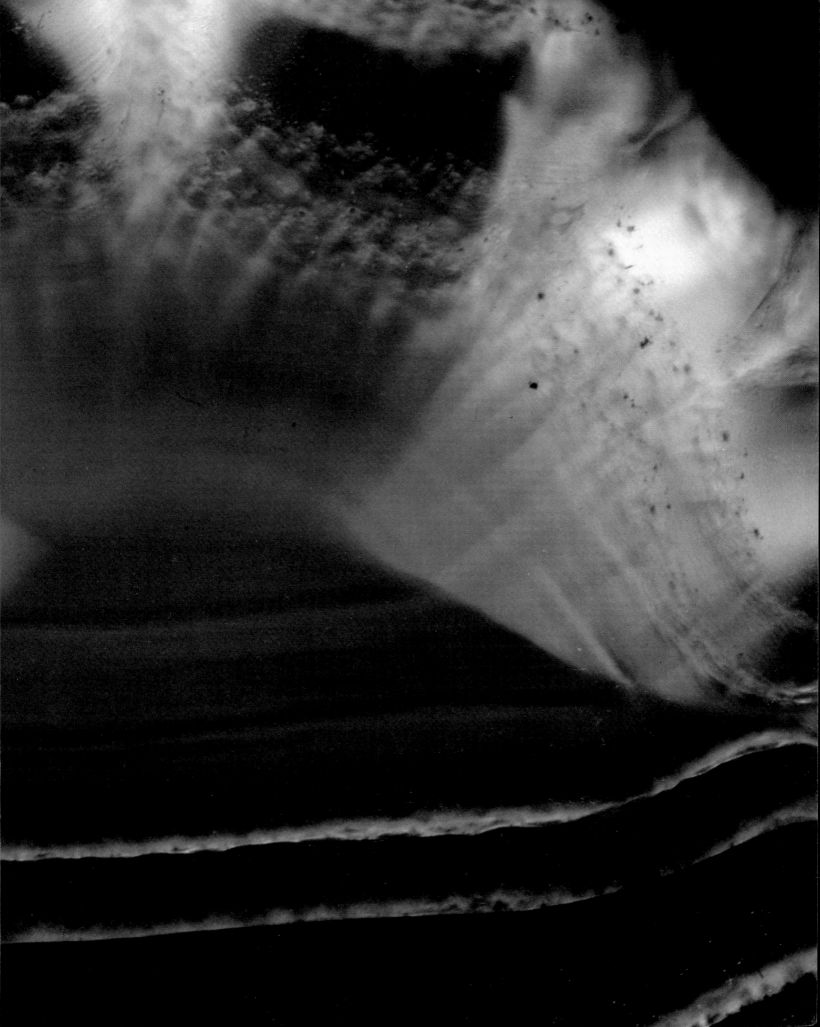

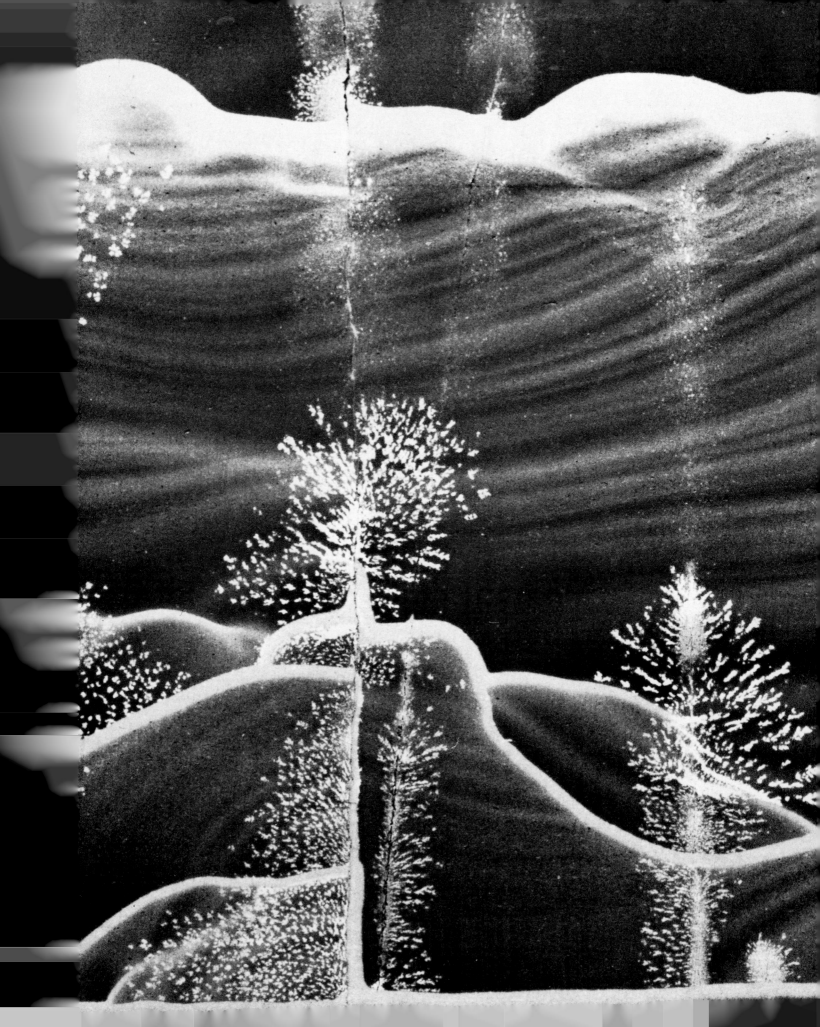

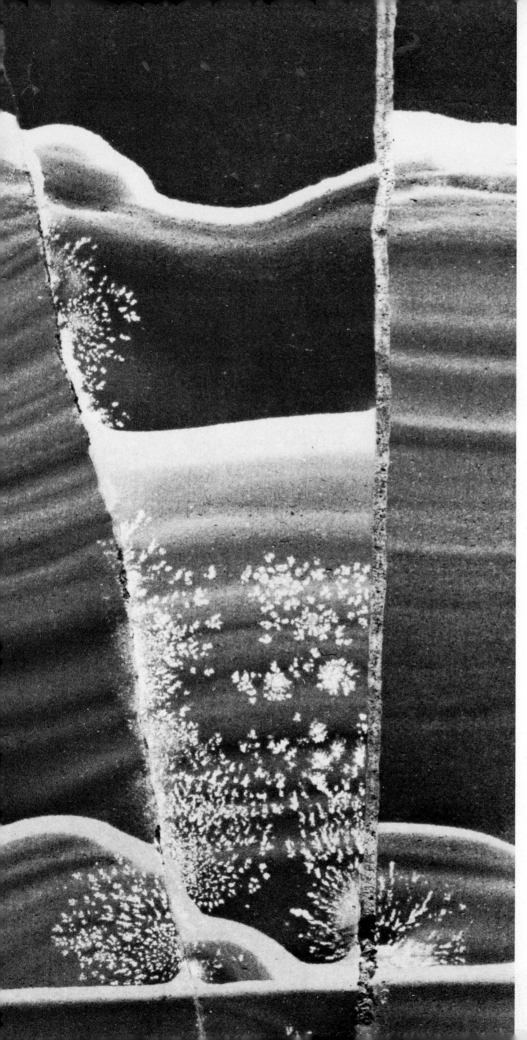

Cross section of a piece of brecciated limestone shown here in the form of a negative print. Magnification is 11× linear. The stone flower garden at night.

Overleaf, left: A thin slice of chalcedony seen in transmitted light. Molten lava and superheated gases roiling in the crater of a volcano?

Overleaf, right: Specks of gold in lapis lazuli, magnified approximately 18× linear. The star-spangled night sky beyond Andromeda.

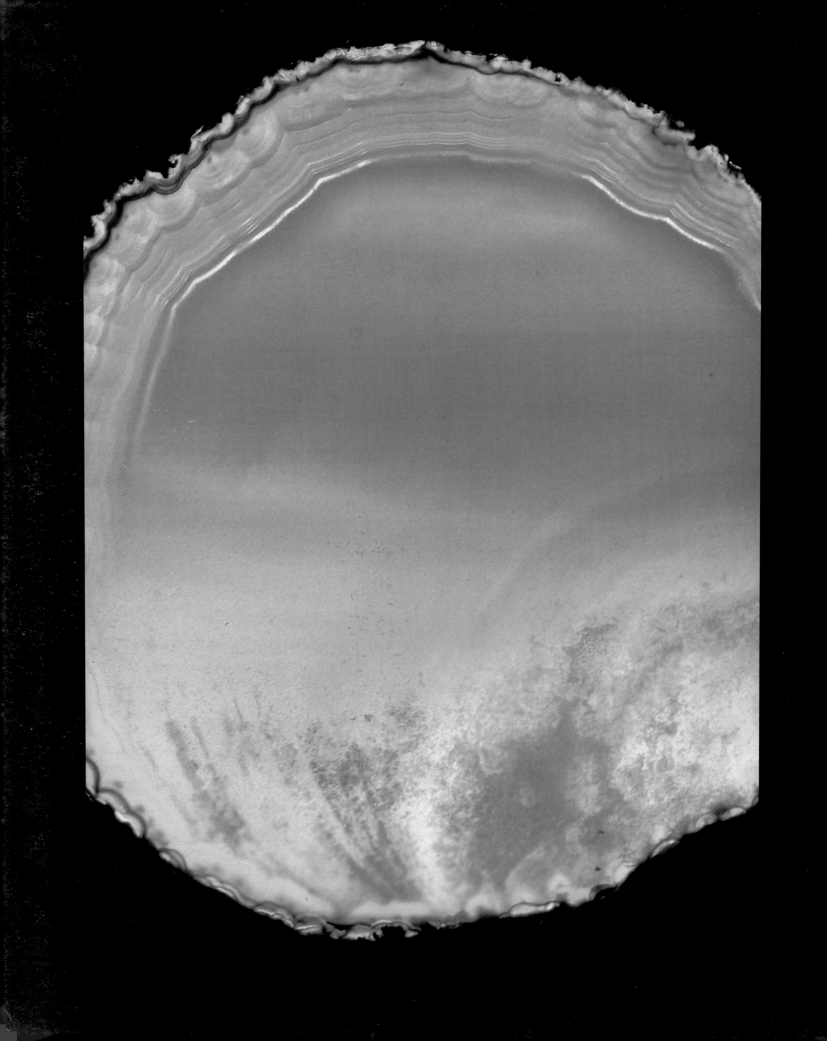

Epilogue

Again I walk the narrow path over my land. Darkness is falling; a feeling of serenity and peace pervades the oncoming night. Surrounding me, black trees stand silent and asleep — birches and oaks, sugar maples and tulip trees, native cedars, slim and tall, pointing skyward like missiles. And again my thoughts take off into fantasy and I see with my mind's eye the missiles waiting silently in their underground silos and nuclear submarines. Only, they are not asleep but alert, their guidance systems ready to carry death to millions, thousands of miles away. I see a million human lives extinguished by a single missile, a million human bodies burned and torn apart and vaporized by the act of a finger touching a button a continent and an ocean away.

The thought is so monstrous that it is inconceivable, like the mass of the sun. But my mind continues to work; my brain takes the figures apart and the unthinkable becomes real: one H-bomb = three megatons = three million tons of TNT. I try to visualize one ton of TNT; it is easy. Then ten — a truckload, although a big one. Then ten big dump trucks lined up side by side. Then ten rows of dump trucks ten abreast: that gives me a thousand tons. Now multiply this parking lot full of heavy dump trucks by three, then take the big jump: multiply again, this time by one thousand — that is three megatons, the destructive potential of a single hydrogen bomb.

And then I try to visualize a million human beings, starting again with one: what goes into the making of a single human life? A child adored by its parents, a boy, a little girl . . . growing up nurtured by care and love . . . the anxieties and expectations . . . the time of learning and growing up. Knowledge and skills acquired by hard work and persistence fueled by hope for a shiny future.

. . . native cedars, slim and tall, pointing skyward like missiles.

Clothing, food, and shelter in terms of dollars and cents. . . . And again I multiply figures: ten human lives times ten times ten times ten times ten times ten—that is one million. But it still is only a beginning. Because not only one bomb is involved, but thousands of atomic warheads ready to fly at a given signal, to turn the earth into a white-hot furnace of radiation, a nova, an exploding star.

Did I get carried away by an overheated imagination? No—the figures are only too real and can easily be verified by anyone who cares to take the time. Yet despite the fact that man now has the power to turn this earth into a fireball, blowing up his planetary home as if it were an exploding star and destroying in the process all life on earth many times over, there still are people—politicians, military analysts, demagogic ''leaders''—who clamor for more. More bombs and submarines and missiles and warheads to assure ''numerical superiority'' over the potential enemy . . . sixteen-inch battleship guns applied to killing flies.

Why do I evoke these horrors? Because my conscience and my imagination don't let me forget them. And because of an ever-growing sense of helpless frustration. Alone, I am powerless, as each of us is powerless as long as he keeps his feelings to himself. Perhaps it is a universal lack of imagination—inability to visualize the unthinkable. Imagination, then, is the key to action:

visualizing what is involved, discussing it with others, taking action, writing congressmen. But since one-sided action cannot bring the desired result, more important still is mutual trust and understanding. Getting together with "the enemy" in an attempt to solve the human problems common to all—uncontrolled population growth, food shortages, waste and pollution control, just and fair distribution of wealth. Because the only alternative to living together in peace is vanishing together in the fireball of a world-wide nuclear blast.

I force my thoughts from their fantastic journey back to reality. I call my dogs and continue my walk under the stars. All around me the creatures of day are asleep and the creatures of night begin to awaken. Overhead, bats fly in search of food. Day and night, from birth to death, life flows in a timeless cycle—life in the soil, water, and air, life of animal and plant, life of man and earth, always in constant change and growth so that in all nature no thing is the same at day's end as it was at day's beginning.

September 23, 1976 Andreas Feininger